Oil Pastel

MASTERPIECES
IN 4 EASY STEPS

ANNA KOLIADYCH

Author of the bestselling
15-Minute Watercolor Masterpieces
and founder of *DearAnnArt*

PAGE STREET
PUBLISHING CO.

PAGE STREET
PUBLISHING CO.

First published in 2022 by
Page Street Publishing Co.
27 Congress Street, Suite 1511
Salem, MA 01970
www.pagestreetpublishing.com

Distributed by Macmillan, sales in Canada by The Canadian Manda Group.

26 25 24 23 22 1 2 3 4 5

ISBN-13: 978-1-64567-510-5
ISBN-10: 1-64567-510-6

Library of Congress Control Number: 2021939530

Illustrations by Anna Koliadych
Cover and book design by Meg Baskis for Page Street Publishing Co.

Printed and bound in the United States of America

Page Street Publishing protects our planet by donating to nonprofits like The Trustees, which focuses on local land conservation.

TO MY SWEET SON, LEO.

You are my love, universe and the biggest inspiration.

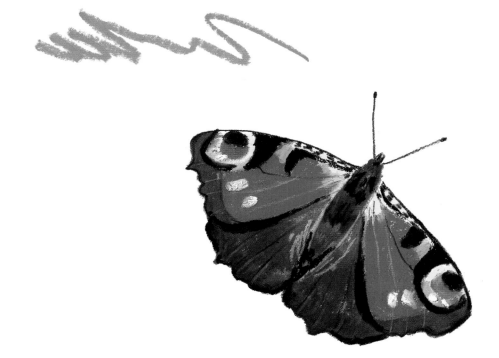

Contents

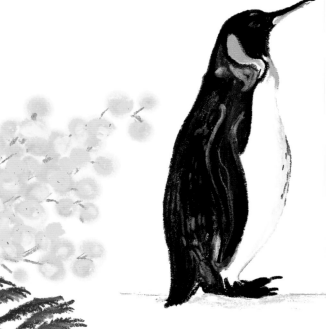

INTRODUCTION

Hello, my name is Anna. I am an illustrator, artist, art teacher and also a very happy person—and already a mom of one little boy. My artistic journey began six years ago when I first picked up watercolor paints. From there, it only continued to grow as new mediums became available for me to explore. I haven't stopped creating since then—the world of art exploration just keeps getting bigger every day! This book covers everything you need to know about how oil pastels work and how to get started with them yourself. Oil pastel is my new passion, and I believe it will be the new trendy medium in the future.

Why oil pastel? I was looking for a new medium to try because I love to explore new mediums, techniques and styles. When I first tried oil pastels, it took me by surprise! It's absolutely different from watercolors and gouache, which is what I had been working with before. I wasn't sure at first whether the material would be right for my work. But I didn't give up and kept trying. After months of learning, looking at millions of works done by other artists with this material and practicing a lot—the techniques finally clicked! Today, oil pastels are a huge source of creativity for me. This medium is amazing! It's easy to draw with, and the colors are so varied that your eyes run wild when you see a box of yummy oil pastels. All it takes to get started drawing with this medium is patience, a little guidance and practice. And if you hold this book in your hands, then you are on the right track.

What is the book about? This book will help you get started drawing with oil pastels if you are a complete beginner. It includes 50 easy projects that can be done in four simple steps and mastered by anyone, even if you've never tried this medium before. With the projects in this book, you will learn to confidently practice drawing skills with oil pastels. You'll be able to

discover for yourself what it's like to use these materials and quickly see that they're not difficult at all! The best way is always through practicing something new—so give it a try. If you are an artist in other mediums, this book will be interesting and helpful. If you're looking to try something new or gain inspiration for your current work, give it a read.

HOW TO WORK WITH THIS BOOK

The format of the book is straightforward and easy to follow. The first part contains all the techniques you need when working with oil pastels, including a list of tips and tricks that will come in handy later on. I have tried my best to keep explanations simple without any unnecessary fluff—only important information! The second part of this book is about practice projects. There are six chapters with different themes, from stunning landscapes (page 15) to a few mixed-medium projects (page 171). Each project contains step-by-step instructions and color schemes, so you won't get lost in the creative process. Art is not just a form of expression; it's the way to heal and grow. Allow yourself to make mistakes and experiment. Enjoy each moment you will spend with this book because it's going to be a lot of fun! I hope you'll love oil pastels and that they will bring joy into your life.

With love,

Anna

OIL PASTEL TECHNIQUES AND SPECIFICS

WHAT IS OIL PASTEL?

Oil pastel is incredibly versatile and has beautiful, vibrant colors. I really appreciate this medium due to its unique texture, soft application and rich color quality. As an artist, it took me some time to understand this medium, but once I did, I fell in love working with it. **Oil pastel is a graphic medium formed from colored round or square sticks or pencils with pastel cores.** Another name for pastel sticks is pastel crayons. Here are the specifics you need to know about oil pastels:

- They're a very versatile medium: it can be used for sketching, but also for sustained works in different styles. Oil pastels can be applied to a range of papers, such as drawing paper, special paper for oil pastels, mixed-media paper or watercolor paper.

- You can draw with oil pastels on white, toned or even black paper.

- Oil pastels are considered a fast medium because they are easy to draw with and convenient to carry.

- Oil pastel can be blurred on paper or other surfaces.

- Oil pastel colors can be blended easily.

- Oil pastels are a water- and light-resistant medium.

- You can work in two ways with oil pastels, from light to dark layers, or from dark to light layers.

- Oil pastels can stain your hands and other surfaces. And the crayons themselves can be stained with residues of other colors, so be sure to have a paper towel at hand at all times to clean your hands or the oil crayons.

- When drawing with oil pastels, the transparency of the layers can be set by the force of pressing the crayon on the drawing surface.

- Oil pastel can be used along with other mediums, such as watercolor, gouache, acrylic and colored pencils.

These are just some points that might help you tiptoe into the world of oil pastels. Further along, it will be more interesting as we consider all the techniques and features in detail and definitely get some practice by actually drawing full-fledged projects.

OIL PASTEL TECHNIQUES

In this section, I will introduce some techniques I use when drawing with oil pastels. Each of these methods will help you create a beautiful final project and learn more about this amazing material in general. Try each technique before you go on to the following chapters.

I assure you that taking the time to study and practice the techniques in this book will make you feel more confident with your drawing abilities using oil pastels.

NOTE: The names of these techniques may differ from those used elsewhere.

BLURRING

Blurring is a basic and effective technique of drawing with oil pastels and I use it all the time. **In essence, this technique means blurring one color.** As I mentioned earlier, oil pastel is a drawing medium formed into a stick. It's possible to draw directly on the paper, but you get a rather textured stroke. Which is fine if you want something like that. However, oil pastels have the ability to be blurred on paper. For this purpose, you can use a blending stump or cloth, your fingers or paper towels. Let's try this technique (see Figure 1). First, draw any abstract shape. Then, take a blending stump (or use any other option for blurring) and gently start to blur the pigment of oil by moving the blending stump into the paper to get a smooth texture. When practicing this technique, try to blur a line and any shape (Figure 2 and Figure 3).

The direction of movement is important, depending on what you're trying to blur. For example, if you blur a little spot by making a circular movement, you can get a glow effect. This is especially visible on dark-toned or black paper (Figure 4). If you're blurring inside a shape or some detail, then the direction of movement is not important (Figure 2 and Figure 3).

A blending stump is a good choice if you are blurring details or small areas. But for large areas, such as a sky, it is better to use a cloth for blending. Sometimes it makes sense to use both: a cloth for blurring the shape inside and the blending stump for the edges.

Figure 4

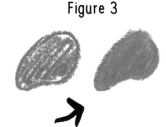

Figure 3

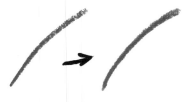

Figure 1

Figure 2

BLENDING

Blending is another technique often used in drawing with oil pastels. It's used in almost every project in this book. To do it, take three sticks of different colors. Apply them next to one another on a piece of paper and then take a blending stump and blend the borders where these colors meet (Figure 1).

This method is perfect for coloring shapes that require more than one color. For example, a leaf will look much more realistic if the base layer is blended with three shades of green (Figure 2). Blending is also the technique that is used if you need to blend the base layer with another layer that is added on top of it. In this case, we are mixing two pigments, but they are on different layers (Figure 3).

As with the blurring technique, the direction of movement when blending colors matters and allows you to achieve certain effects. So, try experimenting and mixing the pigment in different ways.

GRADATION

At its core, it is a blending technique. In this case, the direction that is used for mixing plays a key role. So, let's draw such a gradient. We will be drawing a linear gradient along the horizontal; therefore, the movement used for blending must be horizontal. Take two colors and start to paint with them from opposite sides. Continue to paint with these colors in turns until they meet each other. At some point, one color will be overlapping the other. Then, take either a cloth for blending or a blending stump and start to blur each of the colors in turn, then blend the colors' transition (Figure 1). Remember that the cloth for each color should be different, and it's best to use a clean cloth or paper towel when blurring the overlap. The gradient can also be radial. In this case, it is important to apply colors appropriately and blur afterward by making circular motions (Figure 2).

This technique is a little more challenging than the previous ones you've learned so far. It requires your attention and patience, but with some practice, you should be able to master it and draw beautiful gradients.

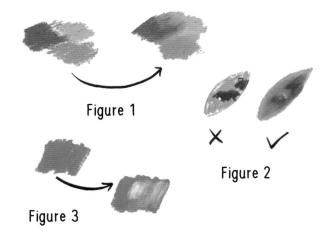

Figure 1

Figure 2

Figure 3

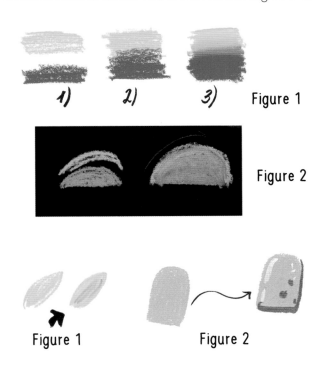

1) 2) 3) Figure 1

Figure 2

OVERLAYING

The next technique is called overlaying. It's just as important and useful as the last two techniques we talked about. The basic idea of this technique is **to draw a new layer over the previous one**. This layer is not blurred or blended and usually retains the texture inherent in oil pastels. The technique is often used in the final stage of a project (Figure 1 and Figure 2).

Figure 1

Figure 2

COLOR MIXING

If you don't have a specific color within your oil pastel set, mixing colors is a great method to use when drawing. Let's execute the technique. First, draw a shape in one color, then add another on top, forming two layers of color. Using a blending stump, **mix the colors into a new, third color** (Figure 1). To understand what color you will get if you mix two certain colors, follow the rules of color theory and the color wheel (read more about color mixing on page 12).

TIP: If you need a pastel shade of some color, you can mix this color with white, using the color-mixing technique (Figure 2).

SCRATCHING

The last technique we'll consider in this section is scratching. It's a common technique in oil pastel drawing, but I personally rarely use it. From the name of the technique, you may understand that it involves scratching some details from the oil pastel layer. To execute this technique, you will need a painting knife or stationery knife or something sharp like a toothpick. So, first draw a layer, then scratch with the sharp part of the painting knife to achieve your desired details (Figure 1). The best and more effective technique works when using black paper. In this case, the dark scratched parts are visible and create a great contrast with the oil pastel layer (Figure 2). This technique is excellent for making details on leaves or petals (Figure 1).

TIP: Scratching is also very useful if needing to clean out some space when adding some details.

For example, if too thick a layer of oil pastels has been used or too many layers were drawn, take a painting knife and carefully scratch out the area where you need to work.

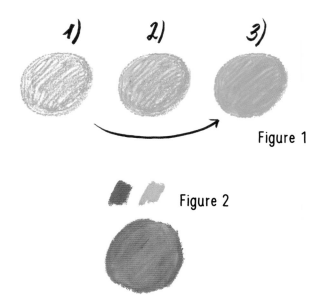

Figure 1

Figure 2

Figure 1

Figure 2

HOW TO DRAW WITH OIL PASTELS AND STROKE TYPES

As was mentioned already, oil pastels are very easy to use. You don't have to do much prep work before getting to draw. You do not need any water and you can begin drawing right away after purchasing the oil pastels. However, there are different ways of how exactly you can draw with crayons. I have prepared a classification of drawing methods depending on different approaches:

- How to use a stick
- How much pressure to apply
- Drawing strokes

It might seem like a big and superfluous topic at this point, but it's important that we go over this, so you have the tools necessary to be able to draw more effectively with this medium. Let's look at each of the points in more detail.

How to use an oil pastel crayon: You can draw with the pointed end of the crayon (Figure 1). This way, you can produce a pretty thin and even, smooth stroke. If you draw with a flat side, or a blunt piece of crayon, you can get completely different strokes (Figure 2). This approach is perfect to fill a shape or color an area. Play with both ways to practice, if you are a newbie in oil pastel drawing. With practice, you will develop a certain intuition for how to effectively use the sticks.

One of the beauties of oil pastels is their ability to **draw with heavy, light and medium pressure** (see Figure 3). With heavy pressure, you simply add your color of choice to the paper and try drawing with enough pressure to create a solid layer without interruptions or bald spots. It provides a striking, bold and textured layer. With light pressure, the action is the same but you're only touching the paper slightly, to achieve an uneven application. This method will allow you to work further with the layer, such as to add other layering, blurring, and so on. Medium pressure gives an almost smooth layer, but is not as intense as when heavy pressure is used.

Figure 3

Light Medium Heavy

Throughout this book, I will give you recommendations on how much pressure to apply in some projects, usually where there is a need to specify it. Otherwise, try to draw with medium pressure.

Depending on the drawing strokes, I may ask you to do **hatching**, **crosshatching** or **stippling**. In Figure 4, you can find examples of these strokes:

- **Hatching** is drawing with closely drawn parallel lines.
- **Crosshatching** is drawing an area with intersecting sets of parallel lines.
- **Stippling** is drawing using numerous small dots or specks.

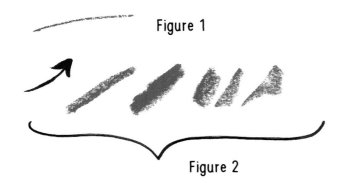

Figure 1

Figure 2

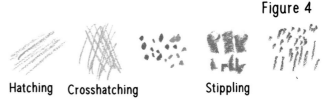

Figure 4

Hatching Crosshatching Stippling

COLORS OF OIL PASTEL

It's time to talk about the colors of oil pastels! This section is all about the nuances you need to know for practicing the projects in the book. In addition, I've included a basic color wheel that you can refer to if you need help mixing specific colors for your projects. It's all that you need to successfully execute the projects.

For drawing the projects in the book, I used a set of 48 colors (see all the colors in Figure 1). Of course, the more oil pastel colors you have, the better. But I think that 48 colors are more than enough to create a true masterpiece.

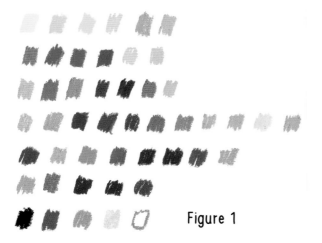

Figure 1

Being familiar with colors from your set will help you create a color swatches card. This is a paper card or sheet of paper on which you create reference samples of all the colors you may need to use for your projects. For this, I advise you to glue together white, black and toned papers, and then to draw all the colors of your oil pastel set on each paper type (see Figure 4 on page 13 for an example of color swatches). It will help orient you as to how all your colors look drawn on different papers versus how they appear simply as a crayon, and how to find certain colors very quickly.

Each of the projects in this book will include a respective list of the colors you need. Before you begin a project, you will need to find those in your set that closely fit that project's colors. If you don't have such colors or only some of them, you can mix them on your own as you draw (read more about color mixing on page 10). And exactly for this reason, we'll cover some of the basic aspects of color theory.

Let's begin with the **color wheel** (see Figure 2). A color wheel is a circle that contains twelve hues: the three primary colors (red, yellow and blue); the three secondary colors (orange, green and purple); and the six tertiary colors (red-orange, yellow-orange, yellow-green, blue-green, blue-purple and red-purple). The tertiary colors are made by mixing a secondary color with a primary color.

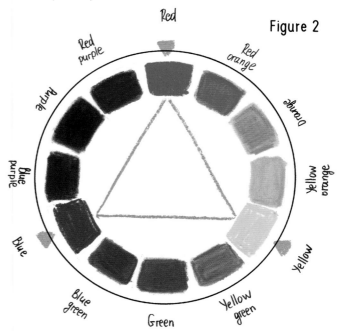

Figure 2

For instance, according to the color wheel, if you need a tint of green, you should mix yellow with blue as you draw. And to be sure you will get the desired green shade, try to mix a few combinations of whatever blue and yellow you have. You can also change the proportions of the colors you mix if you draw with different pressures for different colors (read more about pressure on page 11). Don't be afraid to mix colors together! You'll be surprised by how enjoyable and interesting the outcome can be.

Another important point in understanding color theory is the difference between **cool and warm tones** (Figure 3b). The simplest way to put these particular concepts into perspective is by considering warm colors as being red, orange or yellow, and cool colors as blue, green and purple. There are also colors that combine both warm and cool tones: red-purple and yellow-green. This is quite basic, but understanding this principle of color theory will help you mix and choose colors for your own projects. In Figure 3, you can see the two tones of red. The first one is scarlet and it is a cool color. The second one is vermilion, a warm color. And the last thing I would love for you to consider is **mixing with white** (Figure 3a). You can mix any color with white. And here I just emphasize that you can get a pastel (paler) tint if you mix a color with white. For example, if you mix light blue with white, you will get a pastel tint of blue (see Figure 4).

Figure 3a

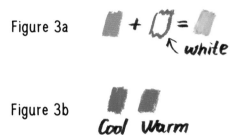

Figure 3b

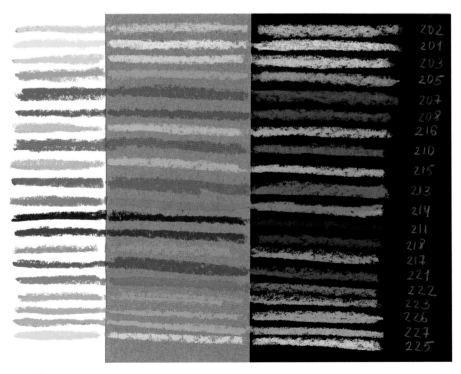

Figure 4

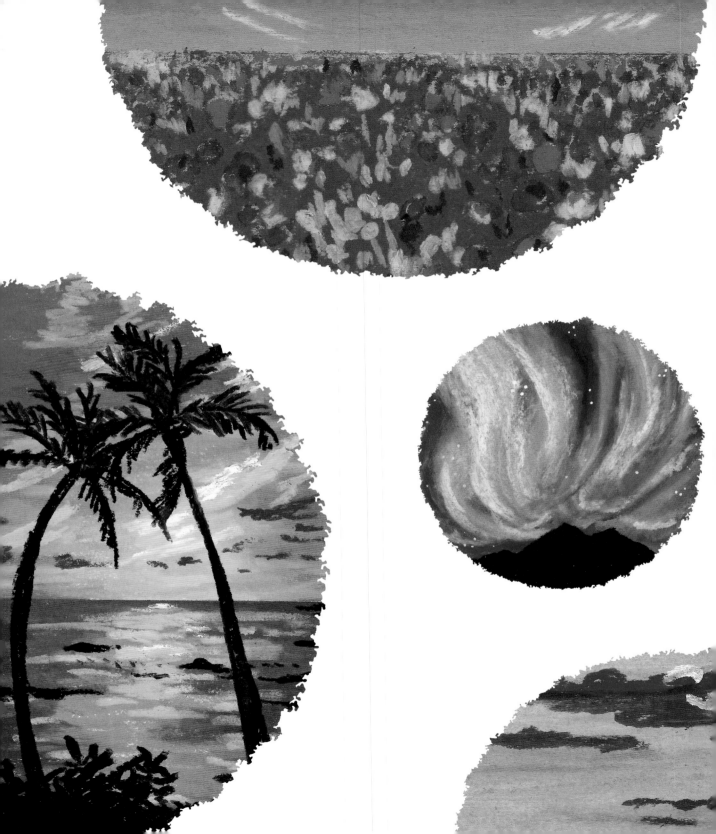

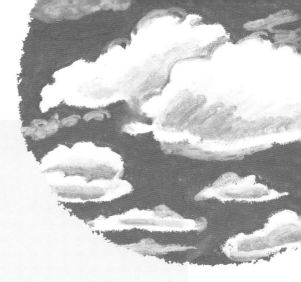

SPECTACULAR
Landscapes

This chapter contains incredibly beautiful and varied landscape oil pastel drawings. I invite you to create a magical Aurora Borealis (page 16), immerse yourself in the atmosphere of a beautiful Sunset on a Tropical Beach (page 25) or re-create a dramatic sky with lightning in a thunderstorm (page 41). Discover all this and more in this chapter!

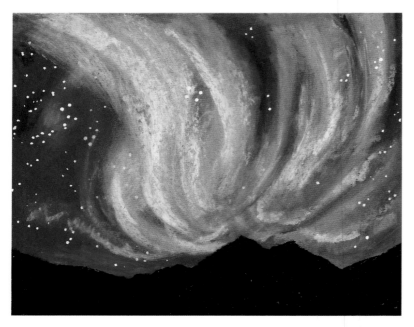

AURORA BOREALIS

The aurora borealis (a.k.a. northern lights) is one of the most spectacular natural phenomena in the world. It amazes everyone who has been lucky enough to see it once. So why not depict it on paper with oil pastels? Drawing this type of landscape is so relaxing and meditative when compared with other types of landscape drawing. But without much experience, this can be intimidating. In this lesson, I will share some secrets and top tips for making the process easy and fun.

SUPPLIES

- White or toned paper
- Masking tape
- Cloth for blending
- Blending stumps
- Paper towel
- Pencil
- Eraser
- White chalk pen or marker

OIL PASTEL COLORS

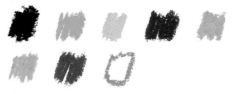

Black, Jade green, Pink, Prussian blue, Turquoise blue, Turquoise green, Ultramarine blue, White

NOTE: For this project, you can use white, black or toned paper. However, I recommend choosing a toned paper if you're a beginner.

TIP: If you're using masking tape on the paper, test it on the paper first. Add a small piece to the paper and then remove it slowly. If the paper is not destroyed, go ahead and use the paper for the project. If it is, try to find a paper that will work with the masking tape.

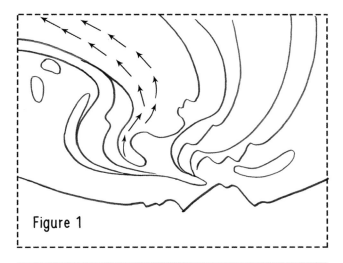

Figure 1

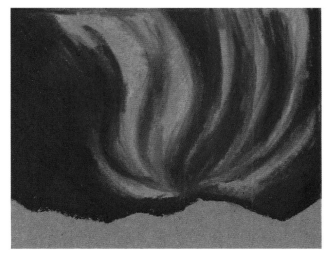

Figure 3

Let's color the landscape. The secret to drawing the aurora borealis is to think about light sectors before drawing. You can mark them using their outlines (Figure 1) or at least keep them in mind while coloring. It's also important to decide their directions (an example of the direction of one light sector is shown with arrows in Figure 1), and then use these directions for blending. So, use turquoise blue, jade green and turquoise green to color the light sectors, adding these colors randomly in each section (Figure 2). Then, blur these colors, each sector separately, in the corresponding direction of light (read more about blurring on page 8).

STEP 2

Now, we need to fill the rest of the sky with ultramarine blue (Figure 3). Apply heavy pressure when coloring (read more about pressure on page 11). Next, blur this layer, using a cloth, then blend the blue sky with the light sectors drawn in step 1 (read more about blending on page 9).

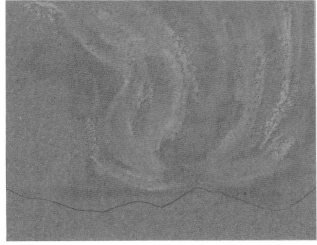

Figure 2

STEP 1

For this project, we will not make a preliminary pencil sketch, only some marks, if needed (the line of the mountain). However, I recommend preparing for the painting by securing the paper with masking tape to the surface of your table or board.

 Figure 4

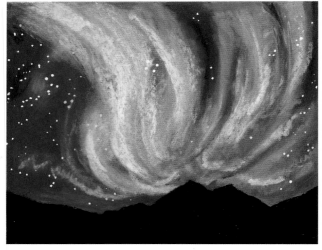 Figure 5

STEP 3

Let's move on with our landscape drawing. Add a little pink to the bottom part of the sky. Blend these details with a base layer. Then, add extra strokes to the sectors of light, using turquoise blue, jade green, turquoise green and white (Figure 4). These make the light clearer and more expressive. Blend these details. Once again, while blending, keep in mind the direction of each sector—each blending movement should follow the corresponding direction of the sector.

STEP 4

With black oil pastel, color the silhouette of the mountains. Blur this area, if needed. Then, add some dark areas in Prussian blue to the sky. Blend these accents to get a smooth layer. And, finally, using the overlaying technique, draw some more accents of northern lights with white oil pastel (Figure 5). These details should not be blended (read more about overlaying on page 9). To complete the landscape drawing and make it absolutely stunning, I suggest you take a white chalk pen and use it to randomly draw some stars in the sky. Try to make these dots in different sizes. After the work is done, remove the tape and here is your little masterpiece.

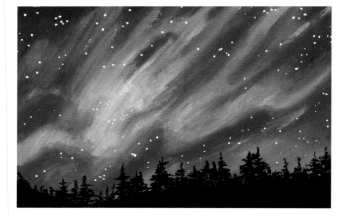

Figure 6

This is a really lovely project and I hope you enjoy drawing it. If you change the directions of lights and experiment with the composition of the landscape (for example, you can add some silhouettes of trees), you can create more drawings of the aurora borealis (see an example in Figure 6). When you get more experience in drawing such landscapes, try to play with the colors of the light: add some purple and yellow-green.

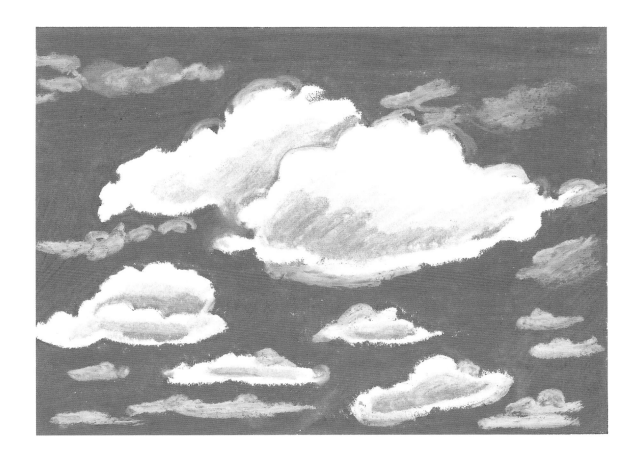

FLUFFY CLOUDS

There are all types of clouds, and each has its own opacity and shape, and there are different ways to draw them. Within this lesson, I will teach you to draw fluffy clouds by using oil pastels. This project is super easy and beautiful—anyone can do it! Let's go!

SUPPLIES

- White paper
- Masking tape
- Cloth for blending
- Blending stumps
- Paper towel
- Pencil
- Eraser

OIL PASTEL COLORS

 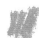

Light blue, Light gray, Sky blue, White

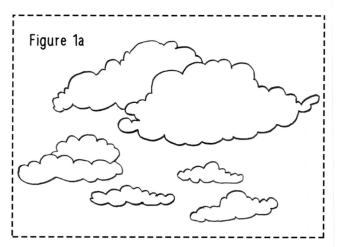

Figure 1a

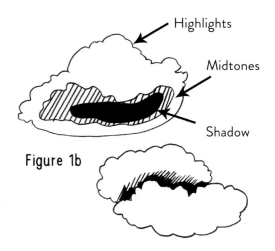

Highlights

Midtones

Shadow

Figure 1b

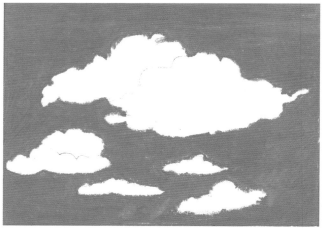

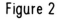 Figure 2

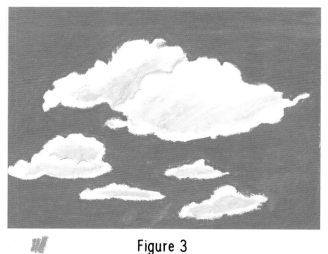 Figure 3

STEP 1

Define your work area before beginning by creating a rectangular border around your area with masking tape. Now, you can make a light sketch of the clouds with a pencil, following the outlines in Figure 1a. Once the sketch is ready, add light blue to the area around the clouds (Figure 2). Here is my tip to quickly achieve the best results: First, outline the clouds with light blue. With the same color, create hatching around the clouds (read more about hatching on page 11), then blur the drawn background with a cloth and a blending stump (read more about blurring on page 8).

STEP 2

Let's go ahead and make the clouds look realistic. For this, we need to add the shadow and midtones. To make it easy, I prepared a simplified sketch of a cloud. As you can see from Figure 1b, a fluffy cloud has a highlighted area on the top and a little around the shape of the cloud, midtones located in the middle and a shadow a little down from the middle. Where two clouds bond together, the shadow and midtone visually separate them (see Figure 1b). According to this, we already have highlights on all our clouds; these are the white areas free from the color we used in step 1. To add midtones, use a light gray crayon to draw the corresponding areas on each cloud (Figure 3). Then, blur them by using a cloth.

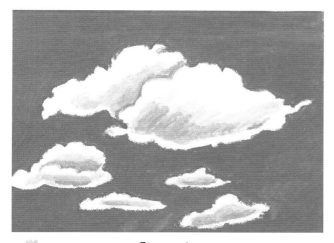

Figure 4

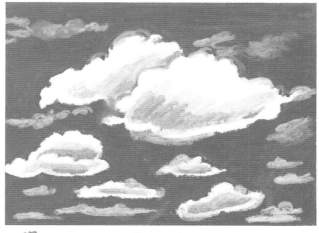

Figure 5

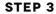

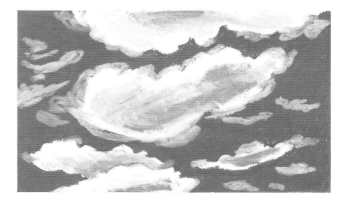

Figure 6

STEP 3

The clouds already look more dynamic. It's time to add shadows. With sky blue, add shadows to each cloud (Figure 4). Blend these areas with the midtones we added in the previous step to get a smooth and soft effect (read more about blending on page 9).

STEP 4

Let's now draw some clouds with a white crayon, using the overlaying technique (read more about this on page 9). I suggest adding them randomly, or you can follow the example in Figure 5. These clouds are pretty transparent, which makes them look as if they are in the background. With the same color, let's make some adjustments to the shapes of the big clouds: make them smoother, maybe expand somewhere if needed. Take off the masking tape and our fluffy clouds drawing is done.

Using this lesson's principles, you can create a variety of skyscape drawings. And with oil pastels, the process of drawing is so easy and fun. Figure 6 shows a drawing made by following this lesson, but the clouds' shapes were changed. Use the method of this project for drawing the sky for any landscape. You can also play around with the colors, but the most important thing is to enjoy the process!

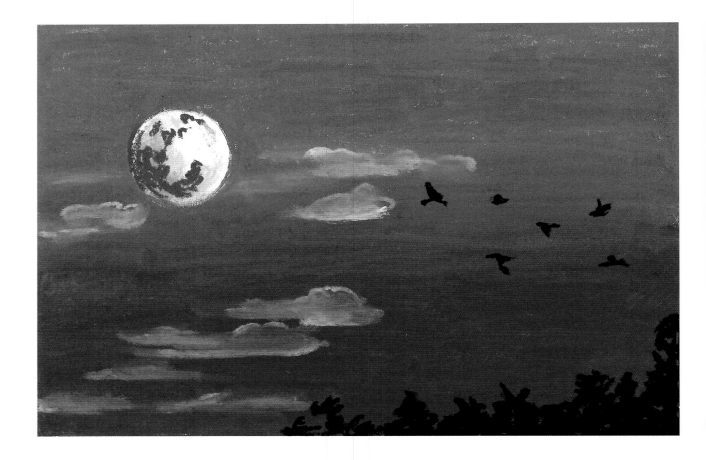

BIRDS BY MOONLIGHT

This cute and simple project is proof that everyone can draw with oil pastels without having any drawing experience. Just prepare all the listed supplies, follow my instructions and enjoy the process!

SUPPLIES

- White or toned paper
- Masking tape
- Cloth for blending
- Blending stumps
- Paper towel
- Pencil
- Eraser
- Compass, or a round object with a small diameter

OIL PASTEL COLORS

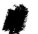

Black, Blue-purple (periwinkle blue), Dark gray, Gray, Lilac, Salmon, White

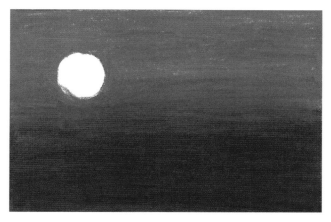

Figure 1

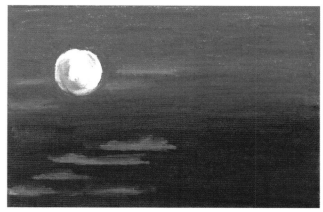

Figure 2

STEP 1

This project doesn't require a sketch. However, we need to define the working space and sketch a circle for the moon. So, with the help of masking tape, define the horizontal rectangular area you intend to draw. Once it's done, use a compass or any round object to sketch the circle. Now, we are ready to start drawing with oil pastels. In this step, we need to prepare the base coat for our beautiful sky scenery. For this, let's apply the gradation technique (read more about this on page 9). Using the blue-purple and lilac oil pastels, start filling the working space, except for the section of the moon, adding blue-purple to the upper part and lilac to the bottom of the sky (Figure 1). Use a cloth to make a smooth and even gradient. For blending the edges of the moon, I advise using a blending stump (read more about blending on page 9).

STEP 2

Let's give our scenery some details. With the gray crayon, draw the layer of the shadow in the moon, as shown in Figure 2. Gently blur this layer (read more about blurring on page 8). Now, switch to the salmon crayon to draw some clouds. Blend those clouds with the base coat layer.

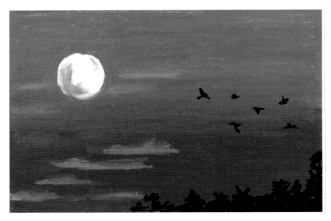

Figure 3

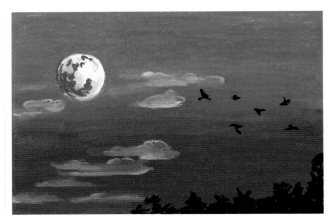

Figure 4

STEP 3

Finally, we can draw the silhouettes of the birds and the forest in black, using the overlaying technique (read more about this on page 9). It will create a great contrast and make the work look really pretty. By using the sharp point of the black crayon, draw birds and the silhouette of the forest (Figure 3). If needed, blur the silhouette of the forest area inside with a cloth.

STEP 4

It's time to draw the details and some accents. With salmon, add a bit of color to the moon. Blend this layer. Then, using the overlaying technique, switch to using dark gray and draw the details on the surface of the moon (Figure 4). These details should not look realistic; let's make them more stylized—just add a few free-shaped spots. Then, last, we will add highlights to the clouds. With white crayon, draw highlights onto the clouds we had drawn in step 2. You can blend those details or level them for a great textural effect. If needed, with white, you can correct the moon edges, to make them look clearer. Carefully remove the masking tape. Your cute landscape is done!

Despite the fact that it's a straightforward project, this is pretty flexible and gives you a wide range for your own variations. Play around with the colors and try to create different gradients for your sky. You can also experiment with silhouettes of your landscape. It's so easy to draw any silhouettes of trees, as well as little birds. I hope the instructions of this lesson allow you to create many beautiful skyscapes.

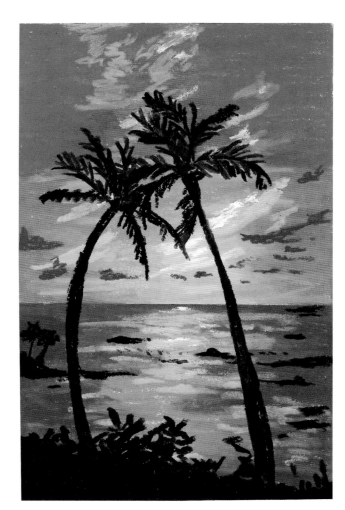

SUNSET ON A TROPICAL BEACH

Drawing sunset landscapes with oil pastels is pure pleasure. All the transitions of tints are so easy to make with the soft crayons of oil pastels. And then, you just need to add some accents and your masterpiece is ready. It's as if the pastel was originally created for drawing such landscapes. In this project, I invite you to create a super-vivid drawing of a sunset landscape on a tropical beach. Gather all your necessary supplies and let's draw!

SUPPLIES

- White or toned paper
- Masking tape
- Cloth for blending
- Blending stumps
- Paper towel
- Pencil
- Eraser
- Cotton swabs (optional)

OIL PASTEL COLORS

Black, Blue-purple (periwinkle blue), Lilac, Orange, Orange-yellow (golden yellow), Pink, Purple, Soft orange (orangish yellow), White

Figure 1

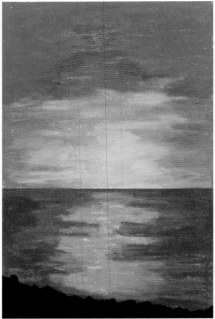

Figure 2

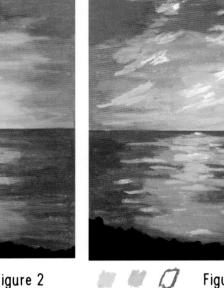

Figure 3

STEP 1

First of all, define the drawing area with masking tape and carefully secure it to the paper. Then, divide the landscape into the bottom (the water) and the top (the sky). To do this, apply one more strip of masking tape. Fill the sky area by adding the following shades: blue-purple, purple and orange-yellow (Figure 1). Now, blur each color individually by using a cloth (read more about blurring on page 8). Then, let's apply the blending technique (read more about blending on page 9). First, blend blue-purple with purple, and then carefully blend orange-yellow with purple. Use a cloth for blending, or any other way you prefer (cotton swabs, for example). Now, you have a smooth first layer. The last touch in this step is to add a few strokes in soft orange, mostly in the middle of the sky; you can also add some strokes around. Blend this pigment with the first layer of the sky. Our sky's base layer is ready. Now, remove the masking tape strip and move on to the next step.

STEP 2

With a pencil, draw a line of bushes. Later in this step, we'll fill this area with black. Now, fix the strip of masking tape over the skyline. Don't press too hard, just gently secure it on the layer of the sky. Fill the water area with lilac, orange and purple (Figure 2). Blur each of these colors with a blending stump. Once it's done, let's blend the tints to make the soft transitions of the water using the blending technique (Figure 3). And finally, fill the bush area with black, using the blurring technique for this part. You can make the upper line of the bush more graphic by adding some sharp touches of black crayon, which make the artwork look more interesting. Remove the masking tape strip from the skyline.

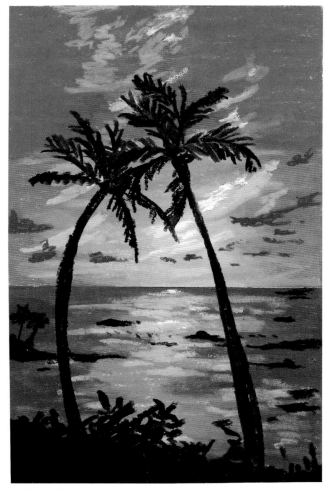

Figure 4

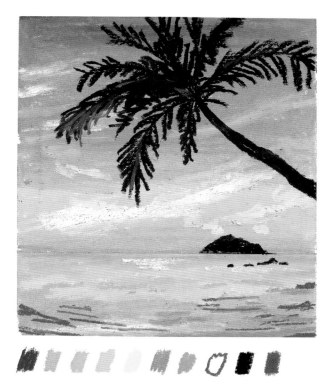

Figure 5

STEP 3

For now, we have a pretty flat landscape, so we will make the colors look deeper and add some details. For this, let's add some touches in soft orange and pink to the sky as the clouds. Blend them slightly with the background by using a finger or a cotton swab. Using the same colors, add details to the water, as shown in Figure 4. These details provide shine on the water and make the drawing look more lifelike. And finally, using the overlaying technique (read more about this on page 9), add some accents with white pastel on the sky and water area as well.

STEP 4

In this step, add elements in black crayon to pull together the artwork into one composition. Draw the palm trees first, as shown in Figure 4. Then, draw small rocks, palms in the background and leaves of the bush in the foreground. Work accurately with the black pastel to try not to make a mess of the drawing. The last step in this project is to add some clouds in lilac to the sky. Remove the masking tape and voilà! The drawing of a charming beach sunset is done.

By using the same techniques and by following these instructions, you can create a variety of drawings of beautiful sunsets. What can you change? First of all, the colors of the projects. And second, you can draw the palm trees differently: add more palms or draw the palm branches instead. You can make any changes you would like or that you have in your imagination. Find one example, painted by me, in Figure 5.

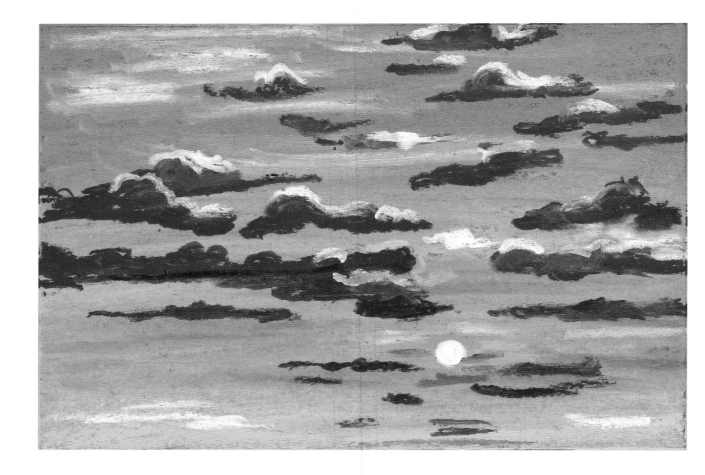

CLOUDS AT SUNSET

Let's draw a romantic cloudy sky at sunset. Drawing such a simple landscape using oil pastels is so relaxing and enjoyable. And, of course, you could use the skills of drawing the sunset sky in other landscape drawing projects. So, let's get to it!

SUPPLIES

- White or toned paper
- Masking tape
- Cloth for blending
- Blending stumps
- Paper towel

OIL PASTEL COLORS

Lilac, Orange, Pink, Purple, Russet, Sky blue, Soft orange (orangish yellow), Ultramarine blue, White

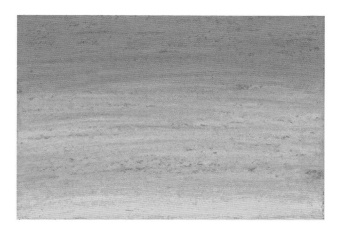

Figure 1

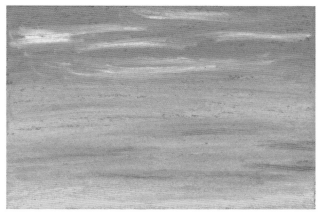

Figure 2

STEP 1

Because this project depicts only the sky, I don't advise drawing a preliminary sketch. Take masking tape and apply it carefully to the paper to create a rectangular or square area for drawing. We will be drawing inside this area. Now, let's fill the drawing area with a base coat, using the gradation technique (read more about this on page 9) and the following colors: sky blue, pink and soft orange (Figure 1). Starting from the upper part of the sky, add these colors, one by one. Then, take a cloth for blending and blend them to get an even and smooth three-color gradient (read more about blending on page 9).

STEP 2

For a more realistic result, we'll add more colors to the sky scenery. Draw some horizontal lines in white, purple and orange, as shown in Figure 2. Then, blend these details with the first layer. Please note that the white details can be added randomly. As for the orange and purple ones, draw them in the bottom right part of our skyscape. Because there will be a sun, these touches visually create some attention.

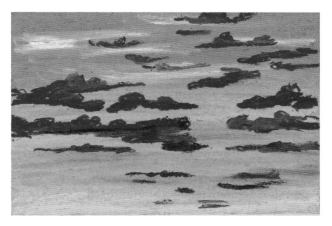

Figure 3

STEP 3

It's time to add some clouds to our vivid and happy background. Using the overlaying technique (read more about this on page 9), draw at the upper part of the sky with ultramarine blue, and at the bottom some clouds with lilac (Figure 3). Add them randomly; however, I don't advise drawing too many clouds. Remember, less is more. Once all are done, jump into the final step.

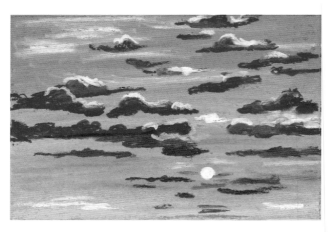

Figure 4

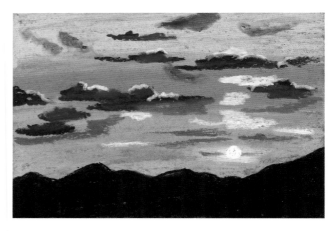

Figure 5

STEP 4

In this step, we'll use the overlaying technique to add some finer elements and accents to complete this beautiful drawing. First, add a few horizontal hatches in russet to the bottom right part of the working area (read more about hatching on page 11). Then, switch to white oil pastel and draw the small sun and highlights to the clouds (Figure 4). Also, with the same colors, add a few extra clouds in the bottom part of the sky.

By following these steps, you can draw a variety of beautiful skyscapes in the sunset and use them to draw an entire landscape. For this experiment with the details, play with colors. You can change the base colors or add some extra tints. You can also show your creativity in this project and draw additional elements, such as mountains or a meadow silhouette in the foreground (Figure 5).

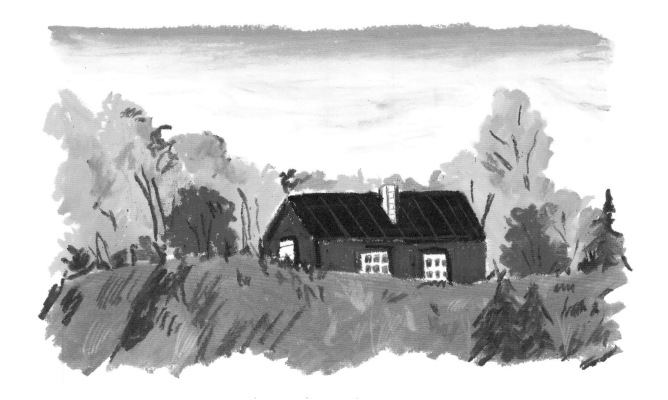

AUTUMNAL CABIN

This is one of the most eye-catching projects in the book. The fall colors are so bright and inspiring. And I just couldn't pass up on such an amazing landscape with all of its gorgeous hues, so it's in the book! Oil pastels allow us to capture all of autumn's beauty with a few creative touches and cool techniques. Let's get started!

SUPPLIES

- White drawing paper
- Cloth for blending
- Blending stumps
- Paper towel
- Pencil
- Eraser
- Brown colored pencil
- Painting knife

OIL PASTEL COLORS

Brown, Carmine, Moss green, Ochre, Olive, Olive brown, Olive yellow, Orange-yellow (golden yellow), Pastel yellow (pale yellow), Russet, Scarlet, Turquoise blue, White, Yellow

COLORED PENCIL COLOR

Brown

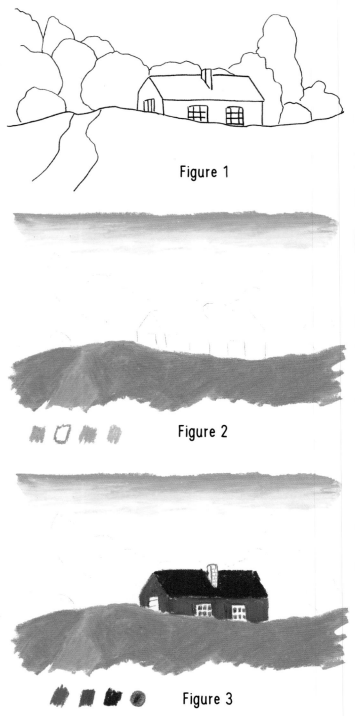

Figure 1

Figure 2

Figure 3

STEP 1

Start by making a light sketch of the landscape scenery, following the drawing outlines in Figure 1.

NOTE: I don't use masking tape to define the working area. For this project, I'm going to encourage you to try something different. Create an abstract rectangular shape that does not require a preliminary draft; you can just mark the angles of the rectangle.

Let's begin with coloring the sky area. We'll use the gradation technique (read more about this on page 9). With turquoise blue, start to draw the gradient in the upper part of the landscape. Then, start adding white from the center. Blend the colors to a smooth and even gradient (read more about blending on page 9). Now, arm yourself with an olive yellow and draw the path on the grassy lawn in front of the house (Figure 2). Blur it, using a blending stump (read more about blurring on page 8). Then, using ochre and olive yellow, fill the grass area randomly. Blend these zones into one layer of the beautiful, grassy lawn.

STEP 2

Now, let's deal with the little Scandinavian house in our scenery. Using scarlet and carmine, color the house walls (see Figure 3) using the color-mixing technique (read more about this on page 12). Then, with brown, color the roof. Blur the roof shape, if needed, with a blending stump. The last thing we'll do in this step is to draw fine details with a brown colored pencil. Using the pencil, draw in the windows and chimney very accurately. *Note that the best method is to use very soft colored pencils along with oil pastels.*

STEP 3

Let's turn the work into a fall mood. First, we'll prepare the base layer of the trees and bushes. And after that, we'll use two techniques (blending and overlaying) to complete these elements. Let's go! Draw the base layer using yellow and olive yellow. Blur them, if needed. Then, add some orange-yellow and olive yellow to some parts of the yellow base and blend them. Using scarlet with the overlaying technique (read more about this on page 9), add a few bushes and leave them without blurring. After all the work we did, the illustration starts playing with autumn vibes.

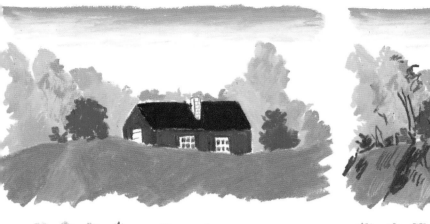

Figure 4

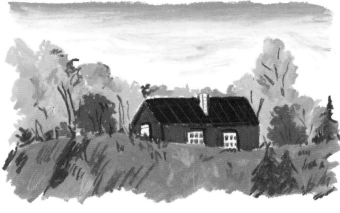

Figure 5

STEP 4

And finally, we can proceed to adding the fine details. There's a lot of work to be done in this step, but all you need to do is use some simple oil pastel techniques to re-create the details—just remember that you can make it "your own thing" by adding whatever details you like, even if they go outside the guidelines.

With turquoise blue, draw some clouds in the lighter part of the sky. Blend these clouds, using the blending cloth.

For the trees and bushes, we'll use the overlaying technique. First, draw the branches and trunks of the plants, using olive brown. Then, using russet and moss green, draw some accents on the trees.

For the grassy lawn, draw details randomly, using olive brown, russet, moss green, ochre, olive and pastel yellow (Figure 5). It brings some texture to the work.

Then, take a painting knife and scratch the grass details on the grassy lawn and on the house roof (read more about scratching on page 10).

Arm yourself with moss green and draw a few fir trees: next to the house on the right side, in the foreground and also from the right side (Figure 5).

The final touch is to take brown and, with the overlaying technique, emphasize the windows and draw the line that separates the house walls.

After the first try, if you don't find landscape drawing easy, take it as an opportunity to learn and grow. The only way to get better at anything is through practice! You have the freedom to draw this however you want, as long as it follows a general color scheme that we covered in this lesson. While trying out some different options, make sure to focus on experimenting with composition and the trees' and bushes' shapes. After getting some practice, change up your coloring entirely so that your landscapes don't get too monotonous to look at. Refer to some photos from your outdoor excursions or visit a forest (or any other lovely landscape) for real-life reference. The more time you spend developing these skills, the better your work will be!

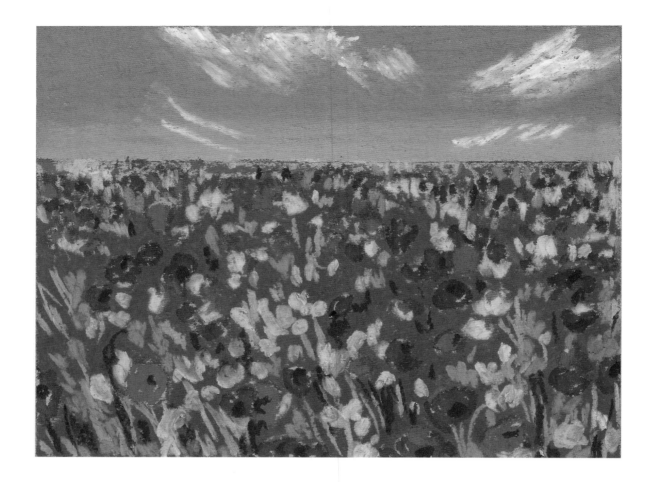

SPRING MEADOW

In this project, if you follow my instructions, you will be able to create a very magical and impressive spring landscape, but it is still very simple: smooth and calm sky vibes, combined with the vivid, blooming field. What beauty! Gather all the necessary supplies and dive in to create worlds of color and creation.

SUPPLIES

- Toned paper
- Cloth for blending
- Blending stumps
- Paper towel
- Masking tape

OIL PASTEL COLORS

Carmine, Light blue, Mauve, Moss green, Olive yellow, Pink, Purple, Raw umber, Red, Sky blue, White, Yellow

Figure 1

STEP 1

First, using masking tape, we define the working area and also prevent the edges of the drawing from staining. Then, with one more strip of masking tape, divide the landscape into the sky and meadow area. For this project, you don't need to sketch first, so let's move right on to the drawing process.

With light blue and sky blue, draw the gradient, using the gradation technique (read more about this on page 9): Start with filling in light blue in the upper part of the paper. Add the sky blue from the bottom and blend the colors in the middle (read more about blending on page 9) to get an even gradient (Figure 1).

STEP 2

With white, add a few clouds to the sky and then blend them with the first layer. Once the sky area is complete, you can carefully remove the masking tape strip that separated the sky and field areas. Now, we're ready to start work on the meadow area. Let's figure out one thing before coloring the green field. We need to reserve some space for flowers. Of course, in theory, we could employ the overlaying technique to draw flowers over the green base. But if we reserve, in advance, some space for blooms, these details will look much brighter and the final piece will be cleaner and quite professional.

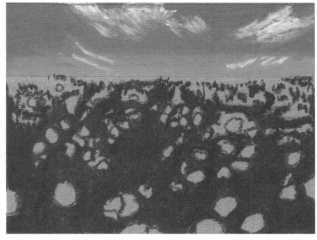

Figure 2

Let's sort the flowers we'll draw into three types, depending on their size:

- The large ones (growing in the foreground)
- The medium ones (we'll add in the middle of the field)
- The small ones (in the background)

Now arm yourself with moss green and fill the rest of the meadow (excluding the flower areas) with it (Figure 2). Then, gently blur this area (read more about blurring on page 8).

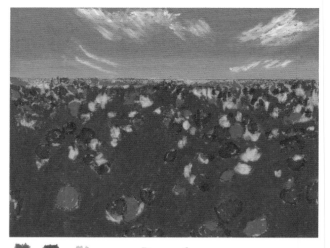

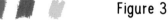

Figure 3

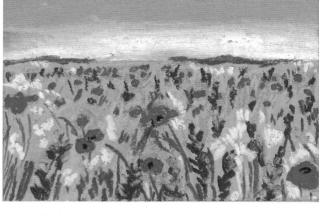

Figure 5

STEP 4

Let's add details to the landscape drawing. In this step, we'll finally use the overlaying technique (read more about this on page 9). Let's go! Using yellow and mauve, add extra flowers on top of the green base layer. Then, draw purple details on the pink flowers. With raw umber, draw center accents on the poppies. Finalize the drawing by adding grass details, using raw umber and olive yellow (Figure 4). *Don't draw too many flowers and grass details—sometimes less is more.*

NOTE: While drawing these details, the closer the details are to the foreground, the bigger they should be.

Remove the masking tape and here is your stunning landscape. In Figure 5, you can see another drawing that was created as a result of following the steps outlined in this project. To create a more realistic landscape drawing, it might be helpful to explore the finer details of a real landscape as well as experiment with colors. The best thing about this lesson is that you are free to be creative at your own pace—enjoy!

Figure 4

STEP 3

We already have the top of our landscape. To complete the bottom base layer, fill in the flowers. Use red, carmine and pink for your florals (Figure 3). Add them randomly, without any order. If you need to, carefully blur the larger flowers, using a blending stump.

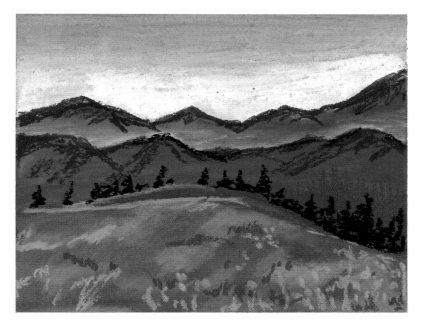

MORNING IN THE MOUNTAINS

There is something magnificent about early morning. Especially if it's early morning in the mountains. The silence and the fog that settles in the hollows between hills and mountains are magical. Let's depict such a scene by using oil pastels. In these next pages, you will find detailed, step-by-step instructions that allow you to create this landscape in no time.

SUPPLIES

- Toned paper
- Cloth for blending
- Blending stumps
- Paper towel
- Pencil
- Eraser
- Masking tape

OIL PASTEL COLORS

Black, Light olive, Moss green, Olive, Pink, Prussian blue, Sky blue, Turquoise blue, Ultramarine blue, White, Yellow-olive

NOTE: For this project you can use white, black or toned paper. But, for practice, a toned paper works best.

Figure 1

Figure 2

STEP 1

Let's start by applying masking tape. It defines the working area where we'll draw our landscape. Masking tape also helps protect the edges from staining the paper while you draw. A sketch is not required in this project; however, you need to mark the following areas with a pencil: sky, mountains and meadow (see the rough sketch in Figure 1). Once all the preparations are done, we are ready to color the areas of the landscape. First of all, let's deal with the sky area. Using the gradation technique (read more about this on page 9), fill the sky with turquoise blue and then add white. Blend the colors (read more about blending on page 9) to get a smooth gradient, as shown in Figure 3.

STEP 2

Time to move on and color the mountains. First, employing the color-mixing technique (read more about this on page 12), use ultramarine blue and sky blue to draw the mountains (Figure 4). Mix these two colors, using a cloth. Then, we need to add white fog; Figure 2 shows the fog on a brown background. To get this effect, you need to draw the background first, then add the white fog and blend it with the background color to create a gradient from white to transparent white. You can use this approach for any foggy effect. Just make sure that the background color is pretty saturated to contrast with white. So, use white and draw the lines, and with this color, hatch a little on the mountain area (read more about hatching on page 11). Then, blend these as shown in Figure 4.

Figure 3

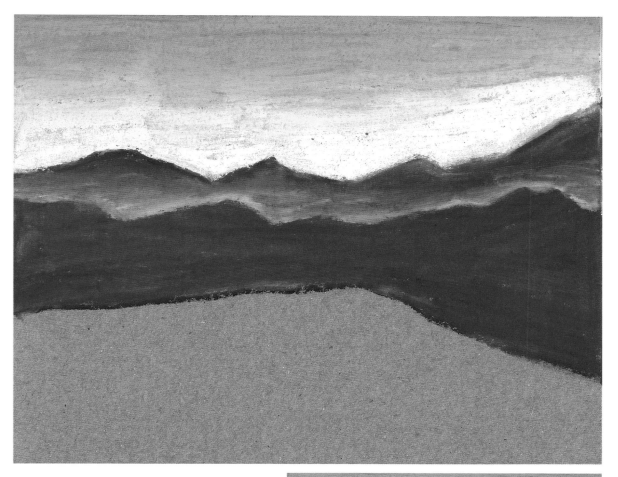

 Figure 4

STEP 3

It's time to color the meadow. Using moss green and light olive, fill the area of the meadow with these colors randomly and then blend them to get a smooth and beautiful layer of a spring green meadow (Figure 5).

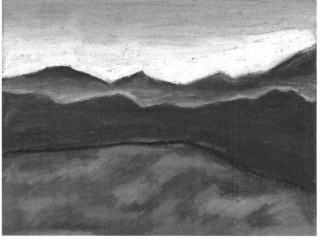

 Figure 5

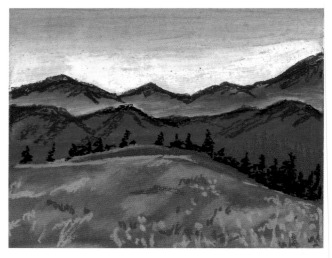

Figure 6

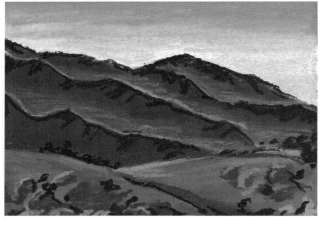

Figure 7

STEP 4

For now, the landscape looks a little empty and incomplete. Let's add accents and make it more lifelike. In this step, we will use the overlaying and blending techniques (read more about overlaying on page 9). Add accents on the sky with pink (Figure 6). Blend these details gently. You can also use pink to draw the blooms on the meadow. To do this, use the stippling technique (read more about stippling on page 11). Draw these details randomly and keep in mind: the closer the spots are to the foreground, the bigger they should be.

The next stage is adding grass details. Using yellow-olive and olive, draw accents on the meadow. These can be arbitrary lines, strokes, spots, stripes and so on. Also using olive, draw silhouettes of the trees in the background on the right side of the landscape, then add trees just over the ridge with black. The last step is to add the shadows on the mountains, using Prussian blue and black. Our work is done!

Using the principles of the lesson, try drawing more landscapes with foggy mountains; change the composition and play with colors (see the example in Figure 7). Remember that details shouldn't be added symmetrically or in any other order; draw them randomly. Also remember that details in different colors and shapes help bring contrast to the piece. Keep this in mind and try to apply it in practice.

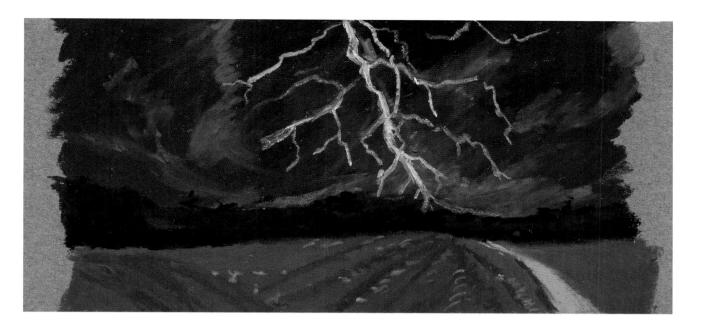

MAGICAL LIGHTNING

Nature always amazes and inspires us with its incredible diversity, and sometimes even seems to conjure magic. One of those miracles is lightning. In this project, I would like to share a beautiful way to depict a moody landscape with lightning. I love how dramatic the heavens are, and the lightning looks so epic in these rich and deep hues. Drawing such a combination of colors is so fun and easy. I hope you will enjoy it as much as I do! Let's get started.

SUPPLIES

- Toned paper
- Cloth for blending
- Blending stumps
- Paper towel
- Pencil
- Eraser
- Masking tape

OIL PASTEL COLORS

Black, Blue-purple (periwinkle blue), Lilac, Moss green, Ochre, Olive, Olive yellow, Pastel yellow (pale yellow), Prussian blue, Raw umber, Violet, White

NOTE: It's best to use toned paper for this project, but you can also draw on black paper.

 Figure 1

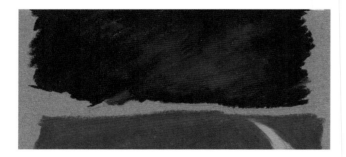

Figure 2

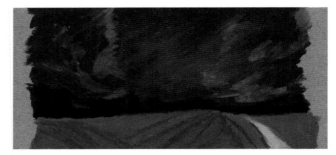

Figure 3

STEP 1

Before starting, define the working area as a horizontal rectangle. I recommend securing masking tape at the top and bottom of the landscape, leaving the sides undefined, to make the final piece look more interesting. For this project, a sketch is not necessary. Just lightly mark the skyline and very roughly draw the silhouette of the bushes and trees.

Let's move on to color the landscape. First, fill the sky area, using Prussian blue around the edges and then add lilac and violet inside the sky area (Figure 1). Blend these colors using a cloth (read more about blending on page 9).

STEP 2

The next stage is coloring the field under the sky. Using ochre, draw the path stretching across the field (Figure 2). Blur it, if needed, for a smoother effect (read more about blurring on page 8). Then, use olive to draw garden beds on the field. You can draw them in a particular order or just follow the image for this step. Switch to the moss green crayon and use it to draw the rest of the field. Blend the drawn areas. I advise blurring the garden beds separately and then blending all the areas into one smooth layer of the field.

STEP 3

The base of our landscape is ready. Now, it is time to take care of image depth by adding more colors and details. Using blue-purple, randomly add some accents on the sky, but not too much. A few strokes and cloud highlights will be enough. Blend these areas with the base layer of the sky. With raw umber and black, create the silhouette of the trees and bushes in the background (Figure 3). Then, blend those two colors into one shape (read more about color mixing on page 12). And finally, add the lines on the field in raw umber as shown in the example. These lines emphasize the garden beds, so they have to be drawn in the order in which you established them in the previous step. Gently blend each line separately.

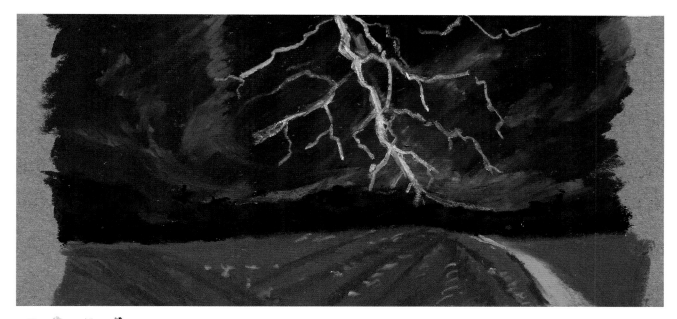

Figure 4

STEP 4

Let's add the final details. With white, add the effect of lightning in the sky. For this, draw the main lightning branch and then blend it (Figure 4). Use pastel yellow to add the light under the sky—a few touches will be enough—and blend them. With olive yellow, draw the highlights on the fields, adding them in the direction of the garden beds with the overlaying technique (read more about this on page 9). Using black, draw some trees more clearly in the background, using the same technique. And finally, draw the main feature of this landscape, which is the lightning. Using the sharp-pointed white oil pastel, and not rushing it, draw the lightning. If needed, you can make the lightning thicker, but the ends of it should be thin.

Our drawing is complete. You can use this lesson to create more landscape drawings and practice your drawing skills using oil pastels. Play with colors and change the composition of the landscape (Figure 5). Then, add the lightning and it will make your landscape look beautiful and special. See Figure 5 for an example. Make your own story through drawing landscapes. Make your own magic!

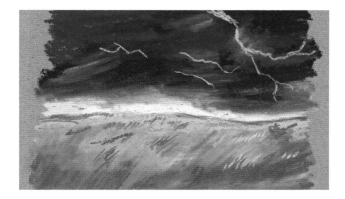

Figure 5

LUSH
Botanicals

Beauty is in everything that surrounds us. And even a small leaf on a tree can bring joy and inspire creativity. This chapter is full of fresh botanical projects. Why not get some bright ideas from beautiful and colorful plants? Here, you'll find how to draw Summer Lavender (page 55), festive holly with bright red berries (page 64), a wreath of autumn leaves (page 74), some flowers and also mushrooms (page 46). I'm sure everyone will find a favorite project in this section—the problem is that you might have another hard decision to make, and that's if you want to choose just one!

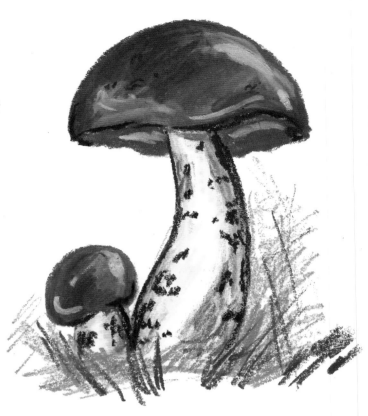

AUTUMN FOREST MUSHROOMS

Let's draw autumn forest mushrooms. This is a super-cute project and I personally love it because of these colors, which remind me of early, warm fall. We'll execute it in a pretty realistic style, but it's still a straightforward project that everyone can draw. You can offer to draw this project with children or a friend. I am sure everyone will enjoy drawing mushrooms.

SUPPLIES

- White paper
- Cloth for blending
- Blending stumps
- Paper towel
- Pencil
- Eraser

OIL PASTEL COLORS

Black, Brown, Dark gray, Light olive, Moss green, Olive yellow, Russet, Soft orange (orangish yellow), White, Yellow ochre

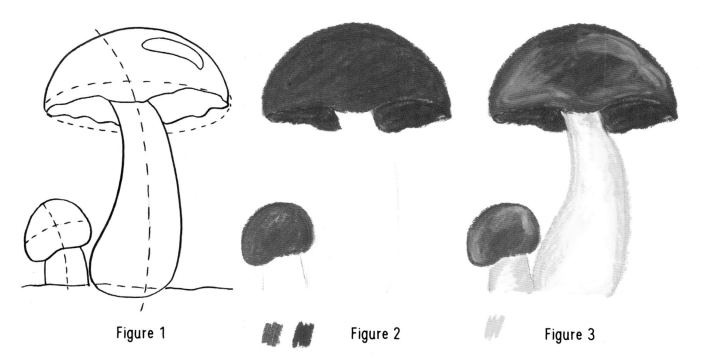

Figure 1 Figure 2 Figure 3

STEP 1

Start with a quick preliminary sketch, making the pencil lines almost invisible and erasing unwanted additional lines (see the sketch in Figure 1). When your sketch is ready, you can start with coloring the caps of both mushrooms. Using russet, color these shapes using the heavy pressure method (read more about pressure on page 11). Then, using a blending stump and cloth, carefully blur the shapes (read more about blurring on page 8). For the big mushroom, the inside of the mushroom cap is visible. Let's color this shape with dark gray (Figure 2). Blur it carefully, using a blending stump.

STEP 2

Now, draw the stems of the mushrooms with soft orange. Next, use soft orange to hatch a little from both sides of each stem (read more about hatching on page 11) and then blur these areas inside (Figure 3). With the same color, add midtones on the caps. These tones will make the mushroom caps look more realistic and give them volume. Add them randomly on both mushroom caps. And, for a softer result, blend these areas with the base layer (read more about blending on page 9).

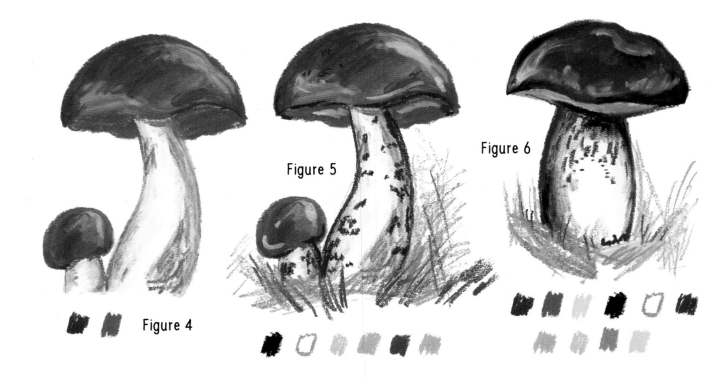

Figure 5

Figure 6

Figure 4

STEP 3

Let's keep going and add some more details to our drawing. With brown, outline the caps and add accents on the left side. Blend these details with a cloth. Now, use dark gray to draw shadows from the caps on the stems (Figure 4). Draw some details with this color on the stems, too.

STEP 4

At this stage, the mushrooms are already recognizable but we'll make them look more interesting for viewers. So, let's add final details, using the overlaying technique (read more about this on page 9). With white, draw highlights on the mushroom caps, as shown in Figure 5. Using black, draw details on the caps and some spots on the stems.

NOTE: If you add shadows (or highlights), they should be added from the same sides for each mushroom you have in your composition.

Basically, at this stage, the drawing is done. But I think this little illustration will look even cuter if you add some background details. The background will be done in a modern graphic style, using the overlaying technique. Use olive yellow, moss green, light olive and yellow ochre to add an imitation of autumn grass. For this, in the bottom part of the drawing, add hatching. These strokes should not be perfect—some messiness, sharp rough lines and randomness give the feeling of a graphic style.

Try to draw other types of mushrooms (you can see one example in Figure 6). For this, use real mushrooms or images from the internet as a reference. And of course, use the principles of this lesson. You can experiment with the background. You can truly let your creativity flourish here. However, don't make the background too detailed, and keep it in a graphic style. The main focus should still be on the mushrooms.

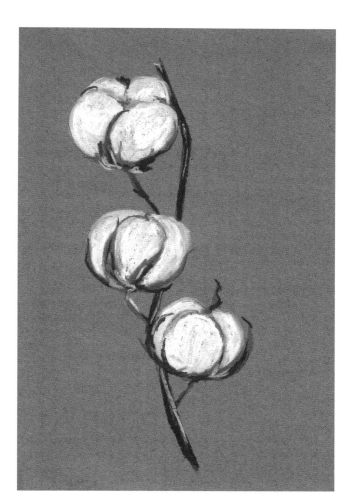

COTTON FLOWER BRANCH

In this tutorial, you'll draw the graceful branch of a cotton flower. Looking at it, I imagine a scene from a fairy tale where such giant, airy and fluffy flowers grow in the background. Despite its lushness, drawing this plant is very simple. To create such a branch, you only need a few colors and the most basic techniques, so you can focus on the drawing process and enjoy it to the fullest. The most important thing in this lesson is to understand how each flower is positioned on the branch. I'll show you how to deal with these details and create something beautiful!

SUPPLIES

- Toned paper
- Blending stumps
- Paper towel
- Pencil
- Eraser

OIL PASTEL COLORS

Brown, Dark gray, Gray, Russet, White

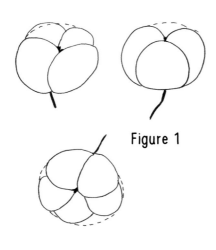

Figure 1

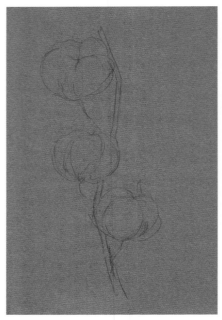

Figure 2

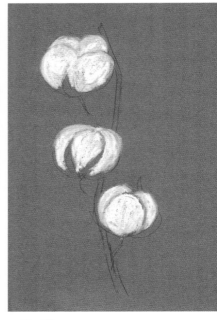

Figure 3

STEP 1

Let's start with a preliminary sketch. To do this, draw a sketch as shown in Figure 2. If you are going to draw cotton then you need to figure out how each flower is located on the branch. In addition, you need to understand the structure of the flower. For this, it is best to have a reference from the internet or a real plant. But still, let's figure it out. To simplify, each flower is a sphere consisting of several sectors. In relation to the branch, the flower can be observed from above, below or the front (Figure 1).

Once the sketch is ready, erase all the unwanted lines and start coloring the cotton branch. Use a gray crayon to mark the sectors of each flower (Figure 4). Then, arm yourself with white and color each flower. Blur each sector of the cotton flower (read more about blurring on page 8) (Figure 3).

NOTE: I want to draw your attention to the fact that if we add white on top of the gray marks (outlines) of the flower sectors, then we get blended colors, which looks great. This effect helps divide a flower into sectors, making it look real (Figure 4).

STEP 2

Basically, in this project, the hard work is behind us and we can move on to the more fun part. The next stage is to draw in the color of the petals of the cotton flowers as well as the stems. To do this, use the tip of a russet crayon to draw the petals and stems. Draw these details with heavy pressure (read more about pressure on page 11). Then, if necessary, smooth out these details, using the blurring technique.

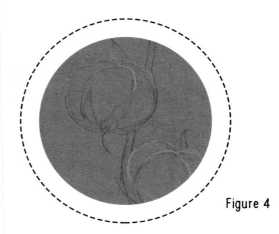

Figure 4

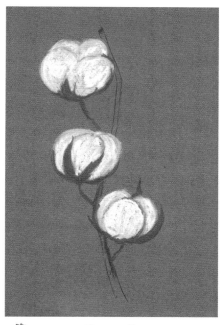

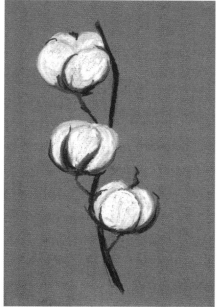

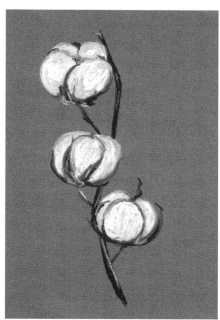

Figure 5

Figure 6

Figure 7

STEP 3

Let's deal with the main branch and the woody parts of the stems. With brown, paint in all the corresponding areas (Figure 5). It is very important to draw with the sharp tip of the crayon, pressing hard with it while drawing. This way, you will get a smooth and thin line (Figure 6). With the same color, draw the fine details on the cotton flower petals, using the overlaying technique (read more about this on page 9).

STEP 4

Now, we need to add the final details. Using white, add some accents on the main branch, stems and petals. Then, switch to dark gray and use it to emphasize the centers and sectors of the flowers (Figure 7). You can leave all these lines unblended, or blend using the blending technique (read more about this on page 9).

That's it! Here is a graceful illustration of the cotton branch. You can keep working, using this lesson. Change the composition of the flowers on a branch and enjoy drawing beautiful branches of cotton (Figure 8). Illustrations of them can be used in interior decoration, as well as on packaging or even with clothing design.

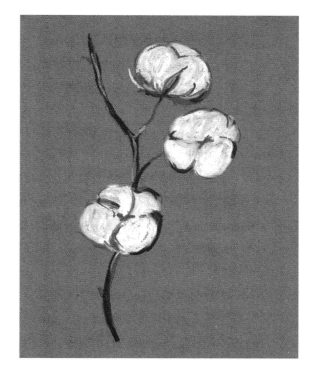

Figure 8

MIMOSA BLOSSOMS

I adore how mimosa blossoms smell so sweet and delicate. The fluffy flowers resemble little cotton balls. And it's just impossible not to draw a branch of mimosa. Nature really is the best inspiration. In this lesson, I'll teach you a quick and simple way to draw this blossom using oil pastels. Just follow all my instructions and have fun.

SUPPLIES

- White paper
- Blending stumps or cotton swabs
- Paper towel
- Pencil
- Eraser

OIL PASTEL COLORS

Gray, Lemon yellow, Light olive, Moss green, Ochre, Olive yellow, White, Yellow

NOTE: If you use black or tinted paper for this project, you will need to add one more layer of yellow at step 1 to get opaque, but still fluffy, mimosa flowers.

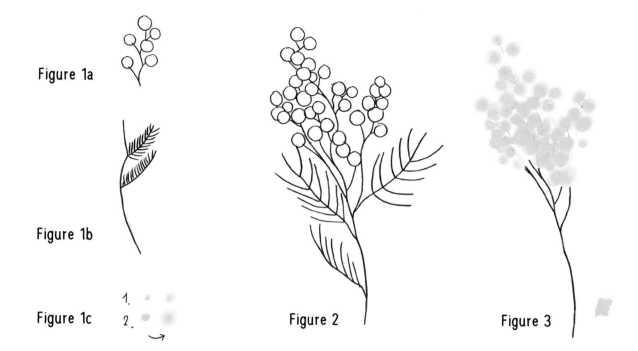

Figure 1a

Figure 1b

Figure 1c

Figure 2

Figure 3

STEP 1

Let's begin with a preliminary sketch. Outlining the branch and stems, using a pencil, will be enough. The flowers and little leaves should not be depicted in the sketch. And make sure that all pencil lines are almost invisible. In Figure 2, you can find an outline of the mimosa blossom. To understand how mimosa flowers are attached to the stem, pay attention to Figure 1a. Also, let's deal with the leaves of this plant (see Figure 1b). Each branch of leaves has its own stems on which small leaves are attached. So, we'll first draw the branch with stems, and then we'll add small leaves (steps 3 and 4).

Once all the preliminary pencil marks have been made, let's draw the mimosa with oil pastels. The top secret of drawing mimosa flowers using oil pastels is to blur the center of every single flower (Figure 1c). So, first draw a little circle with yellow. Then, take a blending stump (a cotton swab will also work for this purpose) and start to blur the pigment, making circular movements from the center (read more about blurring on page 8). Do not make the flower balls too big. Keep in mind that they will be blurred. See the difference in Figure 1c, whether to draw a flower ball big (2) or smaller (1). Next, use yellow to draw the little flowers of the mimosa branch—I recommend starting by drawing flowers on top and then adding more and more balls that overlap closer to the end of the branch (Figure 3).

STEP 2

Next, we'll draw the green part of the plant. Using the sharp end of the olive yellow crayon, draw all the stems of the mimosa that connect the flowers and leaf stems, as well as the main green branch. Carefully blur these lines. Try to make them thin and smooth at the same time. Then, switch to gray and add a few accents along the main branch of the mimosa. Blend these details with the olive yellow base layer (read more about blending on page 9).

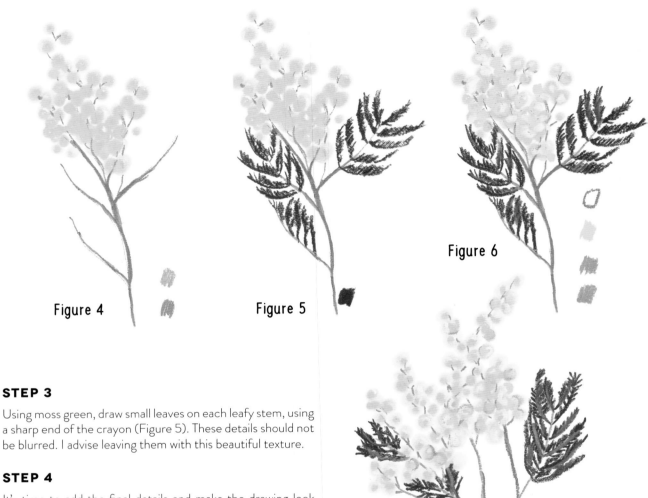

Figure 4

Figure 5

Figure 6

Figure 7

STEP 3

Using moss green, draw small leaves on each leafy stem, using a sharp end of the crayon (Figure 5). These details should not be blurred. I advise leaving them with this beautiful texture.

STEP 4

It's time to add the final details and make the drawing look complete. Using the overlaying technique (read more about this on page 9), draw highlights with white and lemon yellow, placing these details randomly while trying to repeat the round shapes of the flowers. It is not necessary to draw highlights on each flower ball. Opposite these highlights, draw shadows, using ochre, and as with highlights, add them on some flowers, not all (Figure 6). Because the ochre is pretty saturated compared to the previous colors we've used, I recommend blending these shadows gently. The final touch in this stage is adding some light accents in light olive on the small leaves drawn in step 3. Just a few gentle touches, using the overlaying technique, will be enough and bring some more colors to the work. The mimosa branch is done!

Using the same techniques and drawing method, you can create many different compositions with mimosa blossoms (see Figure 7). Or it can be a bouquet, for example. It is a great opportunity to practice different techniques of drawing with oil pastels and make thin and delicate lines with the crayons. I hope drawing such a beautiful project will brighten up your day!

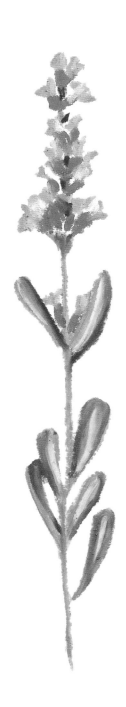

SUMMER LAVENDER

Lavender is so special and, when I draw this herb, I always think of its amazing smell. In this project, I invite you to dive into the lovely atmosphere of summer lavender fields. It's a super-easy and fun project; you can execute it together with your kids or friends and enjoy each moment of the creative process. Let's draw it, step by step!

SUPPLIES

- White, toned or black paper
- Blending stumps
- Paper towel
- Pencil
- Eraser

OIL PASTEL COLORS

Light gray, Light olive, Mauve, Moss green, Pastel purple (light purple-violet), White

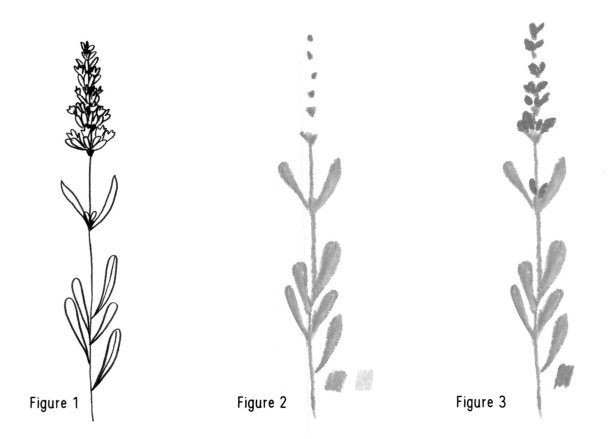

Figure 1 Figure 2 Figure 3

STEP 1

Before we begin drawing lavender, let's figure out the anatomy of its blossoming stalk. In Figure 1, you can find a detailed sketch. To say it simply, a stem, leaves and little flowers make up each separate stalk of lavender. And each of these little flowers includes two parts: the petals of a flower and its calyx. If you have a look at the calyx, you find a green part, and one in a purple tint. So, by using this structure, we will draw the blossoms of the lavender stalk, step by step. For this project, a sketch is not required. However, using a pencil, you can mark a stem of the lavender as well as the calyxes of the flowers. Use the sharply pointed tip of a light olive crayon to draw a stem, leaves and the calyxes of the flowers (Figure 2). Work very accurately and try to make the stem of the plant as thin as possible, while drawing with heavy pressure to get an even layer (read more about pressure on page 11). Then, with a blending stump, blur the freshly drawn details (read more about blurring on page 8). Once it's done, switch to light gray and add some accents to the greenery parts of the plant, blending them carefully with the previous base layer (read more about blending on page 9).

STEP 2

Let's keep building our elegant branch of lavender. The next stage is adding the calyxes of the flowers in a tint of purple. For this purpose, I have chosen a mauve crayon. Start adding the purple calyxes, using this color, over each green calyx (Figure 3). For the best result, use the stippling technique (read more about stippling on page 11). But if needed, to make the calyxes smoother, use a blending stump.

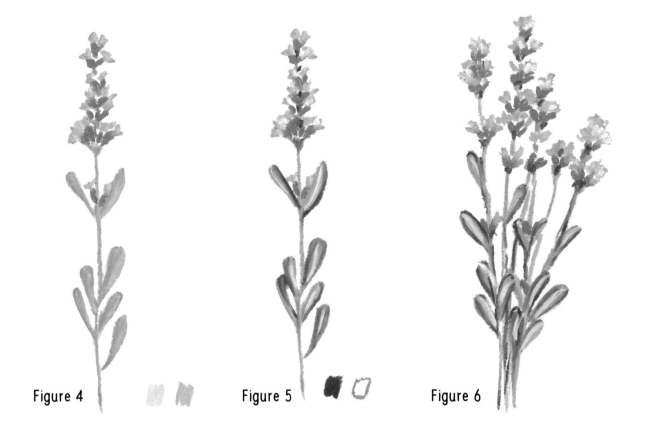

Figure 4

Figure 5

Figure 6

STEP 3

It's time to add the petals of the flowers to our stalk. So, use the sharp point of a pastel purple crayon to draw petals of little flowers over their calyxes. Then, with light gray, add some accent touches to the flowers. Blend the drawn details very carefully (Figure 4).

STEP 4

We already have a beautiful branch of lavender with some additional details that will look more realistic. First, with moss green, draw shadows on the greenery part of the stalk (Figure 5). Blend these details carefully by using a blending stump. Second, use a white crayon to draw some details on the petals of the flowers and leaves, using the overlaying technique (read more about it on page 9). This time, don't blend these details. It brings some texture to the work. Our pretty little drawing is done.

Keep on drawing varieties of this stunningly beautiful herb following the principles of this lesson. It can be a bouquet (Figure 6), or wreath, or any other composition with lavender. I hope you will like this project and it will bring some summery vibes to you.

WILDFLOWER BOUQUET

This project is extremely sweet and proves that everyone can draw with oil pastels, without any special materials or skills. It's perfect for an introduction to oil pastels. In addition, you will have a chance to practice freehand drawing, without any preliminary sketch. It's true freedom and will help you become unafraid to make mistakes.

SUPPLIES

- White or toned paper
- Blending stumps
- Paper towel

OIL PASTEL COLORS

Light olive, Lilac, Moss green, Ochre, Pastel purple (light purple-violet), Pink, Purple, Red (vermilion), Yellow

TIP: If you use toned paper for this project, make sure that all pastel tints are visible on your paper choice.

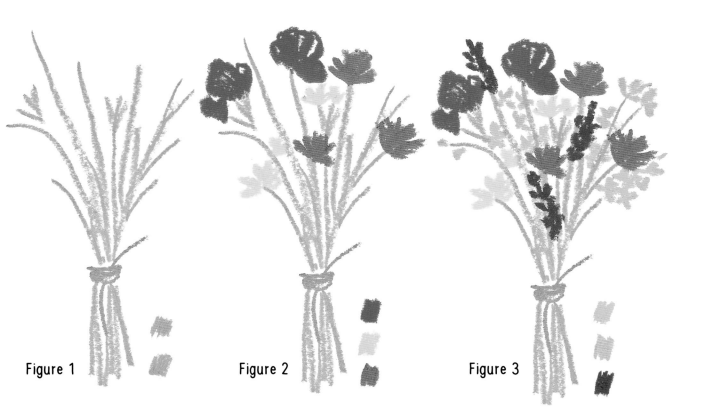

Figure 1 Figure 2 Figure 3

STEP 1

In this project, we'll not use any oil pastel techniques. However, we will draw using the heavy pressure method, which means drawing with the sharp part of the crayon (read more about pressure, page 11). If you do it right you won't need to use a blending stump to blur the elements or shapes. For this project, a sketch is not required. As I mentioned earlier, we'll focus on the freehand drawing style. Let's go!

Start with drawing the ribbon. Roughly speaking it's a point where the top and bottom parts of the bouquet meet each other. Basically, you can draw the ribbon in any color and any thickness. I've chosen ochre because it's a neutral tint, plus it's visible from one side and makes a contrast with greens from the other side. Once the ribbon is done, start adding stems and branches of your bouquet in light olive (Figure 1). Note that there should be more elements in the top part than in the bottom. For drawing such elements, you can follow my example or use a reference of a wildflower bouquet.

STEP 2

Now that the base for the bouquet is done, we can draw flowers. First, we'll add large ones, using red, yellow and purple crayons, but we will add one flower at a time with one color (Figure 2). For example, using red, I draw poppies, but no other kind of flower. Once all the big flowers are done, jump to the next step.

STEP 3

Time to add small flowers to the bouquet. Using pink, pastel purple and lilac, draw the small blossoms following the same rule as in step 2 (Figure 3). Note that with the lilac, you can overlap the greens and draw over the first layer. While drawing in this step, keep in mind the whole bouquet shape. Try to add all the floral elements with this shape in mind.

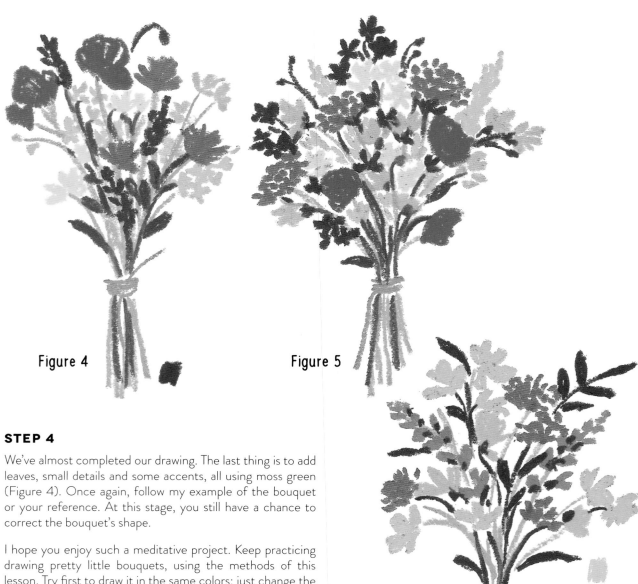

Figure 4

Figure 5

Figure 6

STEP 4

We've almost completed our drawing. The last thing is to add leaves, small details and some accents, all using moss green (Figure 4). Once again, follow my example of the bouquet or your reference. At this stage, you still have a chance to correct the bouquet's shape.

I hope you enjoy such a meditative project. Keep practicing drawing pretty little bouquets, using the methods of this lesson. Try first to draw it in the same colors; just change the arrangement and flower shapes (see example in Figure 5). Then, with some confidence, change the colors of the bouquet (Figure 6 shows an example). This project has no pressure, just pure joy. I recommend drawing it with kids or your friends, with a cup of tea on a cool summer evening.

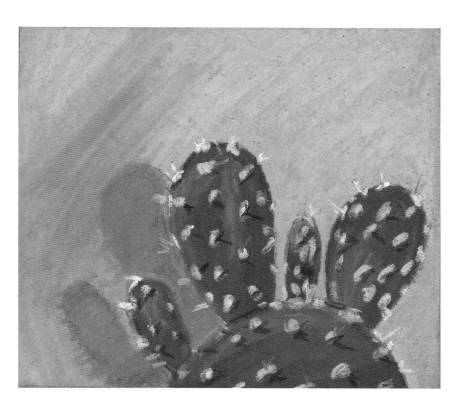

CUTE CACTUS

Let's draw a cactus with a pink background! Cacti are easily recognizable with simple shapes and only minimal details, which is very important for creating art pieces. And the vivid background will make the final result look fabulous. That's why drawing a cactus with oil pastels is super quick and straightforward. So, gather your materials and let's begin!

SUPPLIES

- White or toned paper
- Cloth for blending
- Blending stumps
- Paper towel
- Pencil
- Eraser
- Masking tape

OIL PASTEL COLORS

Dark green, Emerald green, Gray, Light olive, Pink, Purple, White

TIP: I advise you to use toned paper for this project, as it will allow you to make the drawing process with oil pastels much easier and more understandable.

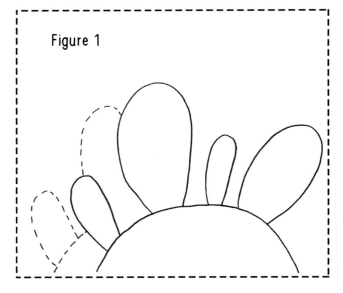

Figure 1

Figure 2

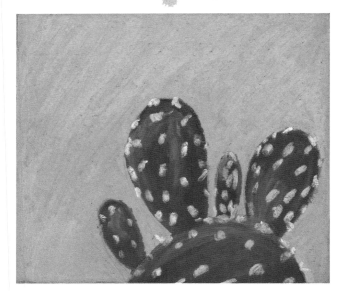

Figure 3

STEP 1

First, define your work area. With a pencil, draw a light sketch (Figure 1). Do not draw details at this stage, though; just baselines are enough. Fill the area around the cactus by adding pink (Figure 2). Use heavy-pressure hatching for this purpose (read more about hatching on page 11). Blur the pink area by using a cloth and a blending stump to achieve a smooth and even background layer (read more about blurring on page 8).

STEP 2

Let's color the cactus itself. For this, use emerald green to draw the cactus base layer, applying hatching with pretty heavy pressure (read more about pressure on page 11). Now, blur the layer carefully. With light olive, add some touches to the cactus (Figure 3). Blend the freshly added details with the base layer (read more about blending on page 9). At this stage, we can add spines. For better contrast, let's add the spines to the cactus with white crayon, using the overlaying technique (read more about this on page 9). Because we're creating a stylized drawing, the spines of the cactus can be drawn with dots, spots, ticks or other graphic elements. Add the spines randomly and don't forget to draw some needles from the outside.

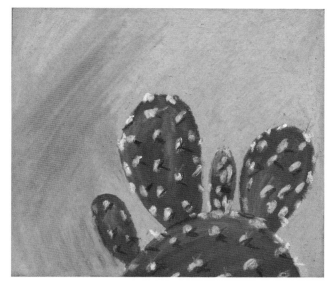

 Figure 4

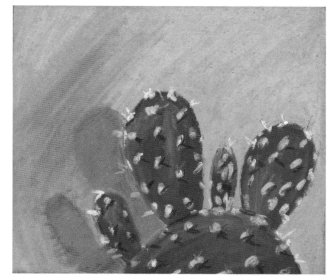

 Figure 5

STEP 3

Basically, at this stage, we already have a recognizable object. But let's make it more lifelike and 3-D. So, use a purple crayon to add hatches on the pink background, as shown in Figure 4 (read more about hatching on page 11). Use the cloth for blending and lightly blend the hatching. Now, add shadows from the spines in dark green, using the overlaying technique. Repeat the elements that I have drawn; or, of course, you can add on your own with the help of references.

STEP 4

To complete the drawing, I suggest that you add a shadow. First, draw the shadow layer in pink and then go over it and another layer in gray, using light-pressure hatching for these actions (Figure 5). Mix these colors to one layer by using the color-mixing technique (read more about this on page 12). You can also blur the layer of shadow and make it look not so clear. Finally, draw some extra spines in white outside the cactus, on the pink background, using the overlaying technique.

By following these steps, you can create a variety of beautiful, modern drawings. Experiment with the finer details and play with colors. You can also change the shapes of the cacti and

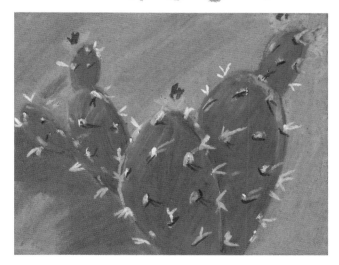

Figure 6

you can even add some flowers blooming on the cacti. Why not? Allow yourself to be creative and enjoy the process of creation. In Figure 6, you can see a variation of a drawing created by following this lesson.

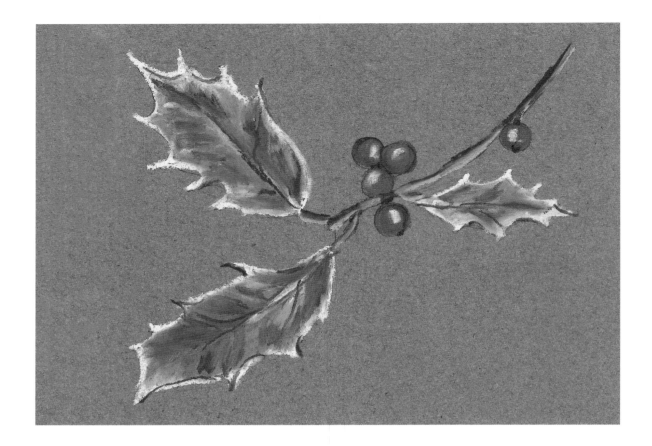

HOLLY BRANCH

This project is great proof that with oil pastels you can create a true masterpiece in no time—without any experience in design or drawing. In just four simple steps, you will be able to create a minimalistic and elegant illustration of a holly branch. This can be a lovely card for your loved ones at Christmas. Let's get started!

NOTE: If you plan to use this work as a greeting card to execute this project, prepare the corresponding paper size. At best, its weight should be 150 gsm or thicker toned or black paper.

SUPPLIES

- Toned or black paper
- Blending stumps
- Paper towel
- Pencil or white pencil
- Eraser

OIL PASTEL COLORS

Brown, Carmine, Dark green, Emerald green, Light olive, Olive yellow, Pastel yellow (pale yellow), Scarlet, White

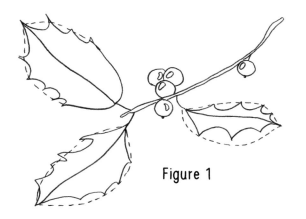

Figure 1

STEP 1

For this project, you will need to draw a preliminary sketch (Figure 1). If you draw the branch on black paper, use a soft white pencil for sketching. Once the sketch is ready, let's start to color. Use scarlet and white oil pastels to color the berries of the plant (Figure 2). Then, with the help of a blending stump, blend those two colors into one solid layer (read more about blending on page 9).

TIP: For coloring the small elements like berries, it is best to first outline and then fill the shape inside with your desired colors.

Use the sharp point of the olive yellow crayon to add the branch to your composition, using heavy pressure (read more about pressure on page 11). If needed to make the lines smoother, blur the branch with a blending stump.

Figure 2

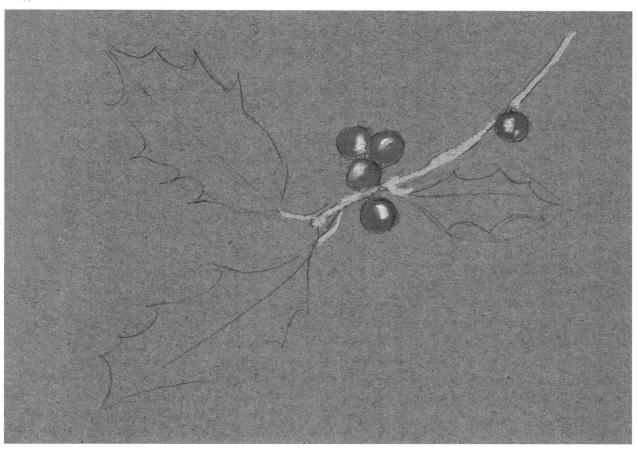

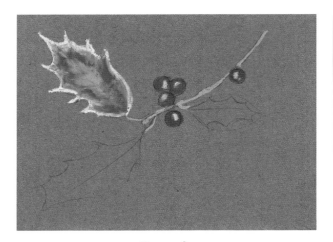

Figure 3a

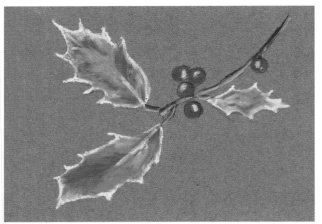

Figure 4

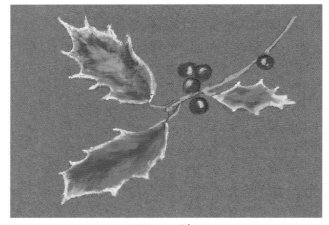

Figure 3b

STEP 2

The next step is to color the holly leaves. I have broken this step visually into two stages (Figure 3a and Figure 3b). Let's first figure out how to color a separate leaf. Outline a leaf in pastel yellow, then blur it (read more about blurring on page 8). Now, fill the shape of the leaf inside by using light olive and emerald green. Blend those two colors into one solid layer. Using the same method, color the rest of the leaves of the branch. The coloring inside these leaves shouldn't be

identical. To get a more realistic result, you can play with the light olive and emerald green, adding them randomly inside the leaf's shape.

STEP 3

Next, we'll add some details to complete the base layer of the holly branch (see Figure 4). Use a white oil pastel to add some highlights to the leaves. Blend these details with the first layer. Let's give some texture to our leaves and, with the same crayon, add more highlights, using the overlaying technique (read more about this on page 9), but this time don't blend them. Now, using brown, draw some accents with it on the branch of the holly plant. Once again blend the drawn details with the first layer.

STEP 4

We are ready to add the final details and touches. Draw shadows with carmine and blend them with a blending stump. Then, with brown, add extra touches to the berries, as shown in Figure 5. Using dark green, draw shadows on the leaves. Blend them. Then, with the same color, draw the veins and some extra touches on the leaves using the overlaying technique to emphasize the natural pattern. Our charming drawing is finished.

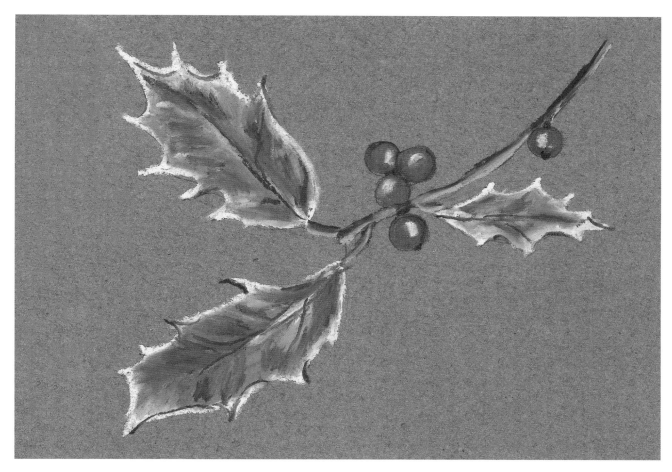

 Figure 5

What can you change when you draw other illustrations based on this lesson? I recommend experimenting with the colors and choosing different tints of green and red, as well as experimenting with the composition of the work. Figure 6 depicts an illustration drawn using this project's methods and techniques. I used a different compositional solution and slightly changed the colors of the project. Look how beautiful the result is. It could be a great greeting card!

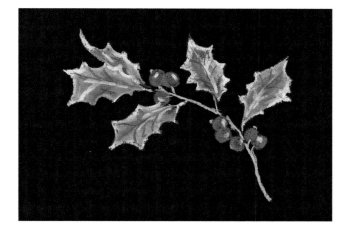

Figure 6

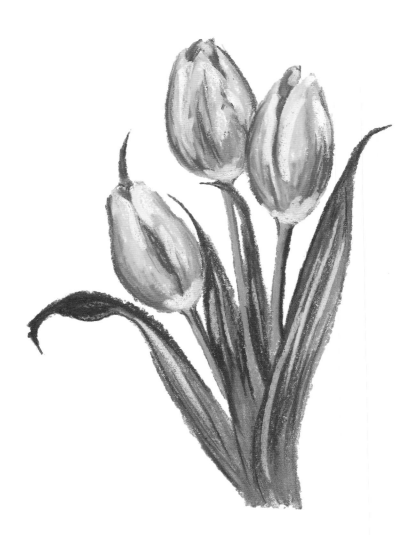

ELEGANT TULIPS

Tulips are one of the first flowers to bloom in the spring. The tulip bouquet represents elegance, grace and love. They come in a variety of colors and types. And all of them inspire me so much. So, I decided to include a drawing of elegant tulips in this book. Now, let's begin drawing, step by step!

SUPPLIES

- White or black paper
- Blending stumps
- Paper towel
- Pencil
- Eraser
- Brown colored pencil
- White colored pencil (optional)

OIL PASTEL COLORS

Light olive, Moss green, Red (vermilion), Scarlet, White, Yellow

COLORED PENCIL COLORS

Brown, White (optional)

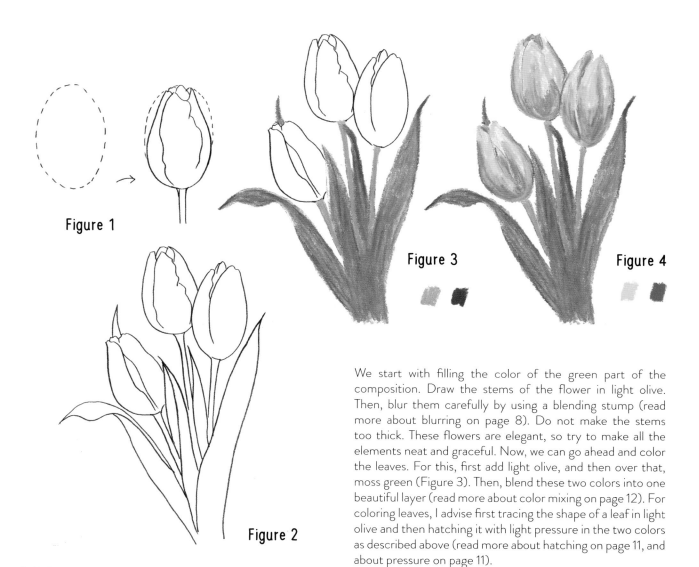

Figure 1

Figure 2

Figure 3

Figure 4

STEP 1

With a pencil, draw a light sketch of the tulips composition shown in Figure 2. To draw these flowers, you have to first understand the shape of the tulip's buds (see Figure 1). As you can see, the bud of this flower fits the oval. So, I advise you, for each flower, to first draw the oval and then add the details showing its petals. And, of course, the best result will be if the details look different for each flower. Once the full sketch is ready, we can move on to coloring the project itself. Let's begin.

We start with filling the color of the green part of the composition. Draw the stems of the flower in light olive. Then, blur them carefully by using a blending stump (read more about blurring on page 8). Do not make the stems too thick. These flowers are elegant, so try to make all the elements neat and graceful. Now, we can go ahead and color the leaves. For this, first add light olive, and then over that, moss green (Figure 3). Then, blend these two colors into one beautiful layer (read more about color mixing on page 12). For coloring leaves, I advise first tracing the shape of a leaf in light olive and then hatching it with light pressure in the two colors as described above (read more about hatching on page 11, and about pressure on page 11).

STEP 2

It's time to add the flower buds. Fill the buds of the tulips with a yellow crayon by hatching with pretty heavy pressure. Then, blur the shapes to achieve an even base coat effect. Now, add the second color—I've chosen red for our project. Draw some details in red as shown in Figure 4: on the top and bottom of each bud, and also in the center, to show the inside petals. Blend those details with the yellow base coat (read more about blending on page 9).

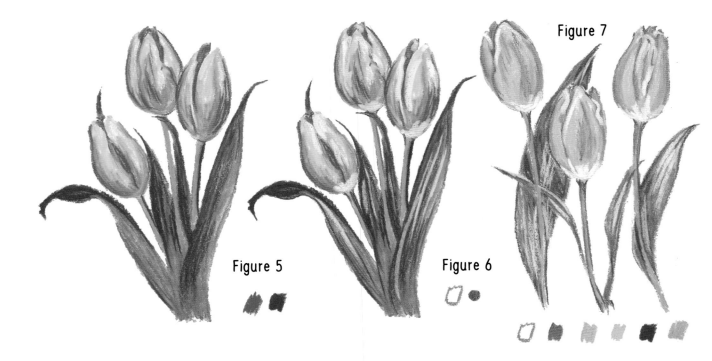

Figure 7

Figure 5

Figure 6

STEP 3

We already have the first layer of the composition. Let's move on and add some shadows. Using scarlet, draw the shadows that emphasize the petals onto the buds, and also add some touches to the outline of the buds (Figure 5). Then, add shadows to the greenery part of the composition, using moss green. Blur all these details and shadows carefully by using the blending technique.

STEP 4

Our project looks already recognizable, so let's complete it with the final touches. For this, use a white oil pastel to add some highlights to the top of the petals and bottom part of the buds (Figure 6). With the same color, draw some details on the leaves of the tulips. I recommend using a brown colored pencil and adding some touches on the stems and leaves to make the drawing just stunning. In this step, we used the overlaying technique (read more about this on page 9).

Our drawing is ready now. If you have some extra time and are willing, you can also add some additional details on the petals and leaves of the flower with a soft white pencil. It will make the work look more detailed. But remember, less is more. Do not overdo the details.

If you would like more practice in drawing tulips, you can draw the tulips in any other colors, not just those shown in this project. You can also play around with the flower arrangement. You can buy real tulips and make your own composition. Figure 7 shows one example of how the colors and composition can be changed by using the methods of this lesson. I personally love this project because of how easy it is to get such a beautiful result in just a few simple steps. I hope you enjoy it too.

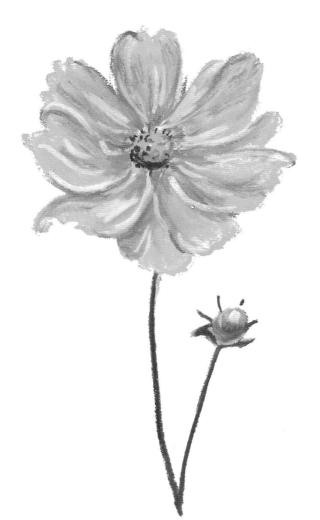

VIBRANT COSMOS

In this project, with the help of oil pastels, I will show you how to draw cosmos flowers in just a few easy steps. These flowers depict the serenity and calmness of the universe and nature. They are beautifully simple and are in vibrant colors of pink, red, yellow and orange, plus white. All those make this plant a perfect object for drawing and exploring with oil pastels. We'll draw in a pretty realistic style, but it's still a straightforward project that everyone can do. Let's begin!

SUPPLIES

- White, toned or black paper
- Blending stumps
- Paper towel
- Pencil
- Eraser

OIL PASTEL COLORS

Brown, Mauve, Moss green, Orange-yellow (golden yellow), Pink, Purple, Russet, White

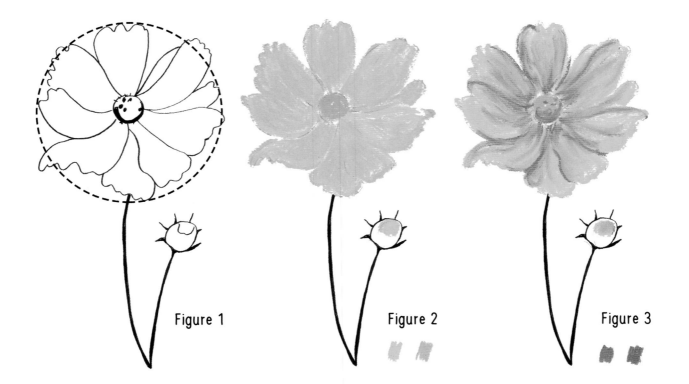

Figure 1

Figure 2

Figure 3

STEP 1

Let's first understand the shape of cosmos flowers. You can see from Figure 1 that the flower fits into a circle. However, the flowers can be shown from different angles. This in turn means the flower can fit into a circle sector, semicircle or oval. Pay attention to those nuances to better understand this object as you draw, and before drawing it, first figure out into which simple shape the flower fits exactly. So, make a preliminary pencil sketch, following Figure 1.

Arm yourself with orange-yellow and draw the center of the flower. Then, blur it by using a blending stump (read more about blurring on page 8). Once it has been done, color the petals and bud pink, blurring the shapes of the petals to achieve an even and accurate first base coat (Figure 2).

STEP 2

NOTE: In this step, we will be using the blending technique (read more about blending on page 9).

Now, let's make the flower's first layer look not so flat (Figure 3). For this, we need to add midtone areas and some accents. Use purple to add an accent to each petal: mostly the outlines, the beginning of the petals, plus some lines to the center of the petals. Then, blend these details with the first base layer. Make sure that those lines repeat the natural pattern of the real petals, and also, while blending, follow the direction that the petal is growing. The last stage in this step is adding the midtone area to the core of the flower. Use russet to draw some accents in the bottom part, as shown in Figure 3. Blend it carefully. Also, with russet, add some extra dots in the center of the flower's core.

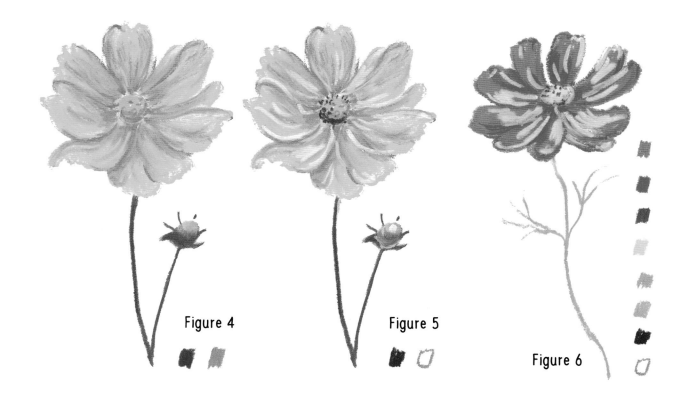

Figure 4

Figure 5

Figure 6

STEP 3

Now, let's move on to add the stems to the composition. Using moss green, draw the stems, the bud and small leaves on the bud (Figure 4). Use the sharp part of the crayon, with heavy pressure (read more about pressure on page 11), for this purpose. Now, blur all the drawn elements accurately. Draw the shadows on the petals in mauve and blend them with the previous layers. Then, with the same color, add some accents on the petals to make the flower look even more realistic, using the overlaying technique (read more about this on page 9).

STEP 4

Finally, we can add details to our cosmos flower. Add white highlights to the petals and the bud as shown in Figure 5. The last thing I suggest in this step is to draw details on the flower's core in brown. In this step, we used the overlaying technique.

As I mentioned earlier, there is a wide range of cosmos colors. Therefore, you can draw these flowers in any other tint. By using this method, you can also practice drawing them in different positions. Moreover, you can easily add leaves, extra buds and even create a floral composition featuring these stunning flowers. Figure 6 shows one example of how the colors can be changed, and the flower is also shown from a different angle. Keep practicing and enjoy the process!

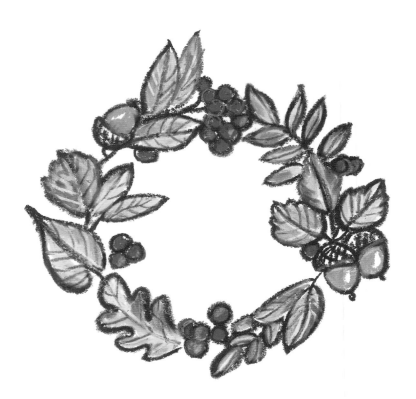

AUTUMN WREATH

If you want to immerse yourself in an autumn mood or love vivid autumn colors, this project is definitely for you. In it, you will learn how to draw a beautiful autumn wreath, using oil pastels. I have prepared for you a special drawing method that is not standard for this book. But it's still straightforward and I'm sure you'll enjoy using it. So, let's learn how to draw the autumn wreath in just four easy steps.

SUPPLIES

- White or toned paper
- Blending stumps
- Paper towel
- Pencil
- Eraser
- Compass, or any round object

OIL PASTEL COLORS

Brown, Moss green, Ochre, Olive yellow, Red (vermilion), Scarlet, Yellow

COLORED PENCIL COLORS

Dark green, White

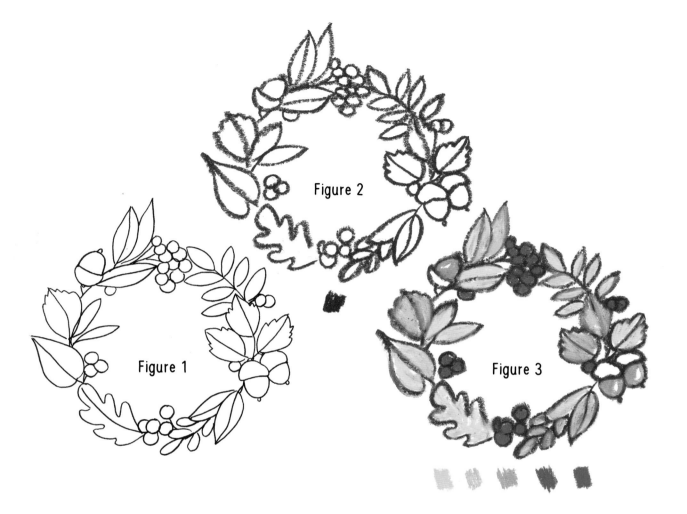

Figure 1

Figure 2

Figure 3

STEP 1

Use a compass or trace around any circular object with a pencil to sketch a circle on your paper. This circle will help to make a preliminary sketch. Using an eraser, make the circle barely visible. Then, draw the preliminary sketch over it, following the outline in Figure 1. Now, using the sharp end of a brown oil pastel, trace around the preliminary sketch (Figure 2). The drawing lines should be solid, so the heavy method of drawing will work the best (read more about pressure on page 11). After the brown outline is done, you can go ahead in two ways. One is to leave the outline without blurring its natural oil pastel texture. The other is to make the line smoother by using the blurring technique (read more about this on page 8). I prefer the first approach and chose it for my autumn wreath.

STEP 2

In this step, we'll color all the elements of the wreath. Using yellow and olive yellow, color the leaves as shown in Figure 3. Then, use ochre to fill in the acorn shapes. And finally, add the berries: first, use red to randomly color some berries, then, with scarlet, color the rest. If needed, you can blur all these shapes inside with blending stumps. I want to draw your attention to the fact that in some places, the brown outline can naturally blend in with the color that the shape is filled with; there is nothing wrong with that. I think it even makes the work look more realistic and uniform in style.

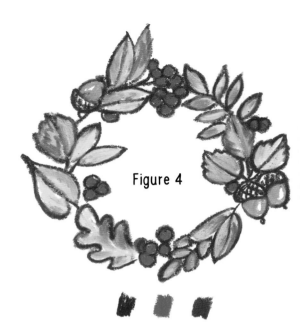

Figure 4

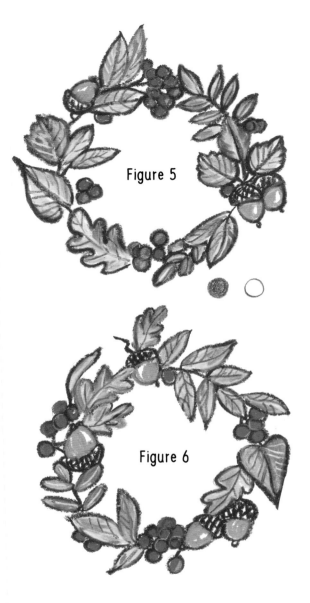

Figure 5

Figure 6

STEP 3

Let's move on, and add more colors to our leaves. With moss green, draw some touches randomly on green leaves and just a little bit on yellow leaves. Then, switch to red and draw details on some of the yellow leaves (Figure 4). Blend these details with the base colors (read more about blending on page 9). The last stage in this step, using the sharp end of a brown oil pastel, is to try to neatly crosshatch inside each acorn's hat (read more about crosshatching on page 11). Of course, it's not easy to do using oil pastel crayons, but it's much easier to draw with the sharp part of the crayon.

STEP 4

It's time to add the fine details to our beautiful wreath. For this, arm yourself with two colored pencils, white and dark green. Use them to draw such details as veins on all the leaves of the compositions (Figure 5). I advise applying these colors randomly. You can also define the berries with the white pencil, tracing just some of them with the pencil.

TIP: Instead of drawing details with a colored pencil, you can apply the scratching technique (read more about this on page 10).

Our project is done!

Despite the simplicity of the drawing, you can learn a lot by practicing and experimenting with this project. Use the same colors to create more autumn leaf wreaths. This will help you gain confidence in tracing using oil pastels and coloring small shapes. You can also change the arrangement of the wreath elements. This is a great exercise for your imagination and feeling for the rhythm of the composition (Figure 6 shows one example).

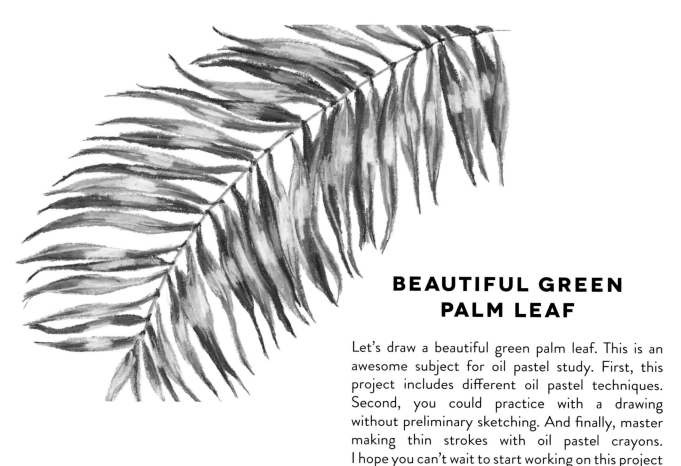

BEAUTIFUL GREEN PALM LEAF

Let's draw a beautiful green palm leaf. This is an awesome subject for oil pastel study. First, this project includes different oil pastel techniques. Second, you could practice with a drawing without preliminary sketching. And finally, master making thin strokes with oil pastel crayons. I hope you can't wait to start working on this project with me!

SUPPLIES

- White or toned paper
- Blending stumps
- Paper towel
- Pencil, optional
- Eraser, optional
- Masking tape
- Brown colored pencil
- Green colored pencil (optional)

OIL PASTEL COLORS

Light olive, Malachite green, Moss green, Pastel yellow (pale yellow), White

COLORED PENCIL COLORS

Brown, Green (optional)

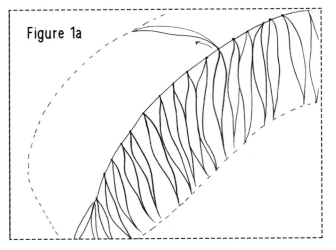

Figure 1a

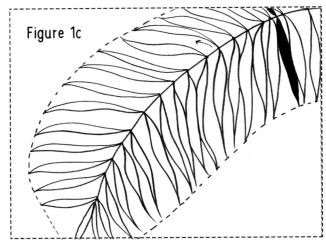

Figure 1c

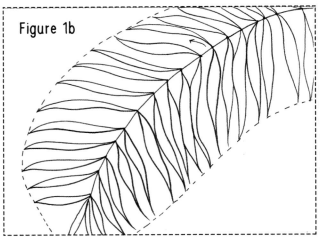

Figure 1b

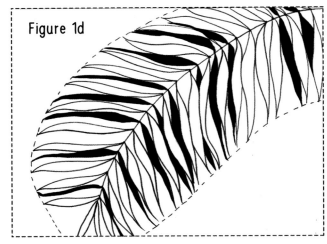

Figure 1d

STEP 1

TIP: I advise you to execute this project in a big format. The paper should be at least letter size (8½ x 11 inches, or A4).

Start by defining the working area with masking tape. As I mentioned earlier, a sketch is not absolutely necessary for this project. Try to work without a preliminary draft. However, it's important to clarify how, exactly, the leaves are located on the big green palm leaf. Refer to Figure 1a. In the figure, you can see the stages of how to build the branch. First, you need to draw the main stem, and then mark the points where the leaves start. After that, you can begin to draw leaves. Draw leaves from one side (Figure 1a) and then continue with another (Figure 1b). These are the upper-level leaves

of the branch. Then, you need to add lower-level leaves (Figure 1c). Add the leaves to the emptiest places so that they appear to be below the first level of leaves. It will make the palm leaf look more realistic. The final result should look like Figure 1d. Now, we can move on to the drawing with oil pastels themselves. Let's begin.

Use the sharp end of a light olive crayon to draw the stem of the palm leaf. Try to make the line pretty thin but, at the same time, use a heavy pressure stroke (read more about pressure on page 11). Blur it with a blending stump (read more about blurring on page 8). Then, with the same color, mark carefully on the stem the points of the leaf locations. Use light olive to draw all the leaves of the upper level, and then blur all by using a blending stump.

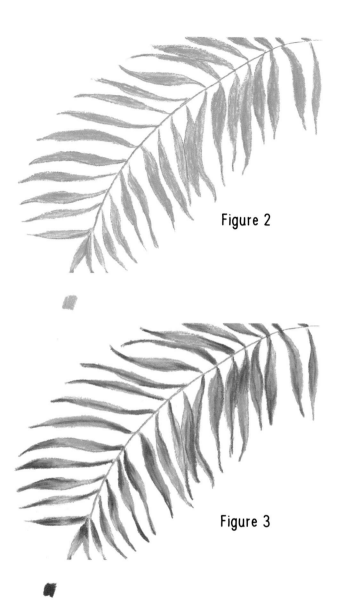

Figure 2

Figure 3

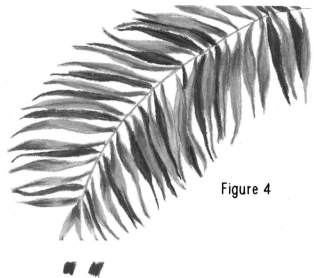

Figure 4

STEP 2

To make the palm leaf more lifelike, to each small leaf, add moss green—sometimes, in strokes on the tips of the leaves and sometimes, on the middle (Figure 3). Add these details randomly to achieve a natural-looking effect. Blend the new layer with the first layer (read more about blending on page 9).

STEP 3

The next step is to add the lower-level leaves to the palm branch. Let's use a different method of coloring—color mixing (read more about this on page 12). For this, draw leaf outlines in malachite green, then fill them with the same color (see Figure 4) by using light-pressure hatching (read more about hatching on page 11). Work carefully and try to make the leaves thin at their tips. Add moss green to those leaves and blend the colors to achieve an even layer for each little leaf.

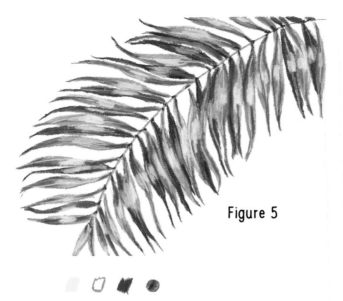

Figure 5

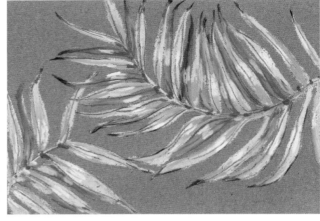

Figure 6

STEP 4

Finally, we can complete the work by adding the details. Draw highlights on the middle of each leaf, first, using pastel yellow and then adding final touches with white, with the overlaying technique (read more about this on page 9). If you wish, use only one color for this purpose, but I recommend drawing with both for a more interesting effect. Let's move on, and draw some more details with malachite green on the leaf stem, and with a brown colored pencil, some strokes in the tips of the leaves (Figure 5). If somewhere on the palm branch, the leaves' tips do not look thin and accurate, I advise you to also add some additional strokes of green colored pencil to them, just to make the tips neater. Remove the masking tape.

The drawing is now finished, and I hope you are happy with the result. Despite this lesson's simplicity, its principles are suitable for creating a wide variety of works. What can you change? First of all, experiment and play with colors. You can try to draw this project with unusual, nonrealistic colors. Or keep working with green tints. You could also create a piece that contains a few palm branches. The other point you can play around with is using different colors of paper: toned or even black ones. Figure 6 shows the picture I created using this lesson's methods, but on toned paper and green shades different from those used in this project. All you need to do is follow the principles outlined in the lesson and not be afraid to experiment.

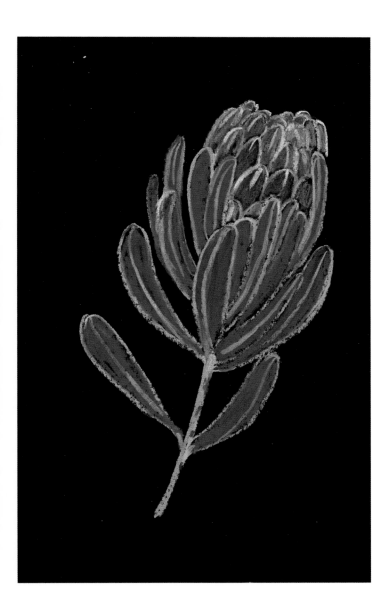

EXOTIC PROTEA FLOWER

I love how botanical illustrations look against a black background. Of course, the botanical drawings themselves are very beautiful. In addition, on the dark background, the colors pop and enhance the contrast even more. When using oil pastels on black paper, you can see the texture even more clearly, which makes the drawing look dynamic and interesting. And another feature of this tutorial is the fact that we will be using a special method that you can use to draw any flower. All this sounds amazing, doesn't it? I hope you are ready to draw an exotic protea flower with oil pastels on black. Let's go!

SUPPLIES

- Black paper
- Cloth for blending
- Blending stumps
- Paper towel
- White pencil
- Eraser

OIL PASTEL COLORS

Brown, Carmine, Moss green, Ochre, Olive yellow, Salmon pink, White

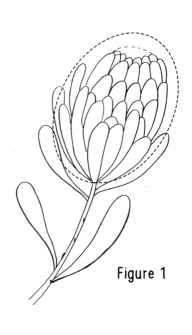

Figure 1

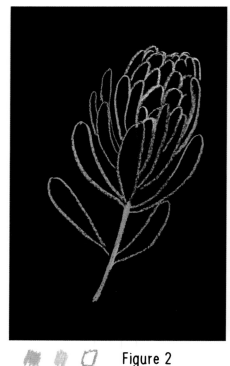

Figure 2

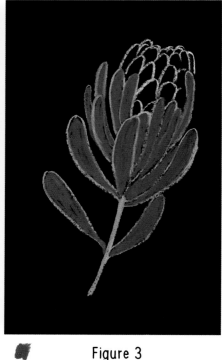

Figure 3

STEP 1

Start your work by sketching a protea flower with a white pencil (see the outline in Figure 1). While sketching, try not to press the pencil on the paper too hard. Some white pencil marks are possible to remove from the black paper by rubbing with an eraser. I recommend you test out your white pencil before drawing with it on black paper. Notice that the flower has an oval shape. For sketching, I advise starting with an oval, then drawing leaves, and finally drawing the petals of the flower, which look like the scales of a fish. Afterward, erase the auxiliary lines. Once your sketch is done, you can switch to the most enjoyable part of the lesson, which is coloring. As was mentioned, we will color the flower in a special way in this project. First, trace the petals of the flower with white oil pastel, and the leaves with olive yellow (Figure 2). Then, color the stem of the plant using ochre. If necessary, blur this step, using a blending stump (read more about blurring on page 8).

STEP 2

Now we'll color the leaves of the protea. For this, we need to fill each leaf separately with moss green. So, use moss green to paint in any leaf within its outline (Figure 3). Then, take a cloth or blending stump and blur the shape inside, while trying not to touch the olive yellow outline. Repeat with the rest of the leaves of the plant.

STEP 3

The next step is to color the petals. Here, I recommend using the color-mixing technique (read more about this on page 12). Use salmon pink and carmine to color each petal separately. Then, blend these colors inside the shape of each petal. Also, in this case, I recommend blending the white outlines of the petals with the shape of the petals (read more about blending on page 9). This will give the flower a realistic look because each petal will look very smooth. But remember that you need to blend each petal separately. This is what will visually provide the effect of individual petals.

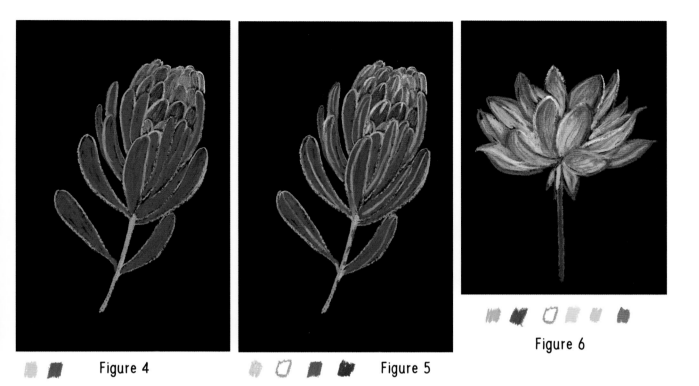

Figure 4

Figure 5

Figure 6

STEP 4

The protea is already looking super vivid and recognizable. Let's bring to it more life by adding details. We will use the overlaying technique in this step (read more about this on page 9). With olive yellow and carmine, add details on the leaves: veins and some extra touches (Figure 5). Using carmine, add shadows to the lower petals. These shadows seem to separate the petals from each other. With white oil pastel, add details on all the petals. And finally, use brown to draw the details in the stem.

The drawing of the protea flower is complete. Look how impressive the final drawing is, and we did it in just a few simple steps. And you can use this method to paint any flower, even a complex one, such as a rose or peony. In Figure 6, you can find a tender pink lotus I created using the method of this lesson. If you want to try it for drawing another flower, remember the following algorithm: start with outlining, then color each petal and leaf separately, and finally add details and accents. That's it. I hope you enjoyed this beautiful project and that it will inspire you to paint other flowers!

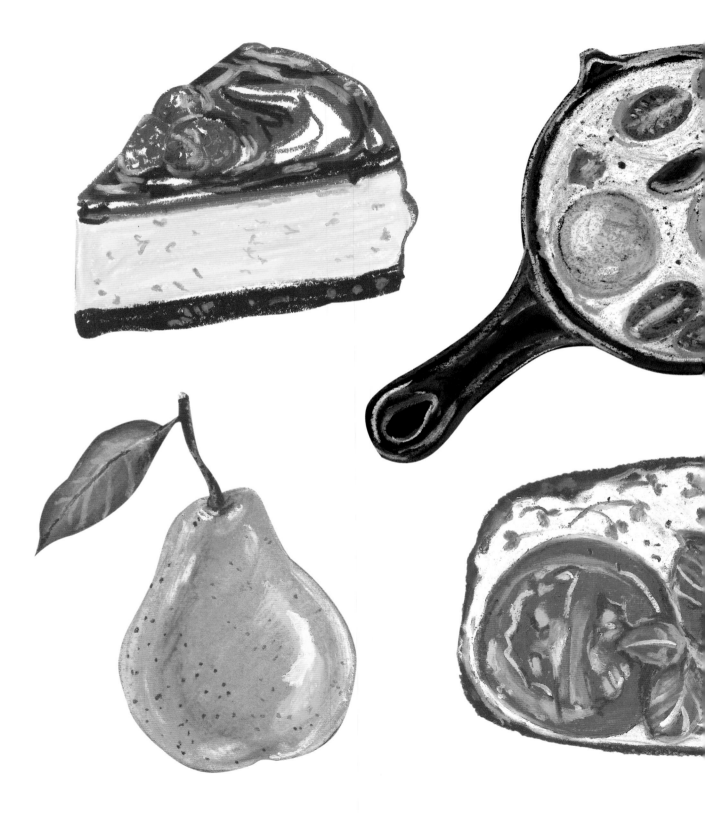

Yummy
FOODS, VEGGIES AND MORE

Food is a topic that's fun for practicing oil pastel drawing. You can draw a quick sketch of a juicy and bright veggie (page 98) on toned or black paper or try to capture a more detailed drawing of a breakfast (page 104). Whatever you choose from this chapter, have fun re-creating these illustrations in just a few simple steps! Every project in this chapter applies oil pastels in different ways, so you get to explore the medium itself through working on these projects.

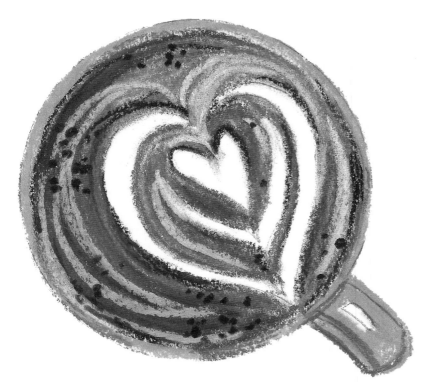

AROMATIC CUP OF COFFEE

As a big coffee lover, I know how beautiful this drink can be. The wonderful patterns and drawings done with milk on the coffee surface look so stunning. Why not draw such a coffee and practice using oil pastels at the same time? So, here is an amazing project broken into four easy steps. This lesson is perfect to get started with oil pastels. It includes the most basic oil pastel techniques, so you can try them out within the project. You may also love this lesson if you're looking for a fun project that is finished in no time. It doesn't focus on a complex sketch or color mixing, only drawing with oil pastels by using essential techniques.

SUPPLIES

- White paper
- Blending stumps
- Paper towel
- Pencil
- Eraser
- Compass, or any round object

OIL PASTEL COLORS

Brown, Light blue, Ochre, Russet, Turquoise blue, White

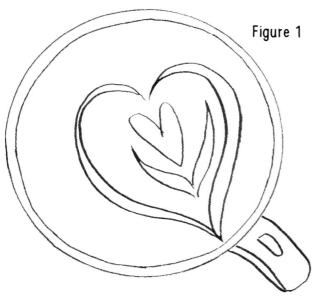

Figure 1

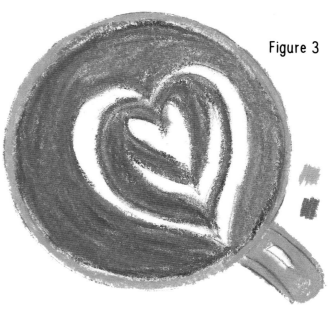

Figure 3

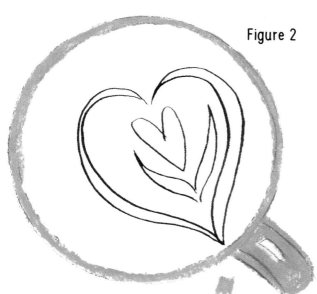

Figure 2

STEP 1

Start working by lightly sketching a circle with a pencil. To do this, use a compass or trace around a circular object, such as a cup. The diameter of the circle should be neither too small nor too big. Then, draw the inner circle of the cup—use the compass or do it by hand. This shouldn't be a perfect circle. And finally, proceed with the rest of the sketch (see Figure 1). Once the sketch is ready, start to color it. Fill the cup outline and create a handle in turquoise blue (Figure 2). Here, I advise you to draw it with heavy pressure (read more about pressure on page 11). Then, carefully blur these areas to achieve a smooth and accurate contour of the object (read more about blurring on page 8). Note that in the cup handle, there is an area free of color; it's a highlight area. Do not fill it with oil pastels while coloring the handle.

STEP 2

The next step is coloring the coffee area itself. We'll apply the color-mixing technique (read more about this on page 12). But we have to do this considering the white pattern. Because we are using white paper, you don't need to draw the white pattern with oil pastels. We use white paper as the white color. So, first add ochre and then russet on the coffee area, except for the pattern area (Figure 3). Then, mix these colors by using the color-mixing technique (read more about this on page 12).

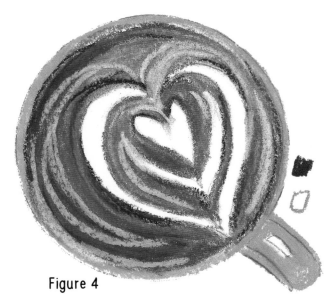

Figure 4

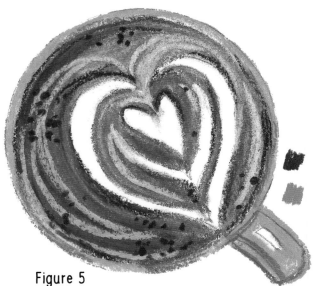

Figure 5

STEP 3

At this stage, we already have a recognizable cup of coffee. But let's make it more realistic by adding more details. Draw some accents in brown and then blend them (read more about blending on page 9). Then with the same color and white, add some more strokes that imitate the coffee and milk patterns (Figure 4), using the overlaying technique (read more about this on page 9). Those details should not be blurred, to bring texture to the work. Once it's done, jump to the final step.

TIP: With the white pastel, you can also correct the white pattern, if necessary.

STEP 4

With a brown crayon, randomly add spots to the coffee surface. Try to make spots in different sizes. These spots will look like bubbles on an aromatic coffee; they make the drawing more lifelike. And finally, add the details in light blue: on the handle and the cup outline (Figure 5). And again here, we used the overlaying technique.

Of course, using the lesson's principles, you can experiment and practice drawing with oil pastels on your own. Change the color of the cup and the pattern on the coffee and you will get another cute little drawing. In Figure 6, you can find such a piece created by following this lesson.

Figure 6

GLASS OF LEMONADE

A refreshing glass of homemade lemonade is a must during the hot summer season. It's also a great object to draw using oil pastels. We'll apply several basic oil pastel techniques to draw it. We'll also experiment with transparency and colors. Sounds great, doesn't it? Let's do it!

SUPPLIES

- White paper
- Cloth for blending
- Blending stumps
- Paper towel
- Pencil
- Eraser

NOTE: The drawing will look even more impressive on black or toned paper. So, you can try them too. However, in these cases, make sure you apply enough white pastel.

OIL PASTEL COLORS

Dark gray, Lemon yellow, Light gray, Light olive, Moss green, Olive yellow, White, Yellow-green

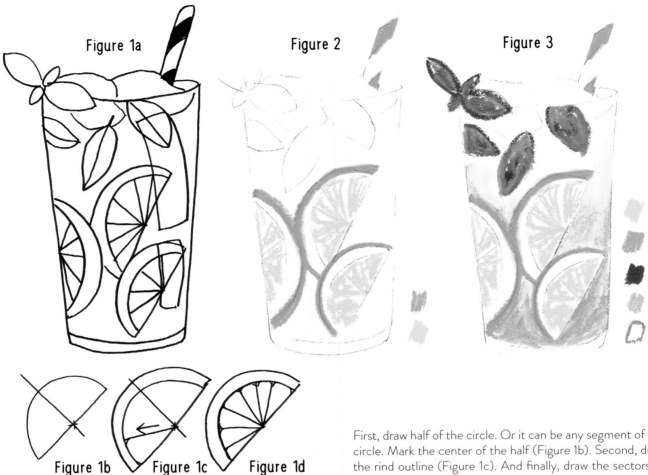

Figure 1a

Figure 2

Figure 3

Figure 1b Figure 1c Figure 1d

STEP 1

Let's start by making a detailed sketch on paper. Draw a light, barely visible sketch, following the outline drawing in Figure 1a. While sketching, try to make the glass as symmetrical as possible. Before diving into coloring the project using oil pastels, let's deal with how easy it is to draw sliced citrus fruits, such as limes, lemons, grapefruit and oranges. These fruits are traditional ingredients in lemonade, so this little instruction may help you draw such a drink. Let's look at Figures 1b, 1c and 1d.

First, draw half of the circle. Or it can be any segment of the circle. Mark the center of the half (Figure 1b). Second, draw the rind outline (Figure 1c). And finally, draw the sectors of the fruit (Figure 1d).

Once all your sketching is done, you can proceed with coloring the project. So, draw the lime slices by outlining them with yellow-green (Figure 2). Blur them accurately (read more about blurring on page 8). Then, color the sectors of the slices, using lemon yellow (Figure 3). The last part of this step is to add the lines on the straw and blur them. Basically, the lines can be any color in contrast to white. But I decided to limit the color scheme of the project and use yellow-green. Add stripes of your chosen color to the straw. Blur those details, using a blending stump.

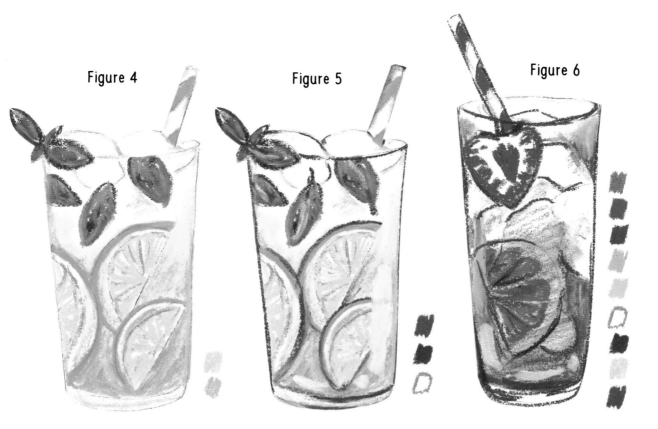

Figure 4 Figure 5 Figure 6

STEP 2

Mint leaves will need light olive and moss green. Draw the leaves in these colors. Then, blend the colors carefully (read more about blending on page 9), especially inside each leaf shape. Next is coloring the drink itself. I recommend employing the gradation technique (read more about this on page 9) first for this purpose. Start coloring from the bottom of the glass in lemon yellow and then change to white. Then, switch to olive yellow and draw lightly with this tint at the bottom of the glass, using the overlaying technique (read more about this on page 9).

STEP 3

Now, the base for our drawing is ready and you can start to add the details. With light gray, draw the contours of the ice cubes, straw and glass (Figure 4). Then, with the same color, add a little touch inside each ice cube and blur the strokes. Next, using olive yellow, add some accents on the lime slices, using the overlaying technique.

STEP 4

The lemonade drawing should look pretty recognizable at this stage, but the final details will complete the project and make the colors look deeper. In this step, we'll again employ the overlaying technique. Use the dark gray crayon to emphasize the outline of the glass and ice cubes as well as the straw. Using moss green, paint in the details of the lime wedges, to make them even more noticeable in relation to the background of the drink (Figure 5). And, finally, using white oil pastel, draw highlights on the lime slices and mint leaves. Also using white, draw the reflection of the light on the glass. Our drawing is complete!

Using the steps in this lesson, I suggest you continue drawing glasses of fresh lemonade, but with different types of glasses, and change the flavor of the lemonade (see Figure 6). It can be orange lemonade with strawberry or classic lemonade with cucumber slices. Any kind you wish. Do not be afraid to experiment!

RIPE AUTUMN PEAR

Let's draw a ripe, juicy autumn pear. This is an excellent lesson to learn how to draw fruits and veggies with oil pastels, and I recommend trying this project if you are short on time. It's very easy and beautiful. Gather all the required supplies and let's go!

SUPPLIES

- Toned paper
- Cloth for blending
- Blending stumps
- Paper towel
- Pencil
- Eraser

OIL PASTEL COLORS

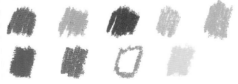

Emerald green, Ochre, Olive, Olive yellow, Orange, Red (vermilion), Russet, White, Yellow

NOTE: Basically, any paper will work for drawing our pear, but for the study process, I advise drawing on toned paper, as it's much easier to follow the progress on such paper.

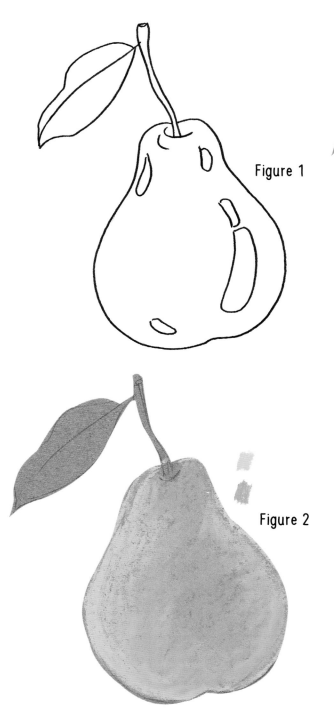

Figure 1

Figure 2

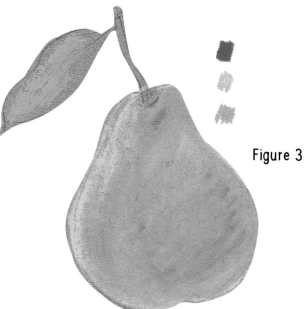

Figure 3

STEP 1

Begin work by drawing a preliminary sketch. For this, use an outline of the pear in Figure 1, or draw your own sketch, using a reference image or a real pear. On the sketch, you can also lightly mark the highlighted areas. Now, let's color the pear with oil pastels. Draw a base layer of the pear: use yellow to color the edges and the left side of the fruit, and for the right side of the shape, use orange (Figure 2). Blend these two colors to one smooth base layer (read more about blending on page 9).

STEP 2

The next stage is to add midtones to the pear by filling in:

- With red—on the right side
- With olive yellow—on the left side
- With ochre—in the middle

Blend these colors with the base layer (Figure 3). While blending, try to make movements that replicate the shape of the fruit—they should not be straight; instead, blend with flowing and circular motions. Let's now start drawing the leaf of the fruit. Arm yourself with olive yellow and fill in the center of the leaf shape. Once it's done, jump to the next shape.

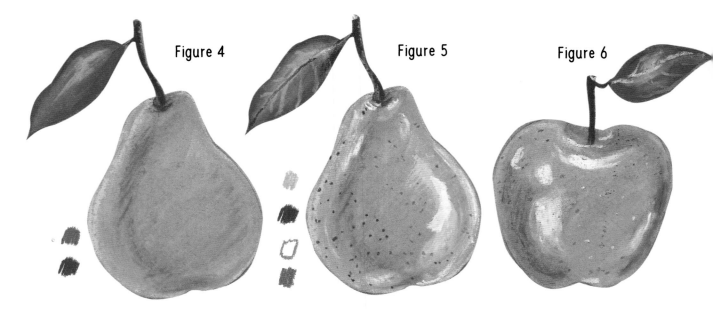

Figure 4

Figure 5

Figure 6

STEP 3

Color the rest of the pear leaf with emerald green and blend this color with the olive yellow area we had added in the previous step. Now switch to olive to add a stem to the pear. Then, with the same color, draw the shadows: in the left part of the fruit, at its bottom and at the base of the stem (Figure 4). If necessary, accurately blur the inside of the stem, using a blending stump (read more about blurring on page 8). As for the shadows, I also recommend blending these details. Have a look at what we've got at this stage: The pear already looks pretty good; it's not flat. The highlights and details will definitely complete the drawing. Don't wait and move to the final step.

STEP 4

Now, add highlighted areas to our pear, using white oil pastel. I advise drawing them in two stages:

First, draw these areas and blend them.

After, just add more highlighted accents, using the overlaying technique (read more about this on page 9), and leave them without any blending for a contrasting and glossy effect.

It's time to add fine details. We will use the overlaying technique for this. With russet and olive, add little dots on the pear's surface (Figure 5). Draw them randomly. However, I advise keeping to the following rule: The russet dots will be more harmonious-looking on warm-toned areas of the pear and the olive ones on cool-toned areas. For drawing details on the leaf, use olive yellow (veins) and olive (central vein). And finally, on the stem, draw accents with olive yellow.

This little and charming drawing is done. Using the principles and methods of this lesson, you can try to draw an apple with the same colors (see example in Figure 6). Next, you can try drawing other fruits. To summarize, for drawing fruits or veggies in this simple method, you need to make the base layer. Next, add midtones, highlights and shadows. Then, complete the drawing with fine details. I hope you liked the project and step-by-step execution. This tutorial will help you draw more yummy and shiny fruits and vegetables.

FRESH COCONUT

I'm happy to share with you this amazing lesson. You will learn, step by step, how to draw half of a fresh coconut. It is a great lesson to start learning oil pastels and see in practice how cool this medium is. Just follow the instructions and enjoy the process. Let's go!

SUPPLIES

- Toned or black paper
- Cloth for blending
- Blending stumps
- Paper towel
- Pencil or white pencil
- Eraser
- Painting knife (optional)

OIL PASTEL COLORS

Black, Brown, Dark gray, Russet, White

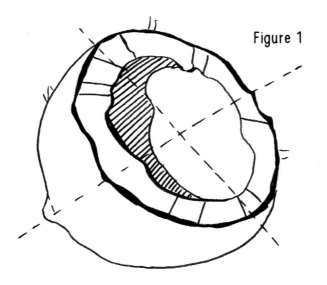

Figure 1

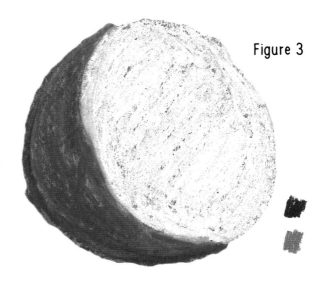

Figure 3

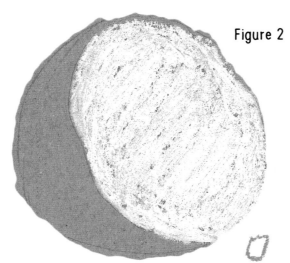

Figure 2

STEP 1

For this project, start by drawing a preliminary sketch, following the outline in Figure 1. If you execute the project on black paper, draw the sketch with a white pencil. Once the sketch is ready, proceed to draw the coconut itself. Using white oil pastel, color the inside of the coconut (Figure 2). The best method for this purpose is to draw with heavy pressure (read more about pressure on page 11). Then, blur the drawn shape carefully (read more about blurring on page 8).

STEP 2

Next, we will color the shell of the coconut, using the color-mixing method (read more about this on page 12). Fill the shape of the shell with russet and brown, applying the colors one by one, and then blending them to achieve one layer (Figure 3).

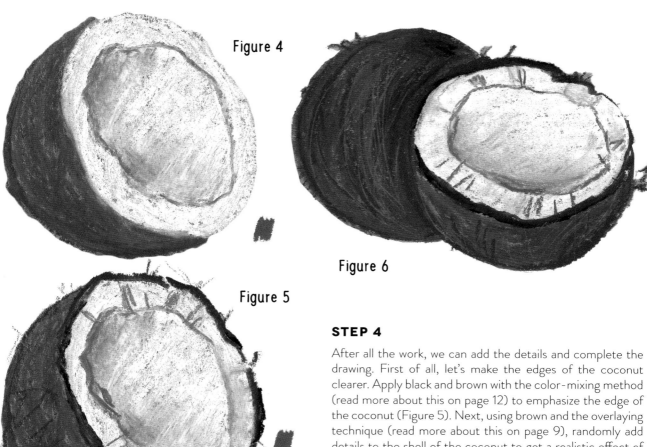

Figure 4

Figure 6

Figure 5

STEP 4

After all the work, we can add the details and complete the drawing. First of all, let's make the edges of the coconut clearer. Apply black and brown with the color-mixing method (read more about this on page 12) to emphasize the edge of the coconut (Figure 5). Next, using brown and the overlaying technique (read more about this on page 9), randomly add details to the shell of the coconut to get a realistic effect of the shell's texture. Also draw the coconut shell's hair that is sticking out from the shell. And finally, draw in dark gray details on the edge of the cut coconut. A few extra touches will be enough to make the edge more textured and rougher. You can also emphasize the shadow inside the coconut by using the overlaying technique to draw one extra line in dark gray. And we're done!

If you would like to practice drawing this lesson, you can change the composition: add more coconut halves or whole coconuts. You can also apply the scratching technique (read more about this on page 10); the drawing is done, so use the painting knife to scratch chaotically on the coconut shell. This approach brings a lovely and natural texture. Check out the example in Figure 6. Such a practice definitely helps you delve into and master exploring oil pastels.

STEP 3

Time to make the coconut look more realistic. Let's add the shadows. Use dark gray to draw the shadow as shown in Figure 4 (from the left inside the nut). Blend this area with the white layer (read more about blending on page 9). Then, with dark gray, draw the little shadows on the edge of the cut coconut. It makes sense to blend some of these details and to leave others without blending. I blended the shadows on the edge, opposite the main shadow we added earlier.

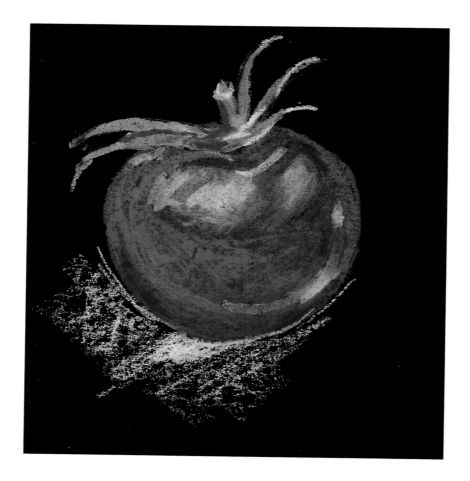

PERFECT TOMATO

Let's draw a shiny, juicy tomato. We'll use a graphic style to portray this veggie, and we'll execute this project on black paper. Drawing on black with oil pastels is an absolute pleasure. This project is a great opportunity to try to practice the ability of oil pastels to make different types of layers: smooth or graphic ones. And this is, of course, amazing for making a drawing with contrast. So, prepare yourself for an enjoyable creative process. Let's go!

SUPPLIES

· Black paper
· Cloth for blending
· Blending stumps
· Paper towel
· White pencil
· Eraser

OIL PASTEL COLORS

Carmine, Light olive, Moss green, Orange-red (flame red), Red (vermilion), White

Figure 1

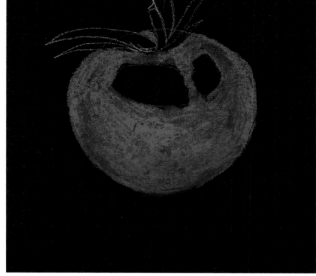

Figure 2

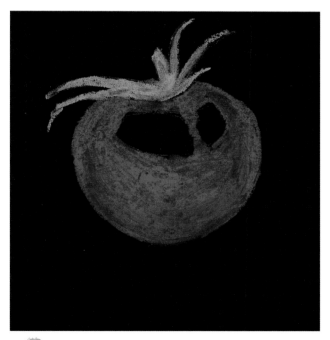

Figure 3

STEP 1

For this project, I recommend drawing a preliminary sketch (Figure 1). Because we will draw on black paper, use a soft white pencil. While sketching, try to make the lines almost invisible and do not press too hard on the paper.

TIP: Instead of using a white pencil for sketching, you can use any pastel tint of soft pencil visible on the black paper.

If the sketch is ready, go ahead and color the base for our tomato. You will fill in the tomato's shape using the gradation technique (read more about this on page 9). Apply red on the upper part, and carmine on the bottom of the tomato (Figure 2). Blend these colors to one solid layer (read more about blending on page 9). For blending, I advise using a cloth and a blending stump in the outlined areas.

STEP 2

Add the stalk and leaves of the veggie with light olive, using a sharp part of the crayon for drawing these elements (Figure 3). Then, blend them accurately, using a blending stump.

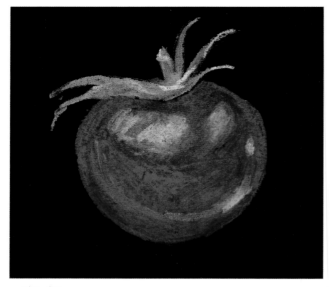

 Figure 4

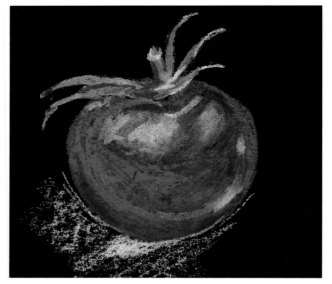

 Figure 5

STEP 3

Okay, we need to figure out the highlight areas. For drawing highlights, use the color-mixing method (read more about this on page 12). First, add highlights in red and then add white to those areas (Figure 4). Mix these colors into one color. You should get a pastel red tint. Using the overlaying technique (read more about this on page 9), draw extra little highlights with white: on the tomato and on the green part as well. These highlights will make the veggie even shinier. The final stage in this step is to add some more color to the base red coat we created in step 1. For this, use the orange-red crayon to draw some touches on the red layer. Then, gently blend them with the red layer. This will deepen the colors of the tomato.

STEP 4

The tomato is almost ready; a few touches and it will be completed. For this, add shadows on the stalk with moss green, using the overlaying technique; a few strokes will be enough. Let's also add some shadows. But these will not really be shadows; let's call them a graphical interpretation of the shadows in white. And because the work is in a graphic style, we'll not blend them. So, draw some strokes in white under the tomato, using the overlaying technique (Figure 5).

Figure 6

You can try different types of hatching or it can be crosshatching (read more about these techniques on page 11). Just don't add too many of them. Remember, sometimes less is more!

The final drawing looks really impressive on black paper, doesn't it? And to draw such a project so easily, follow all the instructions. You can also try to draw a sweet pepper (see the example in Figure 6) or any other fruits and veggies. All of them will look just amazing on black. Experiment with white "shadow" accents. Don't be afraid to use different hatching and practice as often as possible.

RASPBERRY CHEESECAKE

Desserts are excellent subjects for drawing, and oil pastels are an amazing medium for this. This material allows you to make a nice texture from one side and allows you to draw a smooth layer from the other. You can create a perfect transition of colors with oil pastels and then add details on top. We'll draw a classic and beautiful dessert: cheesecake with raspberries and a layer of caramel topping. Sounds good, doesn't it? So, let's get down to business!

SUPPLIES

- White paper
- Cloth for blending
- Blending stumps
- Paper towel
- Pencil
- Eraser

OIL PASTEL COLORS

Brown, Carmine, Ochre, Pastel yellow (pale yellow), Russet, Scarlet, Soft orange (orangish yellow), White

Figure 1

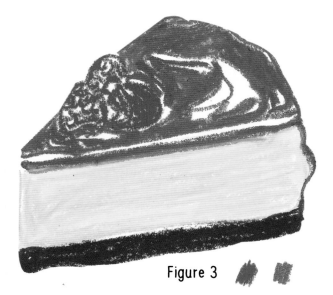

Figure 3

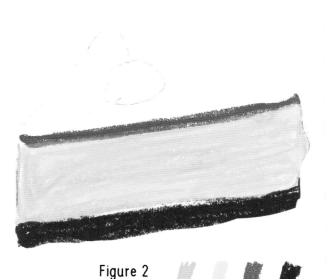

Figure 2

STEP 1

Make a light, barely visible, sketch with a pencil, following the outlines in Figure 1. No need to make it detailed; draw only the base elements. Once the sketch is ready, let's color our illustration. Begin with coloring the side view of the dessert — it's a creamy cheese base. It's best to use the color-mixing method (read more about this on page 12) for this purpose. Use soft orange and pastel yellow to fill in the side of the cheesecake (Figure 2). Blend those colors into one smooth shape (read more about blending on page 9). Now, switch to russet and use it to color the top layer of caramel. This is still the side view of the cheesecake. Using brown, draw the bottom chocolate cookie layer of the cheesecake. Don't blur the caramel and cookie layers; leave a beautiful texture of oil pastels.

NOTE: If you are not a beginner in oil pastels, challenge yourself and try to draw this project without a preliminary sketch.

STEP 2

With scarlet, draw the raspberries, leaving the inside of the berries free of pigment. These little white areas will work visually as highlights. Switch to russet for the top of the caramel layer, leaving some space between the side caramel view and the top layer view (Figure 3). Do the same for the raspberries, leaving the lower edge of the caramel top layer free of pigment, which will work as a highlight effect.

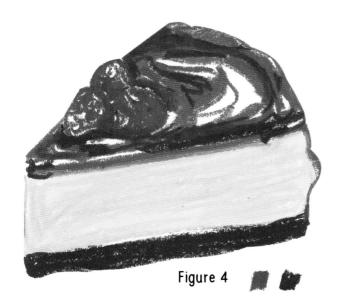

Figure 4

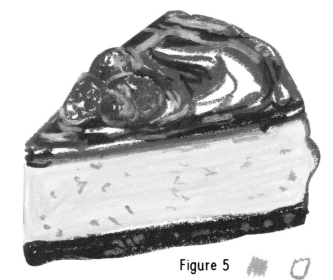

Figure 5

STEP 3

Let's add the second layer. In this step, we'll use the overlaying technique (read more about this on page 9). Using brown, add shadow accents on the caramel top layer (Figure 4). Then, use carmine to add accents on the raspberries. These accents should separate the berries from one another visually.

STEP 4

And finally, we can add details. Using ochre, draw the texture details on the cream cheese layer, using the overlaying technique. Add those details in different shapes and randomly, without any order. Using white, add highlights to the caramel layer and berries (Figure 5). We already reserved little highlights in step 3. As for these highlights, they should be smoother, compared to previous ones. I recommend blending new highlights by using the blending technique. Your piece of cheesecake is drawn!

What can you change when you draw other illustrations based on this lesson? I recommend experimenting with different decorative berries and fruits. Or you can draw a sprig of greens, such as rosemary. You can also try to depict this dessert from a different angle. If you take a look at Figure 6, you can find an example of cheesecake drawn using the instructions in this lesson.

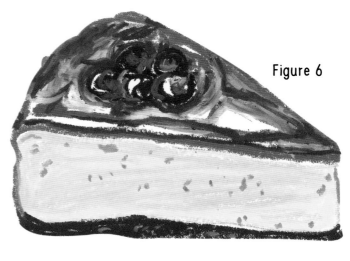

Figure 6

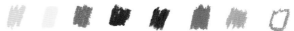

SKILLET BREAKFAST

If you ask me what is the feature of food illustration, I will answer without a doubt that it should look yummy. And this project is really looking like a proper food illustration—colorful and delicious. Let's use oil pastels to draw fried eggs in a pan. In this lesson, we'll use many colors and black paper. And as usual, it will be fun and pretty easy to do. So, let's start our creative journey!

SUPPLIES

- Black paper
- Cloth for blending
- Blending stumps
- Paper towel
- White pencil
- Eraser
- Compass or 2 round objects with different diameters
- Painting knife

OIL PASTEL COLORS

Brown, Carmine, Dark gray, Grass green, Gray, Moss green, Olive yellow, Orange-red (flame red), Orange-yellow (golden yellow), Pastel yellow (pale yellow), Prussian blue, Raw umber, Red (vermilion), White, Yellow

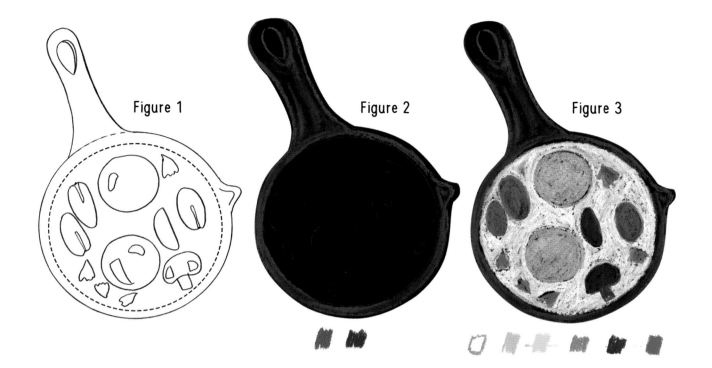

Figure 1 Figure 2 Figure 3

STEP 1

Let's start by making a preliminary sketch. For drawing it on black paper, use a white pencil or any other pastel colored pencil. Draw a very light sketch in two stages:

First, draw two circles with different diameters—a big one, and another about 4 inches (10 cm) smaller in diameter. Use the compass or two round objects with different diameters to do this.

Second, keep drawing the sketch, following the outline drawing in Figure 1.

Don't create pressure with your pencil, so you'll have a chance to erase the pencil line, if needed. Once the sketch is done, you can start coloring the project, using oil pastels. Define the frying pan outlines: Use dark gray and Prussian blue to draw the corresponding outlines (Figure 2). You can leave this layer as is, or blur it a little, very gently (read more about blurring on page 8).

STEP 2

In this step, we will draw a base layer of the dish's ingredients. First, draw the egg whites—use a white crayon to fill the area surrounding the other components of the dish. Blur the drawn area. Then, switch to yellow and orange-yellow, to draw the yolks of the eggs. Blend those colors inside each yolk (read more about blending on page 9). Use red to draw the tomato halves, and brown to draw the mushrooms pieces (Figure 3). And finally, draw the greens with grass green. Blur each of these elements separately, and very carefully. Make sure while blurring that you do not touch the white egg area, that it stays clean from other colors. The most difficult part of the project is done and you can proceed to the more relaxed steps.

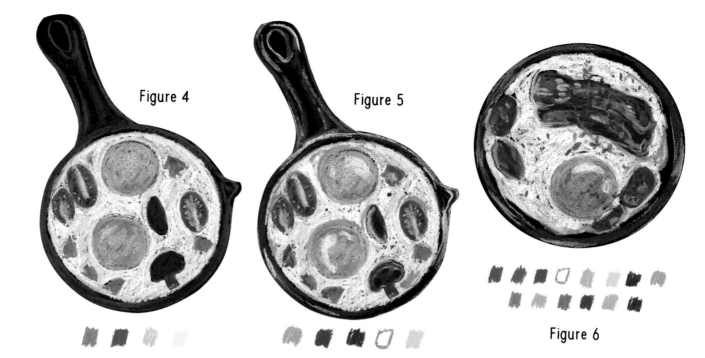

Figure 4

Figure 5

Figure 6

STEP 3

Let's move on. Add a second layer on the yolks, using orange-red, blending it with the first layer. This makes the yolks and the final illustration look more realistic. Using carmine, with the overlaying technique (read more about this on page 9), draw the outline on the tomatoes, and mark their cores with pastel yellow (Figure 4). The last step is to add one more layer on the greens. With olive yellow, draw a few accents on each green leaf, again using the overlaying technique.

STEP 4

Our skillet breakfast illustration is almost done. You just need to add the last details using the overlaying technique. Begin with adding gray shadows from the yolks on the egg whites. Then, use moss green to draw final touches on the greens. Also using raw umber, draw the details on the mushrooms. And in my opinion, the most important aspect is to add highlighted details. Arm yourself with a white crayon and first add highlights on the yolks, tomatoes and mushrooms (Figure 5). Still using white, add accents on the pan as well. And finally, using yellow, draw the seeds on the tomatoes. For this, I recommend employing a scratching technique (read more about this on page 10), using a painting knife, only after drawing the seeds.

This project is a great example of how to draw any dish on a black background. And using this method, you will get a really impressive result. You can find another example of a skillet breakfast dish in Figure 6. Whatever complicated food illustration you draw, following the principles of this lesson, try to draw each ingredient in a few layers. You can also apply different oil pastel techniques. Don't be afraid to experiment. Keep practicing and have patience!

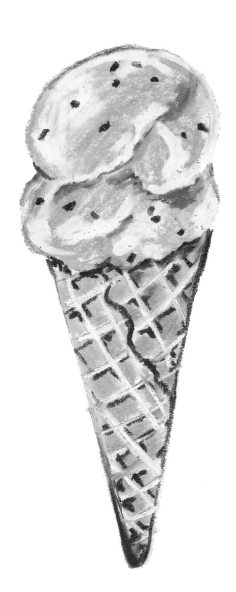

PISTACHIO ICE CREAM CONE

Who doesn't love ice cream? In a waffle cone, yummy, refreshing and beautiful at the same time. Sounds amazing! And in this lesson, you will learn how to draw it with oil pastels in just four steps. Let's get started.

SUPPLIES

- Paper
- Cloth for blending
- Blending stumps
- Paper towel
- Pencil
- Eraser

OIL PASTEL COLORS

Brown, Light olive, Moss green, Orange, White, Yellow

OIL PASTEL PENCIL (OPTIONAL)

White

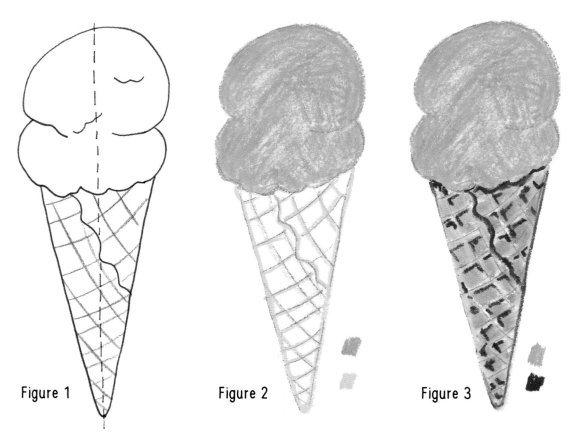

Figure 1

Figure 2

Figure 3

STEP 1

Let's start by making a pencil sketch. Draw a very light sketch, following the outline drawing in Figure 1. Fill the ice cream scoops in a light green tint. In my case, it's a light olive color. Blur the pigment with the help of a cloth (read more about blurring on page 8). Now, draw the outlines and mark the grid of the waffle cone, using yellow (Figure 2).

STEP 2

Fill the cells of the waffle cone with orange and blend them (read more about blending on page 9) with the yellow grid we made in the previous step. Blend each cell separately for a very neat-looking cone. At the same time, the yellow grid unites all the cells. For the blending, I advise you to use a blending stump or cotton swab. Then, to make the waffle cone look more natural, let's add some shadows and details in brown (see Figure 3), using the overlaying technique (read more about this on page 9).

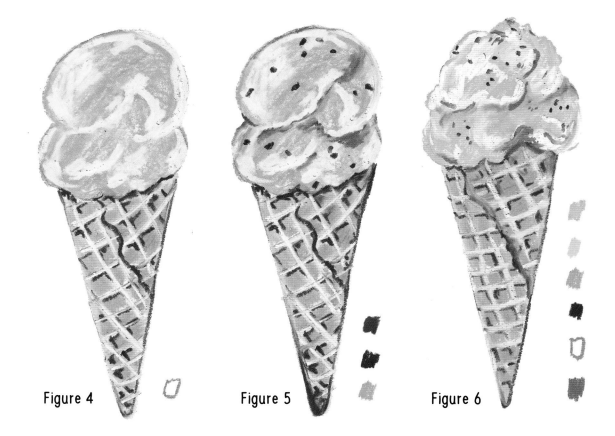

Figure 4 Figure 5 Figure 6

STEP 3

It's time to add some highlights to the drawing. For this, use a white crayon. Add some highlights on the ice cream scoops and blend them with the help of a cloth. Then, add some highlights to the waffle cone; for this purpose, you can use a white oil pastel pencil instead (Figure 4). It will make the work much neater.

STEP 4

We are at the final stage. Let's complete this pretty illustration. Using the overlaying technique, randomly add the small details of nut pieces to the ice cream, using brown and orange. Then, draw the shadows in moss green. The shadows will give the effect of 3-D if you add it under highlights (see Figure 5). Blend the shadows carefully with a blending stump. Our little painting is done.

If you are willing to practice with such a simple object as ice cream in a waffle cone, you can easily do this project. Change colors, experiment with the shape of the ice cream scoops and choose different toppings and decorations. You can find my variation in Figure 6. It is raspberry ice cream with some chocolate pieces. It looks pretty and super yummy, doesn't it?

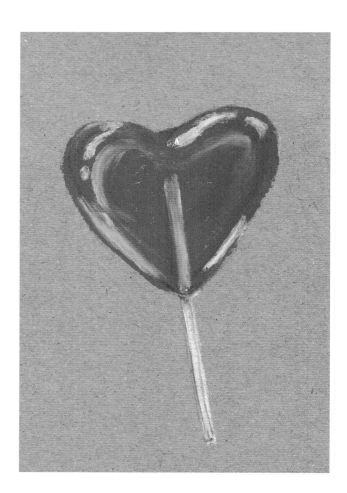

HEART-SHAPED LOLLIPOP

This lesson is one of the easiest in this book. And if you are a newbie to oil pastel drawing, I recommend you start with this lesson. Gather all the necessary supplies. Let's get started!

SUPPLIES

- Toned paper
- Blending stumps
- Paper towel
- Pencil
- Eraser
- White pencil

OIL PASTEL COLORS

Carmine, Scarlet, White

NOTE: The project also can be executed on black paper.

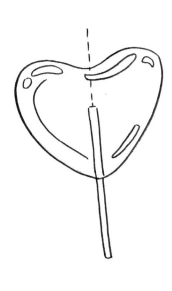

Figure 1

Figure 2

Figure 3

STEP 1

Start working on the project by making a sketch, following the outlines in Figure 1. Once the sketch is ready, you can begin painting. With scarlet, color the heart shape (Figure 2). Then, carefully blur the shape inside (read more about blurring on page 8).

Let's figure out how you can color the first layer. If you apply heavy pressure while drawing a lollipop shape, you will get an opaque base. But if you color with light pressure inside the shape you will get a transparent layer. I suggest you try both approaches (read about pressure on page 11), just to get a feel for this feature of oil pastels. I am choosing to draw with heavy pressure.

STEP 2

Let's keep going. Add the midtones to the heart shape, using carmine in the outline of the heart shape, randomly inside the lollipop (Figure 3) and to mark the stick. Then, blend these details with the scarlet base layer (read more about blending on page 9).

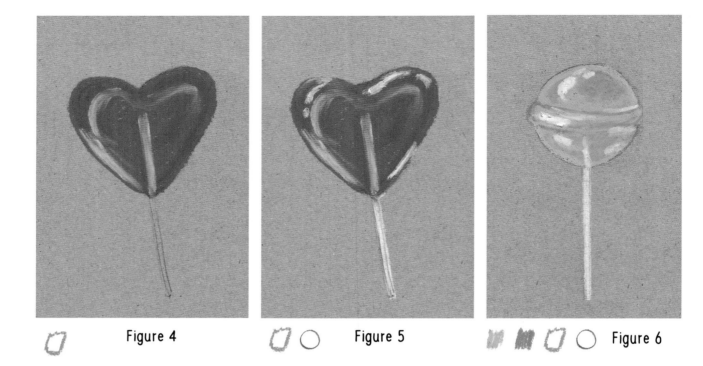

Figure 4

Figure 5

Figure 6

STEP 3

It's time to draw with white highlights. Use a white crayon to add highlights to the areas next to the midtones we drew in the previous step (Figure 4). Blend these details accurately.

STEP 4

Let's add some shine to our glossy lollipop. For this, I advise to first scratch the areas where you are going to draw the highlights, using the scratching technique (read more about this on page 10). Once these are done, add some touches of shine by drawing in the white stick of the lollipop, using the white pencil (Figure 5). Try to draw it pretty thick, but at the same time not too thick.

Use this lesson for learning oil pastel techniques. Simply change the colors (base color, shadow color) of the candy. You can also try to draw different shapes of the lollipop. In Figure 6, you can find a sphere-shaped candy in green shades. Or you can try drawing a star or some simple animal silhouettes. Make sure you add highlights and shine. These are especially important for this project, to make the object recognizable and look lifelike.

HOMEMADE SANDWICH

In this lesson, I will show you how to draw a colorful and yummy sandwich in just a few simple steps. At first glance, it might seem challenging to draw such a detailed object. But with oil pastels, it can be easily done by using different techniques. And as usual, I will guide you, so, I hope you enjoy the process of creation and you will definitely succeed! Let's go!

SUPPLIES

- Toned paper
- Blending stumps
- Paper towel
- Pencil
- Eraser

OIL PASTEL COLORS

Brown, Carmine, Grass green, Gray, Light olive, Moss green, Ochre, Olive yellow, Orange, Red (vermilion), Russet, Scarlet, White

Figure 1

Figure 2

STEP 1

Start working on the project by making a light sketch, following the outlines in Figure 1. The sketch should be pretty basic and include only the main lines of the composition of the sandwich. Once the sketch is done, proceed to color the project. Using white, fill the cream cheese area. Then, add some touches with ochre and gray, as shown in Figure 2. By using any blending tool (I prefer a blending stump), blend those colors to achieve a smooth layer (read more about blending on page 9).

STEP 2

Keep working on the base coat layer. Using brown, color the visible part of the bread slice. Carefully blur the drawn area by using a blending stump (read more about blurring on page 8). Then, use an orange crayon to draw the tomato seeds. Blur the details with a blending stump. Finally, use red and scarlet to color the tomato slices by randomly adding those tints of red (Figure 3). Then, blend the added reds to achieve one smooth layer of two tomato slices.

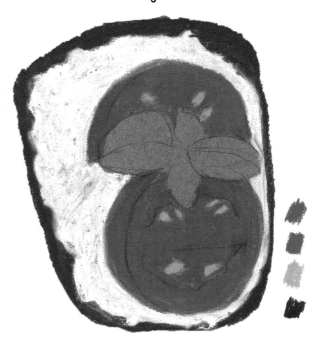

Figure 3

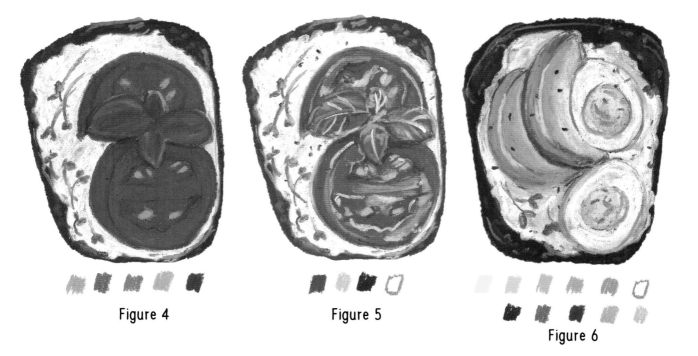

Figure 4

Figure 5

Figure 6

STEP 3

It's time to color the basil leaves. Add grass green, light olive and moss green, one by one, in random order to fill the leaves' shapes. So, for now, the base coat layer is ready. Employing the overlaying technique (read more about this on page 9), use ochre and russet to add some details to the bread crust. This brings some texture to the work. Then, draw some microgreens into the cream cheese area, using moss green (Figure 4). Apply heavy pressure while drawing these details (read more about pressure on page 11).

STEP 4

The sandwich is already recognizable. However, we need to add more details to complete the drawing and make it look yummy and lifelike. Use a carmine crayon to add shadows to the tomato slices. Blend these details carefully. Then, let's move on to add details to the basil leaves and microgreens, using the overlaying technique. Using olive yellow, draw some details on corresponding elements of our composition. With brown, draw some seasoning details on the sandwich. With the same color, I also advise you to draw shadows, which

will emphasize all the elements of the composition and will bring a great contrast. The last stage in this step is to add the highlight. Using white, draw highlights on the tomato slices and the basil leaves (Figure 5). Those highlights make the illustration look shiny and real. Don't overdo the highlights and other details; add them gradually, without rushing.

Take a look at the example in Figure 6. This illustration of an avocado egg sandwich was created by using the method of this lesson. Keep practicing based on this lesson. Because the sandwich can include a huge variety of ingredients, you can truly let your creativity flourish here and draw any sandwich you would like. Just keep the principles I shared with you in this project. Add the elements of composition one by one. Don't forget to add highlights and shadows, and remember about the balance in element sizes.

ADORABLE
Animals

In this chapter, you'll learn how to sketch adorable animals with oil pastels. From a fluffy sheep (page 124) to a realistic butterfly (page 136), these projects offer you the chance to learn how to draw oil pastel animals from scratch if you've never done it before, or further your knowledge of oil pastel techniques and to work on more challenging pieces that will grow your drawing skills!

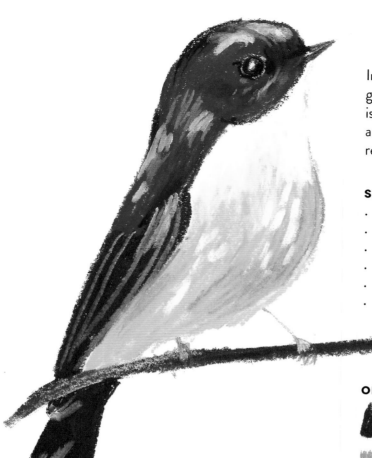

LITTLE GARDEN BIRD

In this project, I will show you how to draw a little garden bird in a very adorable cartoon style. This is an amazing project where you will explore colors and master some oil pastel techniques. If you're ready, let's get started.

SUPPLIES

- White or toned paper
- Cloth for blending
- Blending stumps in different sizes
- Paper towel
- Pencil
- Eraser

OIL PASTEL COLORS

Brown, Orange, Prussian blue, Raw umber, Russet, Sky blue, Soft orange (orangish yellow), Ultramarine blue, White

COLORED PENCIL COLORS

Black, Blue (Prussian blue), Pastel pink (dusty rose)

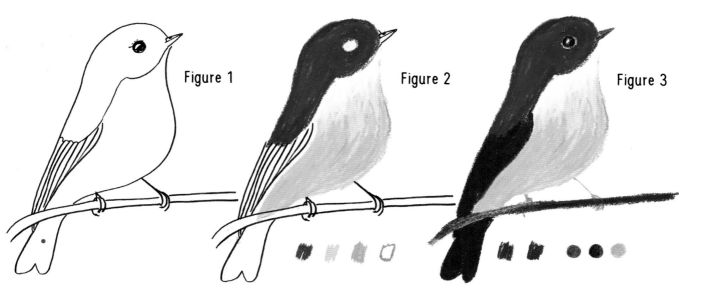

Figure 1

Figure 2

Figure 3

STEP 1

This project requires a preliminary sketch, so make a sketch, following Figure 1. Try to keep the lines almost invisible. Because we will use soft colors for coloring the bird, the pencil lines may be visible through them. Once you have done the sketch, let's go ahead and color our cutie. First, with ultramarine blue, color the head and the visible part of the back, except the eye (Figure 2). Blur the shape carefully (read more about blurring on page 8).

The next stage is coloring the neck and belly. For this, use soft orange and orange to hatch the bottom part of the belly (read more about hatching on page 11). Then, mix together the soft orange and orange (read more about color mixing on page 12). Now, add white in the upper part of the shape. Gently blend where the orange area and the white meet to get a smooth transition (read more about blending on page 9).

STEP 2

Let's keep working on making the base coat of the bird. In this step, we will use the blurring technique. Draw the wing and tail with raw umber. Blur these shapes. Next, color the wooden branch the bird sits on, using brown. Once again, blur the shape. Now, it's time to add the details. For this project, I suggest drawing details with colored pencils, so the final piece will look much neater. Using the overlaying technique (read more about this on page 9), draw a beak in black, an eye in blue and legs in pastel pink (Figure 3). Please note that the bird's eye has a highlight, so leave this small area free of color.

TIP: If you don't have a similar tint of pastel pink, use instead any pastel tint of pink, purple, brown or beige.

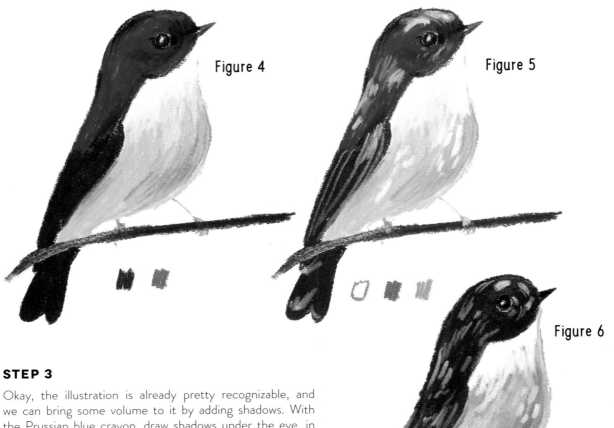

Figure 4

Figure 5

Figure 6

STEP 3

Okay, the illustration is already pretty recognizable, and we can bring some volume to it by adding shadows. With the Prussian blue crayon, draw shadows under the eye, in between the eye and beak and outline the ultramarine blue area (Figure 4). Blend these shadows with the blue coat layer. Then, add shadows in russet on the belly. And, of course, blend them to achieve a smooth layer.

STEP 4

It's time to add highlights and more details. These, along with shadows, bring some volume to the illustration. We will use the overlaying technique and leave the details textured, without blending. Using the sky blue and white, randomly draw some highlights and accents on the blue part of the bird (Figure 5). Draw details on the belly and tail in white. And finally, use soft orange to add lines of emphasis on the wing. Again, try to apply the details randomly, without any order. It makes the illustration look more lifelike.

This project can be redrawn in different color combinations. Why not try pinks and purples (see an example in Figure 6), or any other combo you have in mind? Don't be afraid to experiment with adding different details. Keep in mind that the details should be visible; this will add contrast and make the work look interesting.

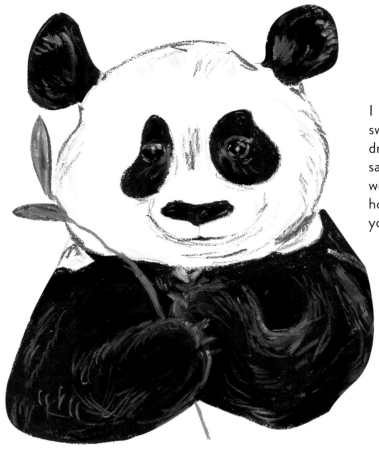

CUTE PANDA BEAR

I think everyone loves pandas. They are so sweet. In this lesson, I encourage you to try drawing this animal using oil pastels. I have to say that drawing a panda bear is not easy, but we'll do it step by step and you will manage how to draw this adorable animal. I promise you will learn a lot in this lesson. Let's go!

SUPPLIES

- White paper
- Cloth for blending
- Blending stumps in different sizes
- Paper towel
- Pencil
- Eraser

OIL PASTEL COLORS

Black, Blue-purple (periwinkle blue), Dark gray, Gray, Light gray, Light olive, Moss green, Ochre, Pastel yellow (pale yellow), Prussian blue, Turquoise blue, White

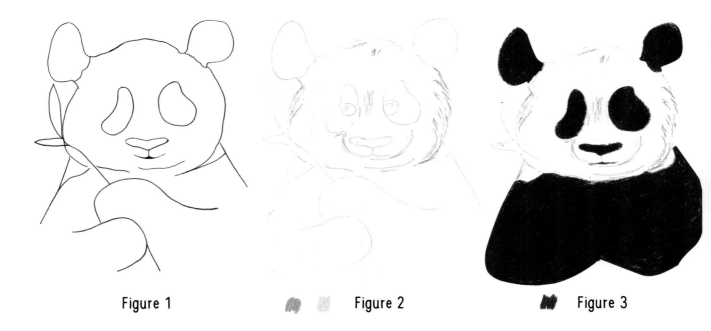

Figure 1

Figure 2

Figure 3

STEP 1

The most difficult part of this project is to make a preliminary sketch. Do your best to sketch Figure 1. Try to capture the shapes of the head and those typical of panda ears. The sketch should be light and barely visible. Because we use white paper for drawing a panda, let's start the color part with the defined white area. Use gray and light gray to draw the contour of the head as well as mark the nose and mouth areas (Figure 2). Make a kind of random hatching (read more about hatching on page 11) to imitate the effect of a fluffy outline of the panda.

NOTE: If you draw the panda on toned or black paper, at step 1 you need to fill the head area (with the exception of eyes and ears) with white oil pastel.

STEP 2

Next, we'll color the dark body parts of the bear to complete the base shape of the drawing. Using Prussian blue, color the following details: ears, around the eyes' zone, nose and mouth details, upper torso and paws (Figure 3). I don't recommend using black for coloring these elements, because you will not be able to give the bear more color depth later. So, we use Prussian blue. Work carefully to not make a mess on the paper. When all are colored, apply the blurring technique (read more about this on page 8). Use the cloth for blending inside the shapes, and work with a blending stump at the edges (read more about blending on page 9).

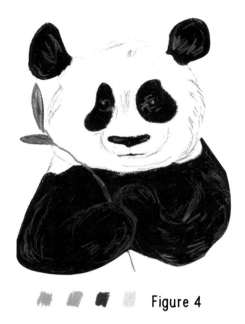

Figure 4

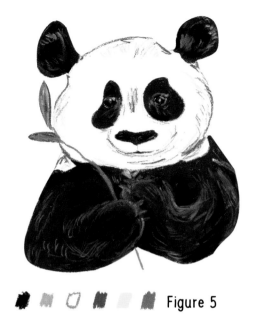

Figure 5

STEP 3

Let's keep going and bring some color to our work. Using the overlaying technique (read more about this on page 9), we'll draw the branch with green leaves, which the panda is holding. Use ochre to draw the stem. With light olive and moss green, color the leaves, employing the blending technique (Figure 4). Next, begin work with highlights, which will visually separate the body parts and will serve as a kind of edge. Here, I also advise making a random hatching for adding these details. Using the overlaying technique, draw highlights with light gray on the following areas: ears, the zone around the eyes, upper torso and paws.

STEP 4

In this step, we'll add the final details and shadows. First, use black to add shadows. To do so, focus on the highlights we had added in step 3. Draw shadows on the ears, around the eyes' zone, and on the nose, upper torso and paws. Then, blend these shadows with a base Prussian blue layer. Then, use black to draw the eyes. Switch to turquoise blue and white and, using the overlaying technique, draw accents on the fur on dark parts of the panda: on the ears, on the zone around the eyes, and on the nose, torso and paws (Figure 5).

And, finally, using dark gray, blue-purple and pastel yellow, draw details on the light parts of the head and body. A few touches in each of those colors will be enough. After all the work, your drawing is complete.

The drawing looks just adorable. I love how it turned out. If you are willing to repeat drawing this project, try to draw pandas in different poses (see Figure 6). Use references from the internet to explore panda poses. I also recommend adding details, such as apple or bamboo branches, to the illustration to make it look more fun and colorful.

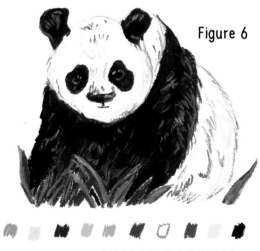

Figure 6

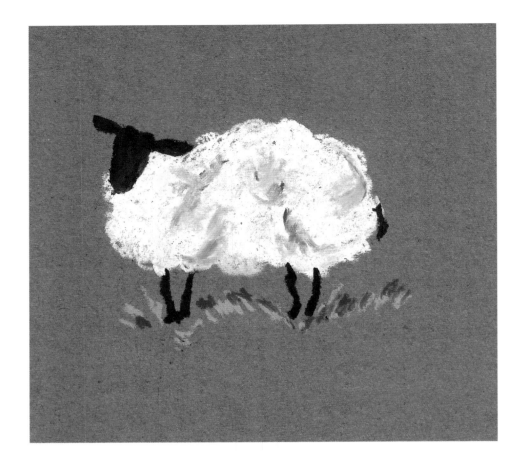

FLUFFY SHEEP

This is a super fun and charming project I'm so happy to share with you. All the steps are so easy to draw. And the process of creation is a pure pleasure. The character is done in a sketching style, so you could have a chance to try this style when using oil pastels. And one more thing is that this project is perfect for drawing with kids. I'm sure that they will love to paint such a cute animal. Let's get started.

SUPPLIES

- Toned paper
- Cloth for blending
- Blending stumps in different sizes
- Paper towel

OIL PASTEL COLORS

Dark gray, Light gray, Moss green, Ochre, Olive yellow, Pastel purple (light purple-violet), Raw umber, White

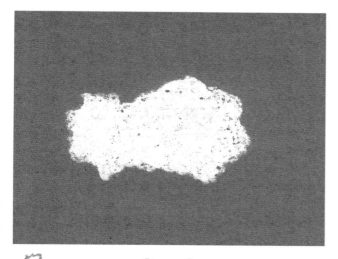

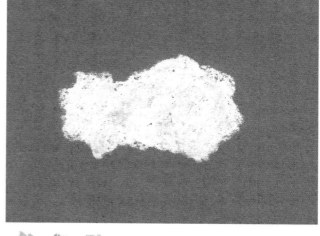

Figure 2

Figure 3

STEP 1

In Figure 1, you can find the outline of the project. However, a preliminary sketch is not needed. We'll draw the sheep freehand with oil pastels. Pay attention to the fact that the shape of the sheep's torso fits into an oval. So, keep this in mind while building the shape of the torso. Start with making the fluffy sheep torso, drawing it with white (Figure 2). Try to make it like a fluffy cotton cloud. Blur the drawn shape inside; you can also blur the edges for an airier effect (read more about blurring on page 8).

STEP 2

Let's give the drawn layer more volume. Draw randomly on the torso shape with pastel purple, ochre and light gray, and then blend those details (read more about blending on page 9). Don't add too much detail when using these colors. The additions can appear all over the white base; still, the sheep should be white. So, a few strokes of each color will suffice (Figure 3).

NOTE: Instead of pastel purple and ochre, you can use any pastel tint. You can experiment here. Just don't add too many colors.

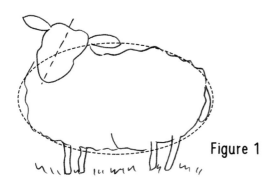

Figure 1

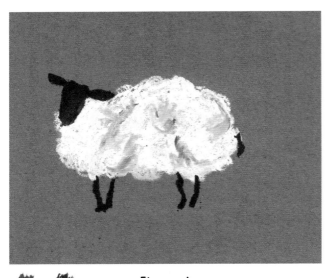

Figure 4

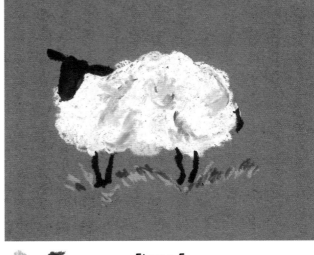

Figure 5

STEP 3

In this step, we add shadows that help provide even more volume. For this, use dark gray to add the details of shadows on the sheep's fur. It is advisable to add these details to only the white areas. A few strokes in this color will be enough. Then, carefully blend the shadow details. With raw umber, draw the legs and the head with ears (Figure 4). These details are a secret of this illustration. They make the silhouette recognizable. If needed, you can draw a preliminary sketch of these parts with a pencil. Accurately blur the drawn elements.

STEP 4

Our sweet illustration is done. But I always say that illustration is first of all the feeling. And to give this feeling that is a sheep standing on a spring meadow I suggest you add the grass. Arm yourself with olive yellow and moss green, and by randomly hatching (read more about hatching on page 11), draw the blades of grass under the sheep (Figure 5). I hope you really enjoy this lesson and it brings some joy! Draw more sheep using this method. For this, change the animal's position and don't be afraid to experiment with details (see Figure 6). You can add clouds above the sheep, or flowers . . . whatever you wish. But don't overdo the details. And don't forget to enjoy the process of drawing. That is the most important thing.

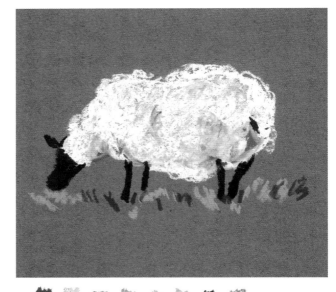

Figure 6

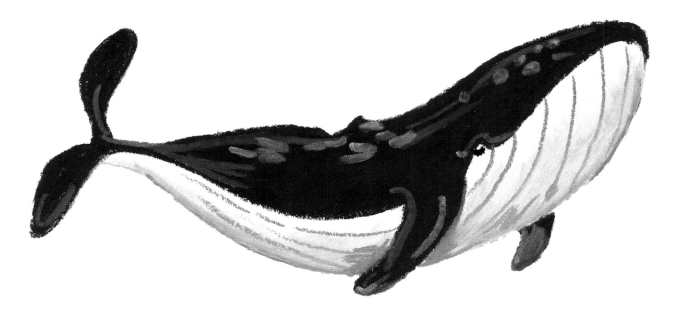

ADORABLE WHALE

Let's draw an adorable whale. I love this project because it's striking and is pretty straightforward. We'll be using an illustrative style, which in this case means simplified colors, shapes and details. And with oil pastels, to execute such a project is a pure pleasure. Let's figure out how to do it, step by step.

SUPPLIES

- White paper
- Cloth for blending
- Blending stumps in different sizes
- Paper towel
- Pencil
- Eraser

OIL PASTEL COLORS

Black, Blue-purple (periwinkle blue), Gray, Light gray, Sapphire blue, Violet, White

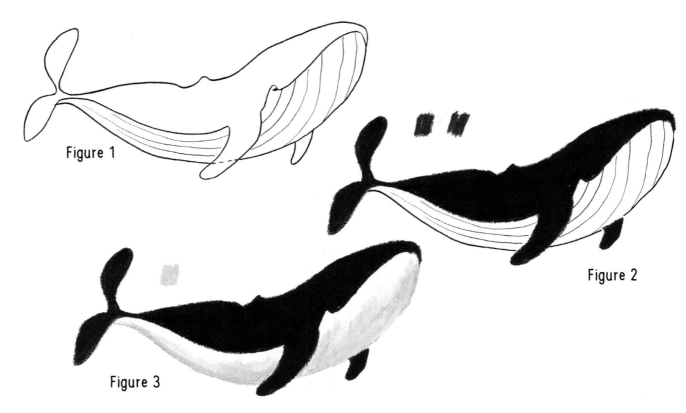

Figure 1

Figure 2

Figure 3

STEP 1

Before you start working, make a sketch, following Figure 1. Try to make the lines almost invisible, and do not press too hard on the paper. It will help to get a very neat illustration of the whale. Once the sketch is ready, you can begin to color the whale. Let's start with coloring the body: top part, head, tail and fins. I suggest that you use the color-mixing method for this (read more about this on page 12). First, outline the shape with sapphire blue. Then, fill the inside of the shape with this color, using light-pressure hatching for this purpose (read more about hatching on page 11). Switch to the violet crayon and add it to the filled-in shape of the whale (Figure 2). Blend those two colors into one smooth base layer (read more about blending on page 9).

TIP: The shape we color in this step is pretty complicated. That's why I suggest using both a cloth and blending stumps. A blending stump is perfect for work with an outline; a cloth is better for blending the big areas.

STEP 2

Go ahead and color the bottom part of our adorable whale. Because we draw this project on white paper, the pigment-free areas will work as white. So, we don't need to add white. Using light gray, add some hatching at the bottom part of the whale, but don't fill the whole area with this color (Figure 3). You need to leave about half of the bottom free of color. Then, blur the color inside the whale shape (read more about blurring on page 8), so that you get a kind of gradient of white and light gray (read more about gradation on page 9). Once it's done, proceed to the next step.

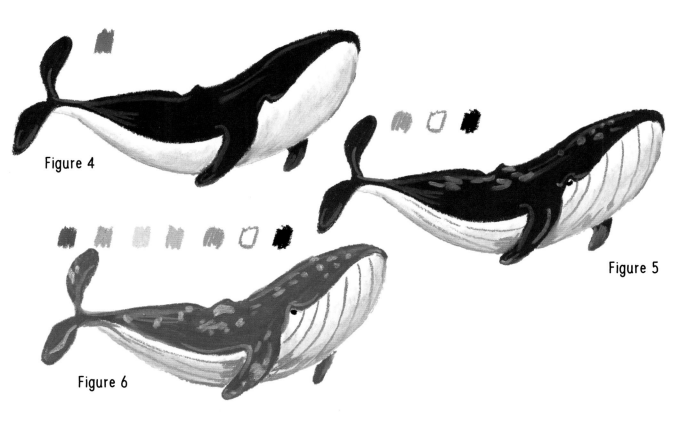

Figure 4

Figure 5

Figure 6

STEP 3

For now, we have a base coat of the drawing. It's like a base where you can add details. However, before adding details, I advise making the illustration look not so flat, by adding one more layer. So, use blue-purple to draw the shadow in the bottom part (Figure 4). Blend this layer with the base layer. Then, using the overlaying technique (read more about this on page 9) with the same color, add some touches to the top part of the whale. Instead of blue-purple, you can try to use another color. The intention of drawing this layer is to bring a 3-D effect to our illustration. It should work like a shadow on a light layer and like highlights on a dark one. The color should be pastel-like.

STEP 4

And finally, we are ready to add details. As I mentioned earlier, we draw this project in an illustrative style; all the details will be simplified. Let's go!

In this step, don't blur the details. We will use the overlaying technique, which I think brings some texture to our drawing. First, draw a whale's eye with the sharp top of a black crayon. One touch and the eye is ready. Then, use gray to draw throat grooves and shadow accents at the bottom part (Figure 5). Switch to the white oil pastel and draw details on the top part of the whale. You can show your creativity at this stage and draw your design details in white (spots, stripes, dots, maybe some abstract shapes). Why not? This project conveys the illustrative style. Just one piece of advice: don't add too many details to the illustration.

Using the methods in this lesson, you can practice coloring and using different color combinations. Figure 6 is a drawing made by following this lesson's instruction, but I tried a different color combination. And it is lovely. Find your perfect colors for the adorable whale and enjoy the process!

GRACEFUL WHITE-TAILED DEER

In this project, I will explain, step by step, how to draw a deer with oil pastels. Just four easy steps and a beautiful painting is done. We'll draw it in an illustrative and even graphical style as you open your eyes to all the grace and beauty of this wonderful animal. I will also show how easy it is to bring a seasonal mood to the drawing by adding background details.

SUPPLIES

- White paper
- Cloth for blending
- Blending stumps in different sizes
- Paper towel
- Pencil
- Eraser

OIL PASTEL COLORS

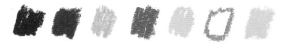

Brown, Moss green, Olive yellow, Russet, Salmon, White, Yellow

COLORED PENCIL COLOR

Black

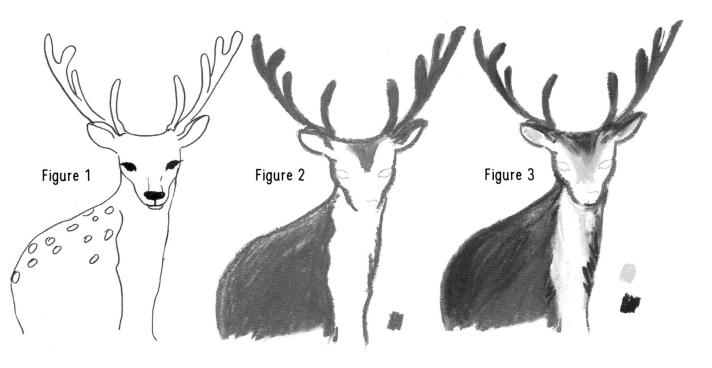

Figure 1

Figure 2

Figure 3

STEP 1

Before you start work with oil pastels, make a sketch of the silhouette of the deer, following Figure 1. Try to depict the most specific parts of the animal's body: antlers, ears and torso contour. It's also important to keep the right proportions. The bottom part of the sketch should not be drawn; leave it for when you add background details. Let's move on to coloring the deer. Using russet, make the base of the deer (Figure 2): draw the silhouette of the animal and then blur all the parts gently (read more about blurring on page 8).

STEP 2

The base of the animal is already recognizably a deer. Now, we need to give it depth by adding more colors. Use salmon to color the following parts of the deer: the center of the head and the inner ears, and also to emphasize both sides of the center of the torso. Blur all these parts. Then, switch to brown and add it to the entire body of the animal—some touches and accents with this color will make the drawing look more realistic (Figure 3). Pay special attention to the back of the deer; add a lot of brown there, as we will be adding spots of white in this area. And for good contrast, the background should be pretty saturated. Blend these details with the base layer (read more about blending on page 9).

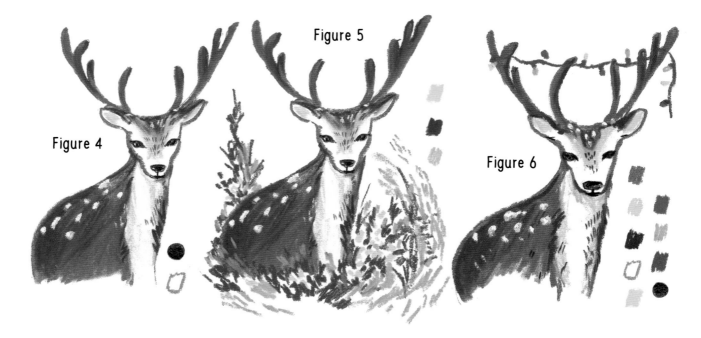

Figure 4

Figure 5

Figure 6

STEP 3

Step by step, we are moving toward a more and more completed version of our illustration. Next, it's drawing fine details. I recommend switching to a black colored pencil to draw the eyes, nose and fur details, using the overlaying technique (read more about this on page 9). Of course, all those details can be done with black oil pastel, but to keep the illustration looking accurate and neat, I would advise using a pencil here (Figure 4). Now, continuing to use the overlaying technique, use a white crayon to draw white spots on the animal's back and some accents on the head. Please make sure that the white oil pastel you are using is soft enough and it's visible. As for drawing fur details, try to add them in random order and without symmetry. This will make the drawing look more pleasing to the eye.

STEP 4

Basically, the deer illustration is done. But, as I promised, we will bring some seasonal mood with a background. For this, using the overlaying technique, start with yellow spots, then add the grass and leaves, using moss green, and complete the composition with olive yellow strokes (Figure 5). Try to make a kind of dance of all these details with some rhythm.

When all the details are added, put away the oil pastels and enjoy the final result. If you feel the summer vibes when looking at this illustration, all was done right. The drawing can be easily transformed into a Christmas deer if you change the details in step 4. Just draw some festive lights instead of the summer meadow, and you will get another little masterpiece (Figure 6).

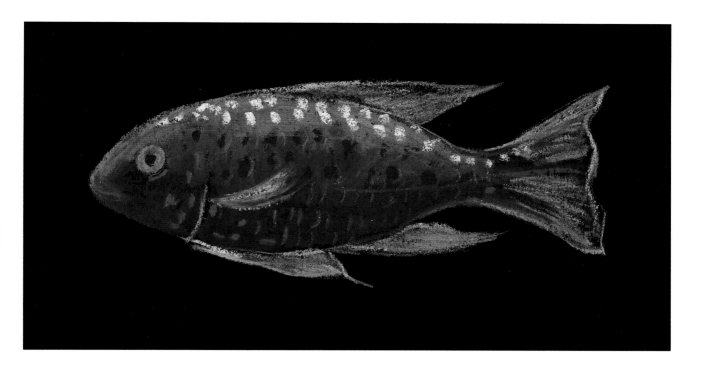

COLORFUL FISH

This project shows the amazing flexibility of oil pastels: the ability to add the textured details from one side, and to make lovely even and vivid coats from the other. Another specialty of this lesson is executing it on black or dark-toned paper. I personally adore drawing with oil pastels on black paper. The dark background will make the colors pop and bring out that contrast. And the final piece will look professional and really impressive. Gather all the listed supplies and let's go!

SUPPLIES

- Black or dark-toned paper
- Cloth for blending
- Blending stumps in different sizes
- Paper towel
- Soft white pencil
- Light blue colored pencil

OIL PASTEL COLORS

Cobalt blue, Light gray, Ochre, Prussian blue, Russet, Sapphire blue, Sky blue, White

COLORED PENCIL COLORS

Light blue (Smyrna blue), White

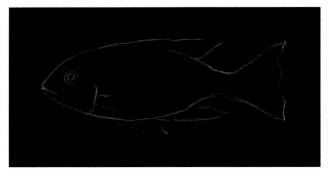

Figure 1

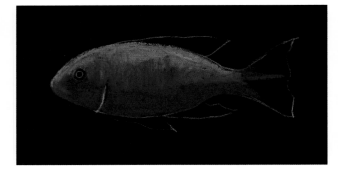

Figure 2

STEP 1

Start by sketching the fish following Figure 1. Because we will draw on black paper, use a soft white pencil for preliminary sketching. I don't make a detailed sketch; instead, I draw only baselines. While sketching, try not to press too hard on the paper. Once the sketch is ready, jump to coloring the object. We'll use the gradation technique (read more about this on page 9) for coloring the body and head of the fish. Start with adding sapphire blue in the bottom part of the fish, then continue in sky blue at the top (Figure 2). Now, let's figure out how to make the beautiful two-color gradient. First, blur each color itself, and then keep adding each of them until they meet each other. And, blur the transition of the colors to achieve an even base coat (read more about blurring on page 8).

NOTE: At this stage, we are coloring the head, but not the eye, which should be left free of pigment.

The final touch in this step is to use sky blue to draw the line that separates the head and the body, using the overlaying technique (read more about this on page 9). Once it's done, go ahead to the next step.

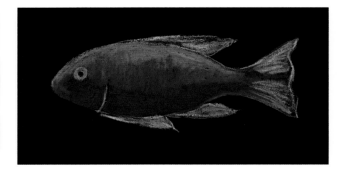

Figure 3

STEP 2

With an ochre crayon carefully draw the fish eye as shown in Figure 3. Now, blur the drawn shape by using a blending stump. Let's deal with the fins and tail of the fish. Using light gray, fill the fins and tail. Apply a very light pressured hatching for this, so you will get a pretty transparent layer (read more about hatching on page 11). Blur the insides of the fins and tail.

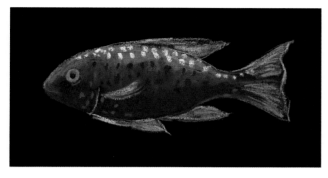

 Figure 4

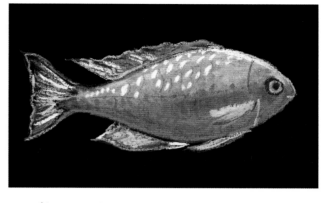

Figure 6

STEP 4

The final step is drawing the fine details and finishing touches. Let's go! Use ochre and russet to randomly add the details on the tail and fins. Do not blur them; let's leave these details unblurred to bring a lovely texture to the work. The drawing is already complete at this stage. But why not add a little more detail with a colored pencil? Using a light blue colored pencil, draw a pattern of fish scales (Figure 5). You can experiment with the pattern and try to add different elements, such as dots, lines and colors. You can let your creativity flourish here to create a truly interesting drawing. Then, with the same pencil, draw a few lines on the tail and fins, which will extend these elements and make them look neater. Figure 6 is a drawing made by following this lesson's instruction, but other colors were used and some of the details are different. You can also play around with the fish shape and change it slightly. But still, I recommend keeping the shape simple and recognizable. This project can be continued by adding details to the background scenery, such as seaweed, rocks and water lines.

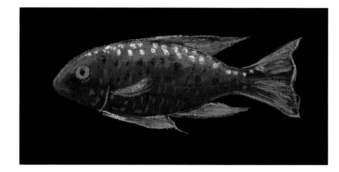

Figure 5

STEP 3

Let's make our fish look more interesting by adding some details and patterns. Using the overlaying technique, and following Figure 4, add white oil pastel on the top part of the body; Prussian blue to the middle of the body; and cobalt blue at the bottom of the head and body, under the eye and to show the mouth. All these details bring out just a great contrast to the drawing. Let's add more details to the drawing. Use the white crayon to draw the fin in the middle of the fish's body. Blur it, trying to blur in one direction to make the fin look neat. Using the overlaying technique, randomly draw more accents to the fins with the white crayon. Then, draw the center of the fish eye in Prussian blue. Basically, if you execute this project on black paper, it's not necessary to add the center of the eye, as it's already made by the background itself. But for the toned paper, draw it for sure.

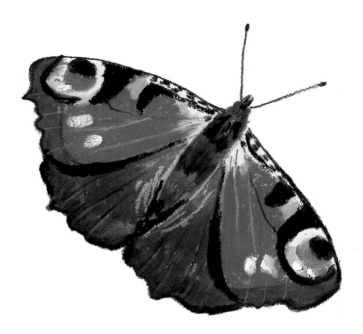

STUNNING PEACOCK BUTTERFLY

If you haven't tried to draw a butterfly with oil pastels, you'll be surprised at how beautiful the result can be. With oil pastels, it's super easy to re-create the wonderful patterns of the butterfly's wings, as well as gradients of some separate areas of these patterns. At the same time, oil pastels give an amazing texture that makes the final project absolutely beautiful. I especially love this project because it shows that it's possible to draw a little masterpiece with oil pastels in just a few easy steps, and in a short time. Now let's dive into the project and draw the stunning peacock butterfly.

SUPPLIES

- Paper (craft or white paper will work the best for this project)
- Blending stumps in different sizes
- Paper towel
- Pencil
- Eraser
- Lightbox (optional)

OIL PASTEL COLORS

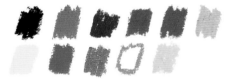

Black, Blue-purple (periwinkle blue), Brown, Carmine, Dark gray, Pastel purple (light purple-violet), Pastel yellow (pale yellow), Red (vermilion), Russet, White, Yellow

COLORED PENCIL COLORS

Black, Pastel salmon (flesh), Yellow (chrome yellow)

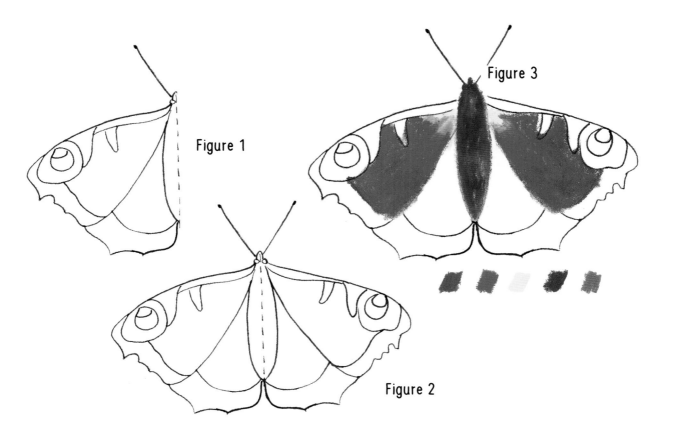

Figure 1

Figure 2

Figure 3

STEP 1

Let's get started by making a sketch. When drawing any butterfly in any style, it is especially important that the left and right wings be symmetrical. To achieve this effect, I advise you to follow the method I usually use. For this, draw an auxiliary preliminary sketch—it's one side of the butterfly (use the outline shown in Figure 1). Trace it onto the drawing paper you are going to use for the project, by using a window or lightbox. Then, flip the auxiliary preliminary sketch to its reverse side and trace once again to add the reversed part of the butterfly to your paper. This forms a perfectly symmetrical sketch of a peacock butterfly (see the sketch in Figure 2). Once the sketch is ready, we can proceed with coloring it.

Use russet and brown to fill in the body shape of the butterfly. Then, using a blending stump, blend the pigments of two colors to achieve a lovely and natural base layer (read more about blending on page 9). Once the body of the butterfly is ready, we can color the wings. The method I suggest you use is the gradation technique (read more about this on page 9) on the biggest areas of the wings and then fill the separate elements with the pure colors. Fill one top wing consistently with pastel yellow, red and carmine, as shown in Figure 3, and blend the colors to form a three-color gradient. Now, repeat all the coloring actions on its reverse top wing.

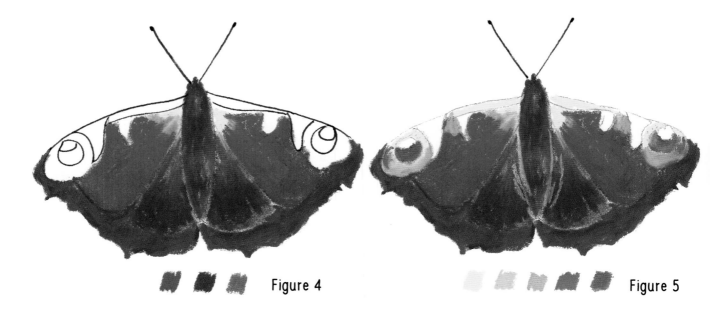

Figure 4

Figure 5

STEP 2

Let's move on. Let's color the bottom wings. First add russet and brown to both of those wings, then blend to achieve an even gradient (Figure 4). Now we can take care of the bottom of the wings. For this, carefully apply the dark gray and then blur the pigment, to make a solid and even layer (read more about blurring on page 8).

STEP 3

Your drawing, little by little, is turning into a beautiful butterfly. Go ahead and fill in the rest of the details of the base coat: I advise you start with adding details in pastel yellow to the top wing and peacock eye. Blur these elements with a blending stump. With the same color, using the overlaying technique, draw details around the butterfly's body; the outline and a few single strokes will be enough. Add russet and pastel purple to the peacock eye and blur the drawn elements. Apply yellow on the top wings and blue-purple to the peacock eye, just a bit, as shown in Figure 5. And of course, blur these colors.

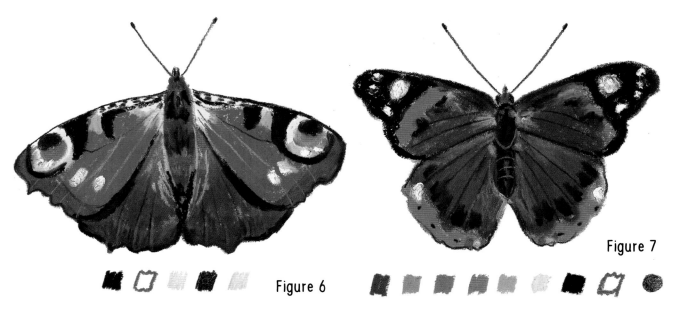

Figure 6

Figure 7

STEP 4

In this step, we add the details in black and white and also draw some additional touches with colored pencils. So, let's go. First, fill the rest of the details in black oil pastel in the top wings. Blur these elements carefully. Then, add shadows and outline in the thicker parts with the black crayon. These details do not blur.

NOTE: If it is too hard for you to make outlines with oil pastels you can use soft colored pencils for this purpose instead.

And finally, draw some strokes in black on the bottom wings and blur them. Now, use the white crayon and, with the overlaying technique, add details on the top wings. Please note that the oil pastels for this step should be very soft. To complete the drawing add details with a black colored pencil: antennae, the pattern on the pastel yellow parts, plus outlines. Basically, your drawing is done, but if you have more time, you can add some more details by using colored pencils. It will make the piece look really stunning.

For the top wings, use black, yellow and a pastel salmon–colored pencil. For the bottom part, I advise a black and a yellow pencil. Add those colors to the pattern on the wings of the butterfly as shown in Figure 6, using the overlaying technique.

Our masterpiece is done. This is a quick and fun project, and I hope you enjoy working on it. Keep practicing with drawing butterflies, using oil pastels. You can also try out drawing other butterflies with different wing patterns. It can be real butterflies or even some abstract ones. Have a look at the example in Figure 7. I used the main principles of this lesson and got this butterfly. Let's sum up: Start with filling the gradient parts, then add the solid-colored details and continue with layer details. Don't be afraid to use colored pencils to achieve a more realistic result.

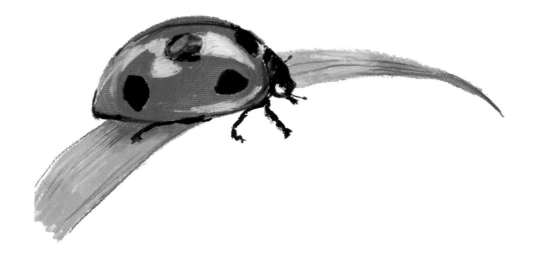

LADYBUG

I haven't met anyone who doesn't like a ladybug, also known as a ladybird. Despite the fact that this is an insect, everyone loves it. Ladybugs look sweet—their colors are super vivid and their shell looks shiny. The ladybug symbolizes luck and fulfilled wishes. So, I decided to include a drawing of a cute ladybug in this book. I have broken down the process of creating this wonderful beetle so that you can re-create the work, step by step. Let's go!

SUPPLIES

- White, toned or black paper
- Blending stumps in different sizes
- Paper towel
- Pencil
- Eraser
- Painting knife

OIL PASTEL COLORS

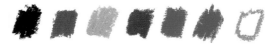

Black, Carmine, Light olive, Moss green, Red (vermilion), Scarlet, White

COLORED PENCIL COLORS

Black, Blue (Prussian blue)

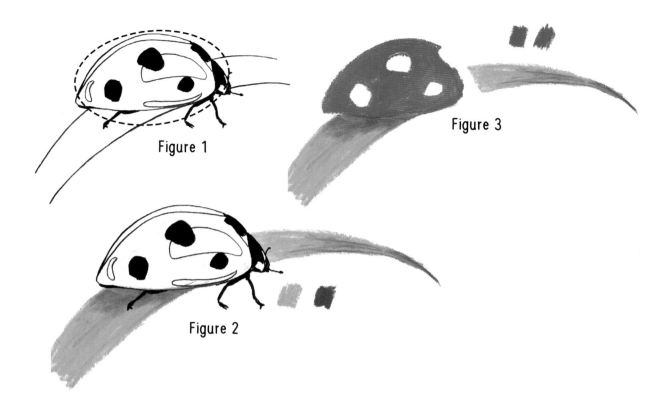

Figure 1

Figure 3

Figure 2

STEP 1

The first thing we need to do is to make a preliminary sketch. Draw an oval and then turn it into a ladybug outline. Complete the sketch by adding the details: spots on the ladybug shell, the legs, antennae and the stem of grass (see the sketch in Figure 1). Don't apply pressure with the pencil while sketching; draw a light, barely visible sketch. Once the sketch is ready, let's turn to the main work.

First of all, we need to color the grass. Use light olive to paint the blades of the grass. Then, blur the shape accurately (read more about blurring on page 8). Switch to moss green to add shadows to the grass, as shown in the example (Figure 2). Blend the freshly drawn shadow accents by using a blending stump (read more about blending on page 9).

STEP 2

Let's keep coloring the project. Add red and scarlet randomly to the shell shape of the insect (Figure 3), with the exception of spots; we will draw black spots in the next step. Blend these two tints of red to get a very smooth and even layer. Work especially accurately within the outline of the shape.

STEP 3

Now, we're ready to add black: Draw the head, the spots on the shell and legs, using the black oil pastel. Very gently and accurately blur all the black details with a blending stump.

NOTE: At this stage, you should work especially carefully, because the black oil pastel can easily mess up your work.

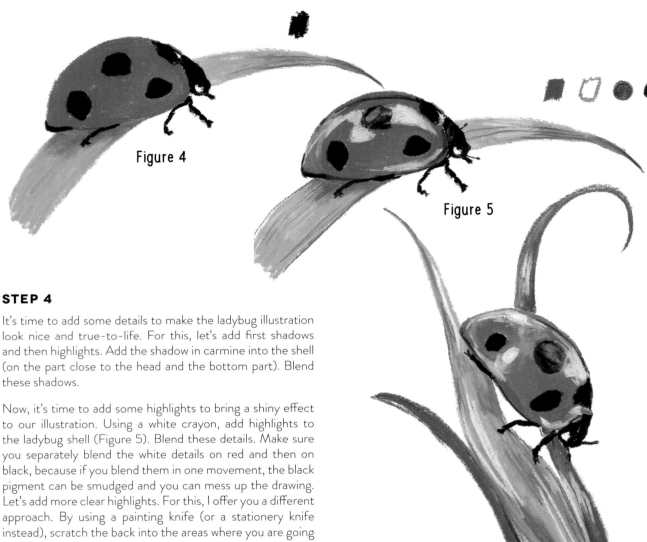

Figure 4

Figure 5

Figure 6

STEP 4

It's time to add some details to make the ladybug illustration look nice and true-to-life. For this, let's add first shadows and then highlights. Add the shadow in carmine into the shell (on the part close to the head and the bottom part). Blend these shadows.

Now, it's time to add some highlights to bring a shiny effect to our illustration. Using a white crayon, add highlights to the ladybug shell (Figure 5). Blend these details. Make sure you separately blend the white details on red and then on black, because if you blend them in one movement, the black pigment can be smudged and you can mess up the drawing. Let's add more clear highlights. For this, I offer you a different approach. By using a painting knife (or a stationery knife instead), scratch the back into the areas where you are going to add opaque highlights (read more about scratching on page 10). Once the areas are scratched, use the white crayon to draw some extra highlights. Basically, you can finish the work at this stage. But if you would like to make it look neater, let's keep working with colored pencils. Arm yourself with the Prussian blue pencil to draw the details on the legs, on the antennae and to add some details to the grass. Using the black pencil, draw the curve line on the top part of the ladybug shell (this separates the shell and wings). By practicing this lesson, you will not only learn how to create a beautiful and charming illustration, but also to master using oil pastels.

Look at Figure 6. It is very similar to the work in this project. However, you can see that I slightly changed the composition and added some extra grass stems. You can also experiment with the background and try to draw some close-up flowers instead of grass. Why not? So, unleash your imagination here and show your creativity.

EMPEROR PENGUIN

All penguins are adorable. We all love them because of their wobbly gait and cute look. And in this lesson, you will find a step-by-step guide on how to depict a penguin by using oil pastels. The project is a little more challenging, but with all the instructions, I am sure you will draw it and enjoy the process.

SUPPLIES

- White paper
- Blending stumps in different sizes
- Paper towel
- Pencil
- Eraser

OIL PASTEL COLORS

Black, Dark gray, Light gray, Orange-yellow (golden yellow), Prussian blue, Russet, White

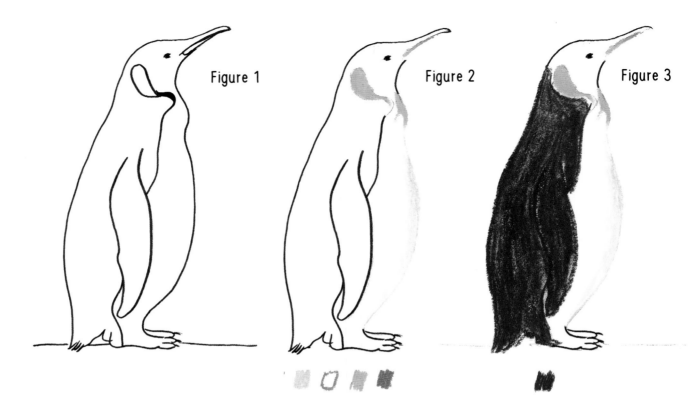

Figure 1

Figure 2

Figure 3

STEP 1

Let's get started with a pencil sketch. Take a look at Figure 1, which shows the outline of the penguin. Follow it to make a light pencil sketch on the paper. Draw the belly of the animal, using the gradation technique (read more about this on page 9). In this case, apply a radial gradient starting with light gray, add white and then blur them. When the belly is colored, we can use orange-yellow to color the head, neck and beak (Figure 2). Then, blur all the orange details accurately (read more about blurring on page 8). Now, add an accent on the beak, using russet. Blend it with the orange base (read more about blending on page 9).

STEP 2

Let's keep coloring the project. Switch to Prussian blue and color the back, wing and part of the neck of the penguin (Figure 3). Using a light hatching method (read more about this on page 11), work accurately, especially in the outline of the shape. Then, blur the shape.

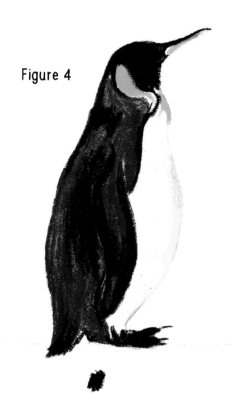

Figure 4

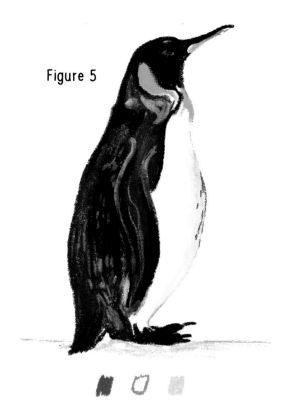

Figure 5

STEP 3

Draw the head, the top part of the beak and the feet and tail with the help of a black oil pastel (Figure 4). Very gently and accurately blur all the black areas with a blending stump. With the same color, draw some extra details: the outlines of the wing and the back, and the area on the neck. Blend those details with the blue base layer. Our penguin is pretty recognizable, so let's go to the final stage.

NOTE: Please be aware that oil pastels in black are very hard to draw with, because it stains and can make a mess and even spoil your work.

STEP 4

It's time to add some details and highlights. We will use the overlaying technique (read more about this on page 9) in this step and leave all the details without blurring. It will bring some texture and make the work look more interesting. First, draw details on the belly with dark gray. Then, switch to white and add the eye and details on the wing and body (Figure 5). With light gray, draw the snow and the accents on the penguin's body. Our drawing is done!

To sum up, I have to say that this project is pretty challenging, because you have to work accurately and consistently. So, I advise that you keep going and practice drawing the penguin in different poses or even a few penguins. Remember, practice makes everything better.

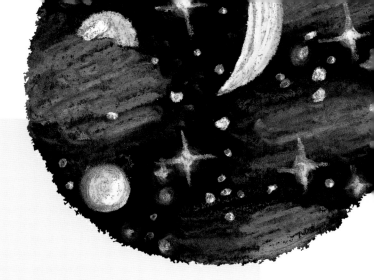

CUTE
Patterns

Patterns not only add a decorative touch to your surroundings, but they can also enhance your creativity. Exploring any new medium by drawing patterns is very helpful. In this way, you can focus on techniques and the process of creation, since the elements of the pattern are simple and easy to draw. In this chapter, I prepared several pattern projects, made in different styles, so you not only get a general idea of the pattern design, but you also get to try many beautiful styles.

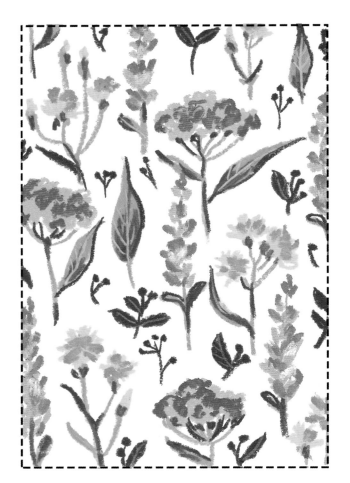

WILD HEALING FLOWERS

In this project, we'll draw a floral pattern in a vintage style. Practicing drawing flowers, especially wildflowers, is always a good idea. The shapes of these plants are usually pretty simple and they come in a diversity of colors. These make the drawing process so enjoyable. For this project, I used just two basic oil pastel techniques, so you could focus mainly on the process and get in a creative flow. Let's go!

SUPPLIES

- White or black paper
- Blending stumps
- Paper towel
- Masking tape (optional)

OIL PASTEL COLORS

Light olive, Mauve, Moss green, Olive, Orange, Pastel purple (light purple-violet), Pink, Purple, Yellow

COLORED PENCIL COLOR

White

NOTE: Toned paper is suitable for this project, too. But if you decide to draw on it, make sure the colors of the pattern elements are in contrast to the paper color.

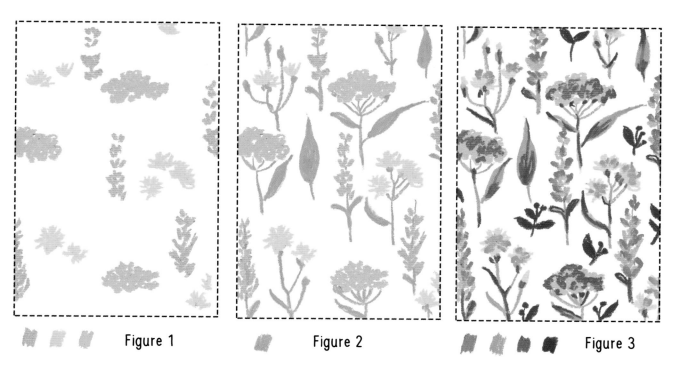

Figure 1 Figure 2 Figure 3

STEP 1

For this work, you don't need to draw a preliminary sketch of the pattern element. We'll use a freehand style of drawing without any sketching. However, you have to define a work area, using masking tape, if you are going to draw on a separate sheet of paper. If you execute the project in a sketchbook, skip using masking tape and just go ahead with the lesson instructions. Start adding the elements of the pattern. Using pastel purple, yellow and pink, draw the flowers' shapes as shown in Figure 1. Draw the elements with heavy pressure (read more about pressure on page 11) to get smooth shapes of the flowers, with rough outlines. If needed, blur the shapes inside with a blending stump (read more about blurring on page 8).

STEP 2

Let's move on and add stems and leaves to the flowers, using light olive (Figure 2). If needed, blur the shapes inside with a blending stump. As for the stems of the plants, try to make these lines thin.

STEP 3

The main work in this simple pattern is done. Now, we need to make the flowers look more lifelike. We'll add the second layer to each flower over each first base shape (Figure 3). Please note that the second layer should be darker but in a similar or close hue. We'll use the overlaying technique (read more about this on page 9) in this step. Add to the corresponding flowers and greenery:

- Mauve on pastel purple
- Orange on yellow
- Purple on pink
- Moss green on light olive

You don't need to blend these details. Just jump to the final step.

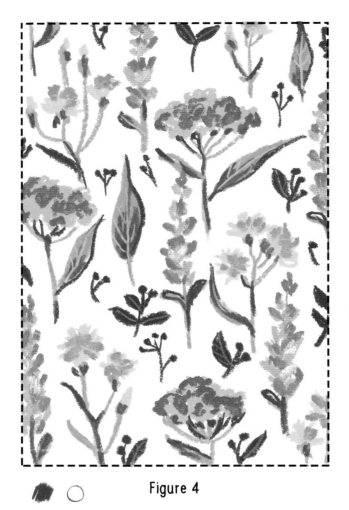

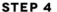

Figure 4

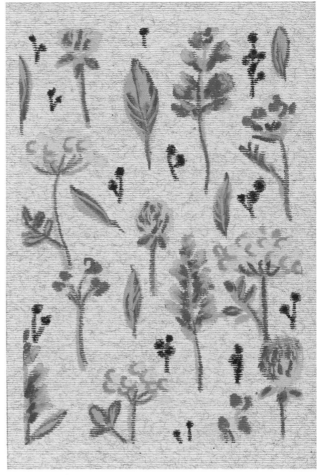

Figure 5

STEP 4

The pattern already looks great. And with the fine details, it will be completed. So, first of all, use the olive pastel to draw the small greenery (Figure 4). These tiny elements should be randomly spread in the pattern layout and at the same time fill all the free space. Well, it's not the easiest task. You should use a sharp part of the stick and draw them carefully. So, be patient. Then, use a white colored pencil to draw veins on the leaves of the pattern. Try to add them randomly, without any order. Once the veins have dried, remove the masking tape

(if using). Try to execute this project on toned paper. Figure 5 shows an example of such a pattern. The shapes of the flowers as well as colors were changed, but the method of drawing was kept. The textured surface of the toned paper strengthens the feeling of the vintage style of this pattern.

AUTUMN LEAVES

When autumn comes, we can enjoy this beautiful season full of colors, and of course, get inspired by it. This project is full of fall vibes and it is super simple to execute. You will learn by practicing how to mix colors of oil pastels and to experiment with shapes. Also, drawing such a project can be a great activity with kids. If you are ready, let's dive into the project and creative process.

SUPPLIES

- White or black paper
- Cloth for blending
- Blending stumps
- Paper towel
- Pencil
- Eraser
- Masking tape (optional)

OIL PASTEL COLORS

Brown, Light olive, Moss green, Ochre, Orange-red (flame red), Pastel yellow (pale yellow), Red (vermilion), White, Yellow

TIP: For this project, I suggest you use white or black paper. Toned paper may work as well. However, the paper should not be orange, beige or yellow, in which case contrast may be lost and the leaves will not be visible in the background.

Figure 1

STEP 1

Start by defining your work area. If you work with a sketchbook, it's not necessary to apply masking tape. Just follow the rest of the instructions. With a pencil, draw a light sketch (see Figure 1). Do not draw a detailed sketch. Outlines of the leaves are enough at this stage. In this project, we color the leaves with different colors and then blend them into one layer (read more about blending on page 9). In this step for coloring autumn leaves, let's combine the following colors:

- First color combination: yellow and light olive
- Next color combination: ochre, pastel yellow and orange-red

Please note that the colors are not spread evenly (Figure 2). For the first color combo, I used yellow as a base color. And for the second, it's ochre. You can decide by yourself which color dominates each color combination.

STEP 2

Let's move on to coloring the rest of the leaves. And again, we will apply the blending technique. This time, use light olive plus yellow and pastel yellow plus orange-red. Once you deal with all the leaves, add berries in red (Figure 3). For this, use a sharp part of the oil pastel crayon and draw by pressing hard (read more about pressure on page 11). If needed, blur the berries' shapes accurately with a blending stump (read more about blurring on page 8).

Figure 2

Figure 3

STEP 3

The base of our pattern is ready and we can make its elements look more interesting. For this, draw veins on the leaves with brown and then blend them. Then, draw highlights on the berries with white oil pastel. Make each highlighted area with one heavy pressure of the oil pastel stick. And don't forget to draw the berries' little stalks in brown. Not for all berries, but for some would be great touches.

Figure 4

Figure 6

Figure 5

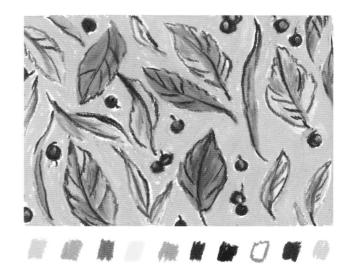

Figure 7

STEP 4

Draw details on the leaves with brown and moss green, using the overlaying technique (Figure 5). Add these details randomly to get a freshness to the work. Remove the masking tape (if using) and here is your sweet pattern!

If you would like to keep working with this lesson, experiment with the shapes and colors of the pattern elements (Figure 6). You can find inspiration in nature and explore the shapes and colors of leaves in autumn. Maybe add some extra elements to your pattern, such as acorns or some seeds.

Then, try to add the background for this drawing with a pastel tint. When you choose the background color, make sure that the background color pops against the leaves and the contrast will not be lost.

Figure 7 shows an example of a pattern that I painted using this lesson's methods. I slightly changed the color combinations and also added the background in a tender, soft tint—salmon. After you draw the background, blur it accurately, and make some corrections with brown, if needed.

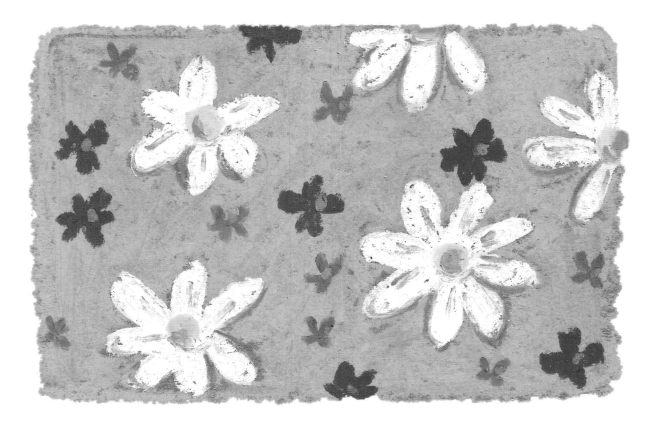

GARDEN FLOWERS

Floral patterns are a wonderful subject for learning and practicing new mediums. These types of patterns are super quick and simple to do, and extremely charming. You don't need to focus on making a preliminary sketch or drawing complicated shapes. You will need to draw only a few simple shapes and apply the basic techniques. That's it, and your sweet pattern will be done. Let's have a look at how to do it step by step.

SUPPLIES

- Toned paper
- Blending stumps
- Paper towel
- Masking tape (optional)

OIL PASTEL COLORS

Gray, Mauve, Orange, Pink, Purple, White, Yellow

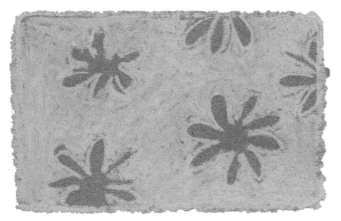

 Figure 1

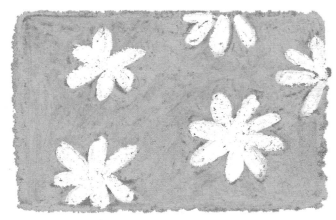

 Figure 2

STEP 1

For this project, you don't need to make a preliminary sketch. Just define a working area and start to draw the pattern. For defining the working area, I offer you two ways. If you prefer the perfect edges, you can use masking tape and define the pattern by securing it on the paper. I will use another way. It's drawing the edges of the pattern in a freehand style. For this, you need to draw a rectangle, using the color of the background. In our case, the background color is pink.

Once the pattern area is defined, draw the outlines of big flowers inside it (Figure 1). Then, with the background color (pink), fill in the space around the flowers. If needed, blur the background carefully (read more about blurring on page 8).

STEP 2

Use white to draw the big flowers in the areas we reserved for them in step 1 (Figure 2). These flowers look like daisies. Basically, for this type of pattern, you can draw abstract flowers or any real ones. Blur the flower shapes inside, if needed. But if you use heavy-pressure drawing (read more about pressure on page 11), I think the blurring is not needed.

NOTE: Take care with the white crayon. It should be absolutely clean every time you draw a new flower. It's especially important if you would like your pattern to look pretty and accurate, and not messy.

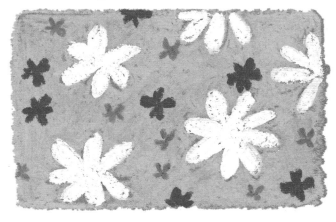

 Figure 3

STEP 3

Let's move on. Now use mauve and purple to randomly draw the small flowers on top of the pink layer (Figure 3), using the overlaying technique (read more about this on page 9). Once these are done, jump to the next step.

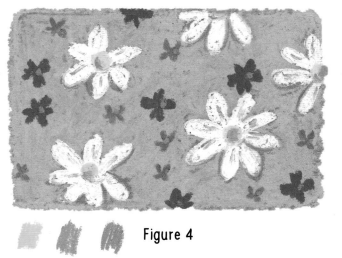

Figure 4

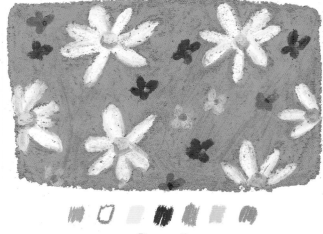

Figure 5

STEP 4

Last, we will add fine details; we'll use the overlaying technique in this step. So, arm yourself with yellow and draw the centers of the daisies. Then, switch to orange and add these centers' accents—one touch of orange on each center. With the same color, draw the centers on the small flowers. And finally, use gray to add the fine details on the daisies' petals and to draw their outline, but from the bottom only (Figure 4). It will look as if these are shadows from the daisies in the background. If you use masking tape, remove it and voilà! Our cute pattern is done.

In Figure 5, you can find another pattern based on the method of this lesson. Experiment with your own designs of the floral pattern: change colors and play with different flower shapes. By practicing this lesson, you can learn to feel the rhythm of the composition, and of course, feel more confident drawing with oil pastels.

SERENE, ABSTRACT WAVES

This is one of my favorite projects in this book because it's so relaxing to draw. And I'm sure you will enjoy each minute of the creation process. Oil pastel is just the perfect medium to draw smooth abstract shapes and designs, and the results are sure to be beautiful every time.

SUPPLIES

- White paper
- Cloth for blending
- Blending stumps (optional)
- Paper towel
- Pencil
- Eraser
- Masking tape

OIL PASTEL COLORS

Blue-purple (periwinkle blue), Mauve, Pastel purple (light purple-violet), Pink, Purple, Salmon, Salmon pink, Sky blue

NOTE: You can use any color of paper. But if you plan to hang a piece on the wall, I advise white paper.

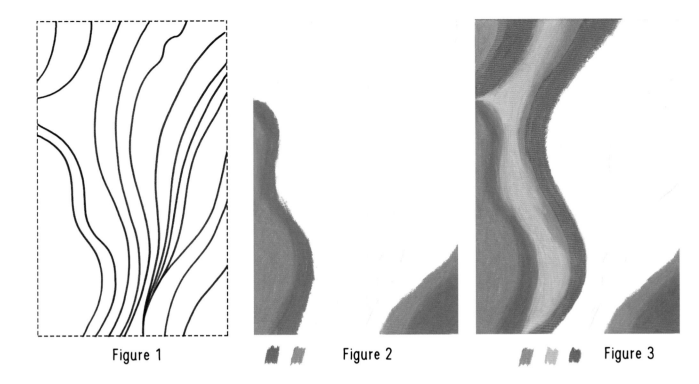

Figure 1

Figure 2

Figure 3

STEP 1

TIP: For practicing this lesson, choose a big piece of paper. I recommend you choose at least letter size (8½ x 11 inches, or A4). There are two main reasons for doing so. The first reason is that it will encourage you to practice your blurring and blending pigment skills with ease (the larger the surface area, the bigger space there is on your paper to create unique shapes and transitions). And second, because you might decide to hang your final artwork in your home or workplace, as it's a pretty cool design!

Before beginning to draw, use masking tape to define the drawing area on the paper. Draw a design with your pencil, following the outline of this abstract work (see Figure 1). The drawing should be light and sketchy in nature, to give you an understanding of where each color zone is and a little of what it will look like when we're finished. In this project, we'll use mostly blurring (read more about this on page 8) for blurring each color zone inside and then blending (read more about this on page 9), to unite two color zones smoothly.

So, let's start coloring our piece. Use blue-purple and mauve to fill the areas as shown in Figure 2. Blur each zone and then blend their transitions. You need to get two smooth-colored zones at the end of this stage. You can use a cloth for blending purposes, or just the tips of your fingers. Try to make these movements follow the shapes of the zones.

STEP 2

Following the same principles as we applied in step 1, use mauve, pastel purple and purple to add more colored zones. Use as a reference the example in Figure 3.

Figure 4a

Figure 4b

Figure 5

STEP 3

Let's continue to add colors to the scene with sky blue, pink, salmon and salmon pink. Draw them into the work using the same steps we followed in steps 1 and 2. Refer to an example drawing in Figure 4a for guidance. Our working area should be fully filled with colored waves. Now, we can just add some extra touches to make it look even more stunning.

STEP 4

It's time to add some details. In this case, they will be curved lines. I recommend following the next rules in this stage. First, the lines should be visible in the background. For this, draw with a light pastel tint on more saturated areas, and vice versa. For example, on blue-purple, draw lines using pastel purple (Figure 4a); and on pastel purple, use blue-purple or mauve (Figure 4b). The second rule: Blend these lines a little with a cloth. And finally, don't add too many lines in this step, as this may make a mess in your artwork. Following these rules, add curved lines over the base layer, using mauve, pastel purple, pink and salmon. Remove the masking tape and your masterpiece is done.

What I really love about this project is how versatile it is. There are so many colors that you can experiment with and a huge variety of abstract art patterns that can be created. Plus, the color wheel is really useful when it comes to picking the tints and shades for your palette. So, use the tints that are next to a friend on the color wheel and limit the colors for your palette. You can also play with the shapes of a new drawing. I recommend keeping the colors' shapes wavy, but surely, you can change the entire composition (see Figure 5). Take your time and try out different ways of molding this idea.

WINTER BOTANICALS

Let's dive into the winter and a Christmas mood by executing this festive project. We'll draw a winter-inspired pattern on black paper. If you're new to working with oil pastels, don't panic! Here, you can find a lot of helpful information and tips, and of course, the instructions are broken down into four easy steps. Through this lesson, you will be able to practice one special oil pastel technique and achieve an eye-catching final result. Once you have finished reading about and practicing this material, you'll be able to teach your children or friends how to draw such a pattern, and spread the happy mood around you.

SUPPLIES

- Black or any dark toned paper
- Blending stumps
- Paper towel
- Masking tape (optional)
- Painting knife
- Pencil (optional)

OIL PASTEL COLORS

Blue-purple (periwinkle blue), Brown, Grass green, Jade green, Light olive, Ochre, Pastel purple (light purple-violet), Scarlet, White

Figure 1

Figure 2

Figure 3

STEP 1

For this drawing project, you don't have to draw an initial sketch—but do remember to define the area you want to work in. Your choices are:

- Defining the rectangular border with masking tape
- Marking the corners of your rectangle with a pencil
- Drawing on a separate black paper or sketch pad

Let's go with filling the pattern with its elements. Basically, the elements of this pattern can be any wintry botanical things or even Christmas decorations. For this project, I chose pine cones, branches with berries, leaves and snowflakes (see Figure 1). Using ochre, draw the pine cones, applying a heavy-pressure method of drawing (read more about pressure on page 11). Then, using a sharply pointed ochre crayon, draw the pine branches. Try to make them as thin as possible. Switch to grass green and add pine needles to each branch (Figure 2).

STEP 2

We'll now add berry branches. Use the ochre for this, trying to spread them evenly in the pattern background. Then, use light olive to add some branches' leaves. The berry branches will be of two types: with red berries and leaves, and with berries in blueish tints. With pastel purple and blue-purple, draw berries onto the branches without leaves (Figure 3). Then, switch to scarlet and draw the rest of the berries. The berries should be added randomly in different quantities.

Figure 4

Figure 5

Figure 6

STEP 3

In this step, we'll not draw with any color. Instead, we employ the scratching technique (read more about this on page 10). Use a painting knife to scratch the natural pattern of the pine cones (Figure 4).

TIP: Each time you scratch, clean the painting knife so that the remnants of the oil pastel do not transfer to other elements of the pattern.

With the same technique, add veins on the leaves of the red berry branches. Once all the details are scratched, you can jump into step 4.

TIP: If you don't have a special painting knife, you can use a stationery knife or something sharp, like a toothpick. If your kids are working on this project, offer them a pencil to scratch the details, and of course, watch them during the process.

STEP 4

The pattern already looks pretty festive, but there's still a little bit more you can add. Using brown, draw little spots on the pine cones, using the overlaying technique (read more about this on page 9). Continuing with the overlaying technique, arm yourself with jade green and draw leaves in the free space of the pattern, then, using white, draw highlights on the red berries (Figure 5). And finally, with white, draw the snow all around the pattern.

Well, that's it. And I think we did a pretty good job. We made our pattern and it turned out wonderful. I really love it because it's super easy to make without any drawing or artistic skills whatsoever! And the best part is, you have endless options for ways to personalize this project. Why not try making some of them? It could be a greeting card or wrapping paper, with any design you wish to come up with. In Figure 6, you can find one example of a greeting card based on this lesson.

MOON AND STARS

This project shows that drawing on black paper with oil pastels is something that everyone has to try out. This starry pattern is so easy to draw and you don't need to spend hours to get an impressive piece of art. In 15 to 20 minutes, your little masterpiece is ready. Follow my instructions and have fun!

SUPPLIES

- Black paper
- Cloth for blending
- Blending stumps
- Paper towel
- Masking tape

OIL PASTEL COLORS

Pastel purple (light purple-violet), Pastel yellow (pale yellow), Sky blue, White, Yellow

NOTE: For this project, I advise you to draw on a big piece of paper. It should be at least 8½ x 11 inches (or A4) or larger. It will allow you to practice drawing stars, which are pretty difficult to depict with a crayon on a small area.

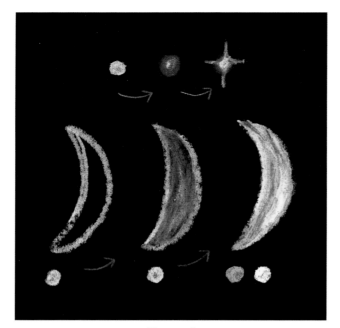

Figure 1

STEP 1

Let's make some magic by using oil pastels and black paper. For this project, you don't need to make a preliminary sketch. We mostly will focus on drawing techniques and will draw freehand. But, anyway, I recommend you secure the paper by using masking tape. It defines the working area and will also make it easy to add the first layer. With pastel purple and sky blue, draw the fog areas by using side hatching (read more about hatching on page 11). Blur these areas with a cloth (read more about blurring on page 8). Those colors may overlap each other; however, try to keep them transparent (Figure 2). Add one more layer in the same colors on top of the already colored areas, but this time just a little and randomly, using heavy pressure (read more about pressure on page 11). And again, blur them with a cloth.

Figure 2

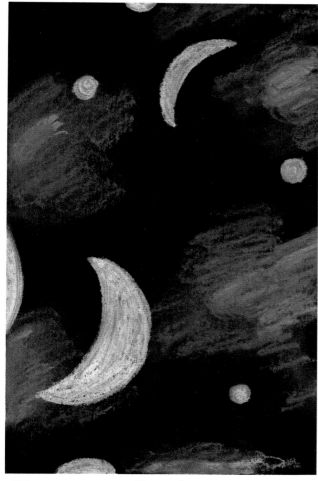

Figure 3

Figure 4

STEP 2

The base for our pattern is done. Now, let's draw moons and little planets. First, a little guide to help you figure out how to draw these elements: Please take a look at Figure 1. Draw the outline of the moon or a planet with pastel yellow. Fill inside the shape with the same color. Then, gently blur it. And finally, add yellow accents on top. After that, blend the yellow with pastel yellow (read more about blending on page 9). In this manner, draw a few moons and planets as shown in the example (Figure 3) or add the elements to the pattern by using your imagination.

STEP 3

Let's add the shiny stars to our composition. For this, I prepared for you the method that is shown in Figure 1 and have broken it up into a few stages. Draw a circle in any pastel tint of yellow, blue or white (in our case we will use pastel yellow). Then, blur it with gentle circular movements. And finally, with pastel yellow, draw the star on top, using the overlaying technique (read more about this on page 9). If needed, you can blur the star accurately by using a blending stump to make the result clearer. Using this method, draw random stars in the background in pastel yellow (Figure 4). Once the stars are added, you can proceed with the last step.

STEP 4

We are at the final stage of creating this magical pattern. To complete the work, with white, using the overlaying technique, draw small dots and spots randomly around the stars, moons and planets (Figure 5). The point of these details is to fill space and to create a harmonious composition. Continuing with white, draw some accents on the moons and planets. Once all these details are added, remove the masking tape. Your magical starry pattern is finished.

By using the principles of this lesson, you can practice and play with composition and learn to feel the rhythm of it. You can also try this method for drawing the background or even a separate illustration, such as in Figure 6. Use your imagination and let your creativity flourish here.

Figure 5

Figure 6

FUN RAINBOWS

If you are looking for a project to relax with and enjoy the process, I definitely recommend you try this one. This lesson is joyful, easy and quick— a perfect lesson to try out oil pastels if it's a new medium for you. If you already practice drawing with oil pastels, I'm sure you will enjoy it too. Let's draw a pattern of rainbows, step by step.

SUPPLIES

- Toned or black paper
- Blending stumps
- Paper towel
- Masking tape (optional)

OIL PASTEL COLORS

Lilac, Orange, Pink, Purple, Red (vermilion), Sky blue, White, Yellow

 Figure 1

 Figure 2

STEP 1

For this project, a sketch is not required. However, you need to define the area of the drawing. For this, apply masking tape. If you use a separate sheet of paper or page of a sketchbook, masking tape is not necessary. Let's draw our rainbows. We'll draw a rainbow of one type, and with the same principles, will add more rainbows. Use lilac, yellow, red and pink, one by one, to draw a rainbow shape (Figure 1). Try to make each curved line with one drawing movement by pressing hard (read more about pressure on page 11), then blur each color separately by using a blending stump (read more about blurring on page 8). Repeat to draw three more rainbows. Their sizes and shapes may vary, but keep the same colors.

NOTE: In this project, we will use only the blurring technique.

STEP 2

Let's change the colors and draw more rainbows for our sweet pattern. Using yellow, red, pink and orange, one by one, draw another rainbow (Figure 2). Once again, blur each color separately by using a blending stump. Draw two more rainbows in these same colors.

 Figure 3

STEP 3

In this step, we will repeat the same concept we used in steps 1 and 2, but just apply different colors. Using pink, purple and lilac, one by one, draw four little rainbows as shown in Figure 3. Don't forget to blur each colored curve of the rainbows. And once all is done, jump ahead to complete the project.

 Figure 4

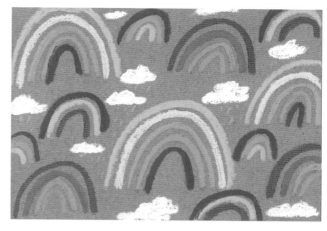

 Figure 5

STEP 4

And now let's add the clouds to the pattern. Using white, draw clouds to fill the space between the rainbows (Figure 4).

The last stage in this project is to add some spots in sky blue. These are actually stylized drops of rain. I think those details will complete the pattern and make it look balanced in size and color. Using sky blue, draw drops under each cloud. The drops have to be drawn in one direction, but at the same time, add them randomly.

I hope you like the lesson and enjoy it as much as I do. There are so many options you can play with in this project:

- You can change colors. But at the same time, I recommend you limit the colors.

- Change the shapes and sizes of the rainbows, but keep the sequence of colors and shapes for each rainbow type.

- Experiment with details. Try to draw hearts, spots and other elements.

Take a look at the pattern in Figure 5. It shows an example of the project by using this lesson's instruction, but with different shapes and colors.

MIXED-MEDIUM
Projects

And finally, by way of a dessert, I have prepared for you a small selection of projects that are fundamentally different from all the other chapters in this book. This time, I suggest that you mix oil pastels with other mediums, such as watercolor and gouache, to create something brand-new! By practicing you will be able to try out how each material works with one another and the final pieces will give off a completely different feeling from the other projects' works.

BLOOMING SAKURA
(watercolor & oil pastel)

Watercolor is an amazing art medium to make beautiful layers. Using watercolor, the pigments are mixed naturally and it has the ability to produce transparency and at the same time deep colors. When oil pastel is added, it can bring wonderful texture, and if you manipulate colors in the right way, you can make the color of the work pop and take it to another level. Let's create a beautiful piece of blooming sakura step by step, using watercolor and oil pastels!

SUPPLIES

- Watercolor paper
- Blending stumps
- Paper towel
- Masking tape (optional)
- Round brush sizes: medium 6–8; large 10–16
- Mixing palette or plate
- Two glasses of water

NOTES: For this lesson, use watercolor paper with a weight of at least 300 gsm, hot or cold pressed. If you use the hot-pressed watercolor paper, the final result of the details will be smoother compared with cold-pressed paper.

Make sure your medium round brush has a fine tip. It allows you to make beautiful thin lines and fine details.

OIL PASTEL COLORS

Carmine, Olive, Pink, Russet, White, Yellow

WATERCOLOR COLORS

Alizarin crimson, Burnt sienna, Burnt umber, Permanent sap green, Winsor blue (green shade), Winsor green (yellow shade)

 Figure 1

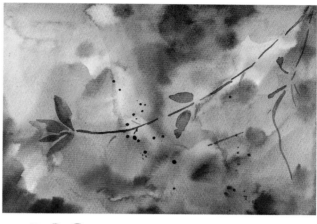

 Figure 2

STEP 1

Secure the paper to your board or table with masking tape, because we will be using the painting-on-wet technique. This will keep the paper from wrinkling while painting. For this project, a sketch is not required, so we can begin with the painting process.

NOTE: If you use a glued pad of watercolor paper, you don't need masking tape.

Let's begin with preparing the watercolors for this work. If you use watercolor in tubes, squeeze a little pigment onto the palette or plate; if using solid watercolor, spray water onto the color pans. We'll begin by making the background. Use a big round brush (size 10–16) to moisten the working area with clean water. There should not be so much water that you get a surplus, but not too little, either. Keep working with the same brush. Start to add permanent sap green, Winsor green, Winsor blue and alizarin crimson on the wet layer. The consistency of the paint should be medium. For this, you can use Figure 1 as a reference. Or you can make a design of your own on the base layer. Allow the layer to dry.

TIP: Don't make unnecessary movements with the brush. Just soft touches are enough. The paint should spread itself over the wet surface.

STEP 2

Basically, you can already start to draw on top of this base coat layer with oil pastels. However, I think you can paint a thin and elegant branch with the fine-tipped brush. And so, we will keep working with watercolor. Arm yourself with a medium brush (size 6–8) and, with burnt umber (use a thick consistency of the paint), paint the sakura branch as well as the stems of the blossom (Figure 2). Then, add the leaves in burnt sienna; the consistency of this paint should be medium. Finally, add splattering using Winsor blue—take just a little pigment on the medium round brush and flick it onto the painting. Let the painting dry completely.

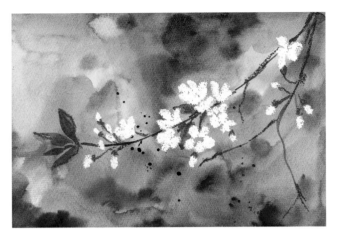

 Figure 3

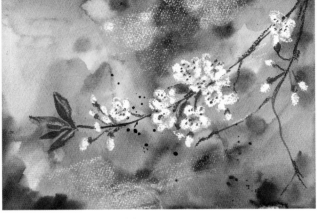

 Figure 4

STEP 3

And now we can start the most pleasant part—drawing with oil pastels. With white, using heavy pressure (read more about pressure on page 11), draw the cherry blossom. Using a blending stump, blur little petals (read more about blurring on page 8). It makes sense especially if you use a textured cold-pressed watercolor paper. Then, use olive to draw some extra stems and to correct the branch, using the pointed part of the crayon. Switch to russet to add details on the leaves and draw sepals on the buds (Figure 3).

STEP 4

Let's complete our piece. Now, we'll draw details. First, using pink, add accents on the blossom. Then, blend these details very carefully with white (read more about blending on page 9). Switch to carmine and draw the centers of the opened flowers, and blend these details. With the same color, using the pointed part of the crayon, draw the anthers. Try to make them as thin as possible. Finally, use yellow to add details on the leaves and spots on the top of the anthers.

The sakura blossom picture is ready. But if you take a white crayon and randomly draw some accents on the background it will make the work look even more charming and completed (Figure 4). Don't overdo a piece with details—less is more here.

I hope that you will like this lesson and it shows you how effective it can be to mix two art mediums by using their stronger aspects. It's a very fun and creative project. And you can use its principles for creating your own masterpieces. Feel free to experiment with the colors. Also, do not deny yourself the pleasure of playing with different themes and portraying them with this method. Why not draw a landscape or a food painting? Allow yourself to be creative and enjoy the process of painting!

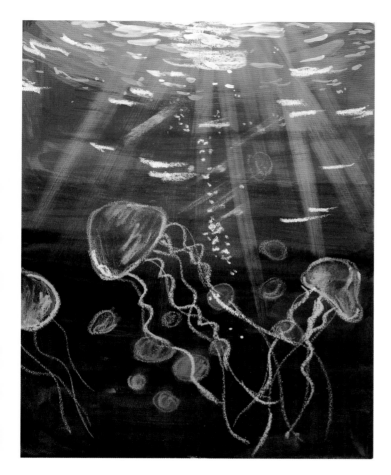

DANCING JELLYFISH
(gouache & oil pastel)

I'm so excited to share this beautiful project with you. Gouache has the ability to paint from dark to light and vice versa. That makes gouache such a versatile material. And the oil pastels are phenomenal with its texture. In this lesson, I will show you a great example of how to use these two mediums to create a beautiful art piece.

SUPPLIES

- Paper
- Blending stumps
- Masking tape
- Paper towel
- Filbert brush size: large 10
- Round brush size: small 3
- Glass of water
- Mixing palette

OIL PASTEL COLORS

Light gray, Pastel purple (light purple-violet), Turquoise blue, White

GOUACHE COLORS

Blue 1, Blue 2, Dark blue, Primary blue, Ultramarine, White

NOTE: For this lesson, it is best to use watercolor paper or thick drawing paper (its weight should be at least 200 gsm).

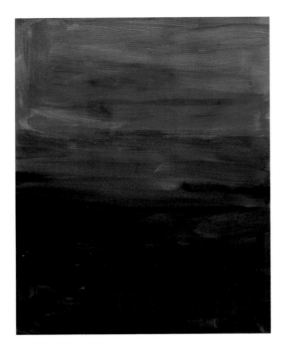

Figure 1

STEP 1

NOTE: When you paint with gouache, your brush should always be moistened but not wet. The exception would be for the dry-brush technique.

First, secure the paper to your board or table with masking tape, to define the painting area. This will also keep the paper from curving and make the edges of the picture flat. Next, let's prepare the gouache colors. Squeeze primary blue and ultramarine onto the palette. We will also need dark blue; for this, mix ivory black with ultramarine in the proportion of 1:3. Use the large filbert brush (size 10) to start making the gradient (read more about gradation on page 9). Add primary blue in the upper part of the working area. Then, start painting from the middle with ultramarine. Little by little, add each color from their sides before blending them together in the middle. This is the top part of our gradient. For the bottom, add the dark blue from the bottom. Then, blend it with the ultramarine. In this way, you should get a beautiful three-color gradient (see Figure 1). Let the layer dry completely.

TIP: While painting, make flowing horizontal movements with the brush.

STEP 2

In this step, we'll keep working with gouache to complete the base layer. Squeeze a little white gouache onto the palette. Then, mix the following combinations of white and primary blue:

- Blue 1 (white to primary blue in the proportion of 1:1)
- Blue 2 (white to primary blue in the proportion of 3:1)

With blue 1, paint in the upper part the round zone of the light, using the filbert brush (Figure 2). If you want to make it look smoother, you can paint the semicircle and then start blurring the paint until it blends with the base layer. Then, with the same brush using the dry-brush method (see Tip), draw the rays in blue 1.

TIP: For the dry-brush method, you should moisten the brush with water, then remove most of the moisture by wiping the brush with a paper towel. Next, place some thick gouache paint on the brush.

Finally, add the light shine of the water with white gouache, using the filbert brush. Then, switch to the small round brush (size 3) and draw shine details, using blue 2 as well as white. These can be spots, dashes or short waves. Let all the details dry completely.

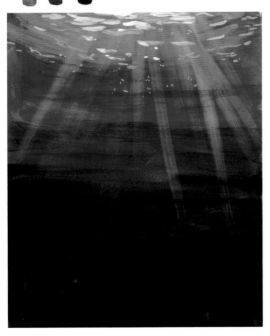

Figure 2

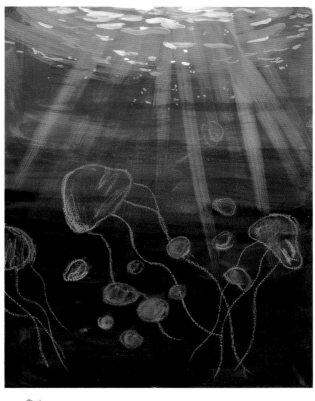

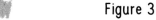

Figure 3

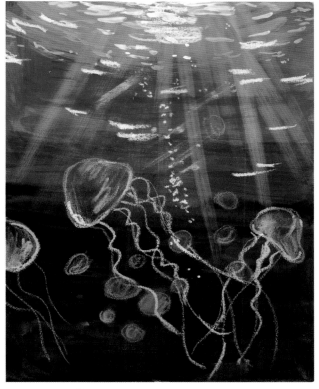

Figure 4

STEP 3

The base layer using gouache is ready. The colors of blues look deep and contrast with highlights. We can now begin to work with oil pastels. Use a turquoise blue crayon to draw the shapes of the jellyfish as well as their tentacles (Figure 3). Please note that there are two types of jellyfish in the work: in the front and in the background. For those that are far away, I don't recommend drawing tentacles. Take a cloth for blending and lightly blur the jellyfish in the background (read more about blurring on page 8).

STEP 4

It's time to add some fine details to the jellyfish. Using white, light gray and pastel purple, you can add tentacles, emphasize the shapes, add colored accents, and so on (Figure 4). Blur these with a blending stump if you would like the details to look smoother. The final touch in this lesson is to add extra shine to the water in the upper part of the scenery. Draw these details randomly, using white oil pastel. Remove the masking tape and here is your dancing jellyfish!

This is just an example of how oil pastels and gouache can be combined. Use your imagination to create more pieces using this pair of mediums—there are no limits in art creation. Remember that because gouache is a water-soluble medium, you can't apply it successfully over oil pastels, but you can draw over the gouache layer with oil pastels.

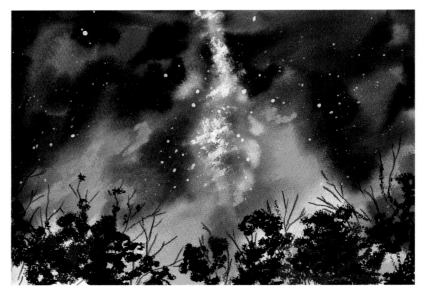

MILKY WAY
(gouache, watercolor & oil pastel)

This project is unlike any other. We will be exploring three mediums at once: mixing watercolor, gouache and oil pastels, which requires a completely different kind of creativity. Throughout the following pages, I will share just one example with you, but you can see how to make the absolute most of each separate material. If you are ready to begin this journey, let's get started!

SUPPLIES

- Watercolor paper
- Cloth for blending
- Blending stumps
- Paper towel
- Masking tape
- Flat brush (optional)
- Round brush sizes: medium 6–9; large 10–16
- Mixing palette
- Two glasses of water

OIL PASTEL COLORS

Black, Pastel purple (light purple-violet), Pink, Prussian blue, Turquoise blue, Turquoise green, White

GOUACHE COLOR

White

WATERCOLOR COLORS

Cobalt blue, Indigo, Viridian

COLORED PENCIL COLORS (OPTIONAL)

Black or Dark blue

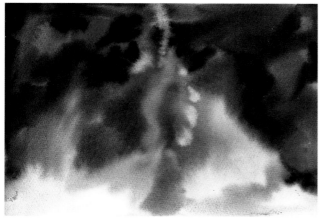

Figure 1

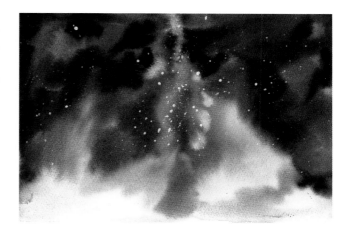

Figure 2

STEP 1

To begin, secure the paper to your table or a board with masking tape. Doing so will keep it from bending or curving while you draw and will make it easier for the edges to be straight when you're finished.

TIP: If you use a glued pad of watercolor paper, you don't need masking tape.

NOTE: The paper used in this lesson is watercolor paper. It has a great density, which will allow for better results than using other lesser-quality papers. Use watercolor paper with a weight of at least 300 gsm.

We'll not make a sketch, to instead focus on the coloring process. Begin with preparing the colors of the watercolor. If you use watercolor in tubes, squeeze a little indigo and cobalt blue onto the palette or a plate; or if you use solid watercolor, spray water on the pans. We will also need a blue-green tint—for this, mix cobalt blue with viridian. Once the colors are ready, wash the paper with clean water, but make sure not to use too much, just enough to apply paint to a wet surface. For this purpose, select a flat brush or a large round brush (size 10–16). Then on the wet layer, start adding the watercolors we've prepared earlier. The consistency of the paint should be thick and rich. Add in the upper part of the piece. Then, add the blue-green tint in the center, and add indigo and cobalt blue from the sides (Figure 1). At the bottom, try to make the layer transparent. For this, add a little of each color thinned to a watery consistency.

TIP: You can still add the paint of each color if the layer is not dry and you think you need to bring more depth to your work.

I advise you to now use white gouache to add a few touches in the center of the work, to imitate the Milky Way. After the first layer is ready, allow it to dry.

STEP 2

Once the base layer is dry, we can add the stars, using the splattering technique, using white gouache and a medium round brush (size 6–9). Take a little pigment on the brush and flick it on the painting (Figure 2). Add splatter only in the top and middle parts of the work. Avoid splatters on the bottom part. You can put a paper towel on this area to protect it. Repeat these actions until you get the effect of the night sky full of stars.

TIP: You can also make splatter patterns by applying white gouache to a toothbrush and splattering it on your surface.

Let the gouache splatters dry, then proceed with the next step.

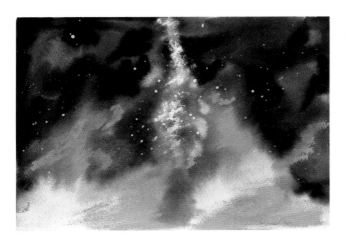

 Figure 3

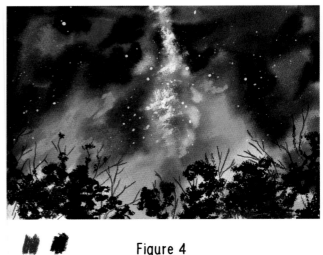 Figure 4

STEP 3

In this step, we'll draw with oil pastels on top of the beautiful background we've made with watercolor and gouache. Use pastel purple and pink on the bottom part; add turquoise green and turquoise blue in the center (Figure 3). Then, blur these colored areas gently (read more about blurring on page 8). The last part of this step is to add a little more accent of stars shining in the center, to emphasize the Milky Way. For this, use a white oil pastel to draw a few touches in the center, then blur them.

STEP 4

At this moment, the work looks pretty abstract. Sometimes, adding just one element, a little hint, can help a viewer immediately guess what the artist meant. Let's add the silhouette of the top of the trees. For this, use Prussian blue and black to draw the crowns' silhouettes (Figure 4). Then blend these elements (read more about blending on page 9). And finally, using the pointed parts of the Prussian blue and black crayons, draw branches of the trees. Try to make them as thin as possible.

TIP: If it is too hard to draw these kinds of fine details, you can use a black or dark blue colored pencil to draw the tree branches.

With this tutorial, you will have the ability to paint unique and beautiful art. It is exciting to paint because it does not require a lot of time or detail. Working in multiple mediums is a great opportunity to experiment with color and design. Practice is the key to perfection, of course. So, why not get started right away? And always, have fun while creating.

SUPPLIES

OIL PASTEL

The first and the most important thing you need to get started with oil pastels is a set of pastel sticks. So, take care of your oil pastels first, before buying other supplies. Artists' oil pastels are usually sold by the set, but they're also available for purchase in single sticks in a huge range of colors. I advise you to purchase at least a 48-color set. I also suggest picking up an extra white oil pastel—that color tends to be used more than any of the others and it can subsequently run out quickly. Oil pastels are available for purchase in a variety of levels, including high-quality (professional) oil pastels and inexpensive (student) oil pastels. Despite the cost, both options are suitable for exploring materials and making unique pieces. However, I recommend that you buy professional-quality oil pastels. It's a good investment and I'm sure you will never regret this. **Very soft, hard** or **soft** oil pastels are three categories of oil pastels that vary by how easily they apply to the drawing surface and how oily they feel in the hands. Very soft pastels, like butter on a piece of bread, lay down on the drawing surface very easily and smoothly. And I would say it gives the effect of painting with oil. I use this type of pastel very rarely. Hard oil pastels are suitable for drawing details and some kinds of graphic sketches. My preference is soft oil pastels. I recommend this type of oil pastel as it works perfectly well and has all the features that you would expect from such a product.

TIP: Be sure to read on the packaging as to what sort of results an oil pastel set offers, so that you get the most out of what you are paying for.

PAPER

Let's talk about paper that can be used when drawing with oil pastels. Here, I have compiled from my own experience several paper options that I feel are ideal for this type of medium. Keep in mind that it is very important to use the right kind of paper when it comes to drawing with oil pastels, so make sure you try each option in the following list.

Drawing paper, a.k.a. sketching paper: You may be surprised, but I find that paper for sketching is perfect for drawing with oil pastels. It is smooth paper, without any texture, and I love how the oil pastels lay down on it. The weight of this paper is usually around 150 gsm and up. And the thicker this paper, the better for drawing with oil pastels. I would like to note that such paper can come in different colors: white, toned (beige or the color of craft paper) and black. Toned and black paper are perfect for drawing with oil pastels. Toned paper is usually preferred for oil pastels because it produces a much deeper, richer color. Black paper, on the other hand, hides flaws; if an artist chooses to have a completely black background, these imperfections will not be as apparent. So, I would highly recommend toned and black paper for learning oil pastel drawing.

NOTE: For each of the book's projects, you will find a specific color of paper in the supplies list; feel free, however, to use toned drawing paper.

There is a **special paper** for working with oil pastels. It is particularly designed for painting with this medium. It can be toned paper, or even in one pad, there can be paper sheets in several tones, from a pale blue shade to black sheets. But personally, I find it too expensive. Of course, you can try this paper. However, I would not recommend using it on a regular basis.

Watercolor paper: You can use watercolor paper when working with oil pastels. Depending on your artistic needs, you can use either a smooth, hot-pressed watercolor paper or the cold-pressed type, which has some texture. For oil pastels, I personally prefer the hot-pressed watercolor paper. As for the cold-pressed paper, it is a perfect option if you work in mixed-media techniques. Paint the first layer with watercolor and then add layers over that with oil pastel.

Mixed-media paper: Mixed-media paper is designed for painting with different artistic mediums on one page and is also suitable for drawing with oil pastels. Typically, this paper is smooth and quite thick, so oil pastels lay on it and then blur and blend easily.

TOOLS FOR BLENDING

In addition to the oil pastel set and paper, you will also need tools for blending and blurring oil pastels. Let's consider what you can use for this.

TIP: It is very important, every time you go to work with a different color of oil pastels, to clean or change the blending tool. Regardless of which blending tool variation you use, it should be clean for every new color you work with.

- **Blending stumps:** First of all, you will need blending stumps in different sizes. Blending stumps are cylindrical drawing tools that the artist presses and moves on the paper to achieve a smooth transition of colors, as well as to create soft blends or blurring strokes/layers. The shape of the blending stump is usually tapered toward the end, so it is easy to blur any details or thin elements. Usually, they are made from rolled paper and thus some may be irregular in shape and size. To clean blending stumps, you can use sandpaper or a paper towel.

- **Cloth for blending:** This is a piece of fabric you can use for blending oil pastels. It can be a cotton cloth, or any other soft and flexible fabric that is excellent for blending colors with oil pastels. For large areas, you can move the cloth with pressure across the surface of your paper to blur or blend the oil pastels. For smaller areas, wrap the cloth around your finger or fingers and then blend the pastel.

- **Paper towels for blending:** A paper towel works the same way as a cloth for blending. But the paper towel cannot be cleaned or washed, so you just have to throw it away when it's dirty. To work with a new color, take a new, clean piece of paper towel or use a clean part of the paper towel you used before.

- **Cotton swabs** are an alternative to blending stumps. The disadvantage of the cotton swabs is that you cannot clean them and have to replace them with new ones.

- And of course, you can use your **fingers** for blending the oil pastels. This is the least expensive way, but your hands are always dirty and I personally make a mess and prefer to blend the oil pastels in other ways.

ADDITIONAL MATERIALS

A **painting knife** is a special tool used in the oil painting process. You can use it for the scratching technique when drawing with oil pastels. A good-quality painting knife will make it easier and more enjoyable to do detailed work, but any other sharp object at home, such as a household knife, would be just as suitable.

Masking tape or washi tape is useful for many reasons. Traditionally, it was used to hold something in place, but within the book, you will use masking tape to secure sheets of paper to your work surface or to define the drawing area if it's required in the project description. When your work is done, you can just remove it without damaging the paper.

NOTE: Some types of paper and some tapes may not work together. So, before drawing the piece and using masking tape, test the tape on the paper. If, after removing the tape, the paper is not damaged, go ahead with the project drawing.

Paper towels for cleaning: I already mentioned the paper towel as a blending option. You will also need them for cleaning the oil pastel sticks and some blending tools, such as blending stumps. I use one extra piece of paper towel to put the dirty tools on it. I advise having a few pieces of paper towel ready during the drawing session, to prevent a mess in the workspace and make the drawing process pleasant, as well as to enable you to only focus on the creation.

Pencil: For preliminary sketching for some projects in this book, you will need a mechanical or regular #2 pencil (also called an HB pencil). For sketching on dark or black paper, you will also need a white pencil. This can be a white chalk pencil or soft white pencil.

Eraser: I prefer to use a kneadable art eraser, and I use it all the time for sketching with a pencil. However, any eraser will be suitable while working on the sketching for the book projects.

OTHER MEDIUMS

Very often, oil pastels are used along with other materials. Let's consider very briefly the materials you will need for the Mixed-Medium Projects chapter (page 171) as well as for other projects that use oil pastels.

Colored pencils of different types can be used with oil pastels. Using pencils is perfect if you need to draw some details or fine details and it's not convenient to do this with oil pastels. Try soft colored pencils; they are easier to work with than regular colored pencils and you don't have to sharpen them often.

A **white chalk pen** is a pen that can paint on a variety of surfaces, including over oil pastels. Because white gouache does not lay over an oil pastel layer, you can use such a pen to add highlights or some details, for example.

The next medium is **gouache**. Gouache does not work over oil pastels. But you can paint over the surface of a gouache layer with oil pastels. If you do not have a set of gouache, but you would like to mix these two mediums, then purchase a gouache set of basic colors, such as red, blue, yellow, ochre, black and brown. It is best to have cool and warm tones of each of these colors. You will also need a big tube of white gouache. The rest of the colors, you will be able to mix on your own.

As with gouache, **watercolor** doesn't allow painting over the oil pastels. But you can draw with oil pastels over beautiful, dried watercolor layers. You can use any type of watercolor: in tubes, in pans (solid watercolors) or liquid watercolor. Whichever type you use, I recommend choosing a professional grade of watercolor.

NOTE: If you paint with gouache or watercolor, you will also need a few brushes, a mixing palette or dish, containers for water and scrap paper (for testing colors).

INSPIRATION & DAILY SKETCHBOOK PRACTICE

INSPIRATION

This section is dedicated to inspiration, and how to keep creating and practicing drawing daily. I picked the top tips and I hope they will help you figure out and keep going in your creative journey. Everyone has the ability to create something creative. Yet people tend not to do so because they don't believe they can create every day. Most people will claim that they simply do not have the time for creativity in their lives. So, what to do and how to actually help ourselves?

The first way to get started with creativity is **to take time out and enjoy yourself**. You may need some time for yourself to refocus your thoughts and to come up with new ideas. It doesn't have to be anything special—just do something that you really enjoy doing! There are any number of activities that might help you feel inspired, such as cooking, drawing, movie marathons or simply taking a walk and admiring the outdoors. Once you've had some fun, though, it will be time to get down to business—so the next step is patience. Sometimes, it takes a little while before the creative juices start flowing again . . . so make sure that when they do, you write down or make a quick, rough sketch of whatever inspiration comes to mind even if it isn't fully developed yet—we don't want all this amazing brainstorming to go to waste, after all!

The second method is a **mood board**. I have been using this method since I was a graphic designer. It always works and gives good results. A mood board is a visual representation of images you like and are inspired by; it contains anything you feel that you can draw inspiration from for current or future use—essentially, it inspires you!

You can make numerous mood boards and create your own base of mood boards. Or you could create one more specifically for a project. Usually, I create a specific mood board before starting work on a painting or drawing. Once I feel I am ready to jump to the sketching stage, I close the mood board and move on to the next step.

Another way you can get creative is by **trying out a variety of mediums**. It may sound weird, but you might be simply working with "not your material." So, I advise you to practice and use all mediums you can try or afford to try out. Sometimes the mixing of some mediums can inspire you and can be the start of your creative journey.

And the last thing on my list is **daily sketchbook practice**. It's a method that everybody, in my opinion, should at least give a try. It's just wonderful how it works in helping you stay focused and in touch with your creative side throughout the day. In the next section, I'll explain what it is and how to practice drawing in a sketchbook every day.

DAILY SKETCHBOOK PRACTICE

As I mentioned before, one of my ways to stay inspired is by painting in a sketchbook every day. No matter what the subject or how long it takes you to finish, you should be practicing on a regular basis. It can be a 15-minute quick sketch, for instance. For oil pastels, you can either use a standalone sketchbook and stick with one medium, or mix different mediums in one sketchbook. **If you are drawing with oil pastels in your sketchbook, you need to use a fixative spray to prevent pages from sticking to each other and smudging out your drawings.**

WHAT CAN YOU DRAW IN YOUR SKETCHBOOK?

A sketchbook is perfect for when you want **to capture simple memories and ideas**. For example, if you're out and about on the street, admiring all the potted plants or flowers outside people's houses, you can draw a quick outline of this with oil pastels or pencils in your sketchbook. You can then take this idea back home and create a full-fledged drawing with it. The great thing about these quick sketches is that they usually look absolutely lifelike, so they're always unique! Again, the key here is to have fun using your imagination and creativity!

Second, if you choose to try **to draw some ideas or experiment** with colors, shapes and compositions, go ahead and use a sketchbook. Where else can you conceivably do this? If you capture your idea on a piece of paper, there's a chance you may lose this piece of paper along the way. A sketchbook will always work as an archive and will always be full of inspiration; you can go back to it at any time.

Finally, use a sketchbook for **quick warm-up drawing sessions**. This could be a quick drawing of a little object or you could draw one part of a big project every day. Draw or paint anything that doesn't take too much of your time, and you will see that it always works as art therapy for you. You can set for yourself a daily ritual: make tea or coffee, for example, and enjoy a quick drawing session in your sketchbook.

ACKNOWLEDGMENTS

Thanks to my husband and my soulmate, Ignat. Thank you that you are always being with me and supporting all my endeavors. It is an invaluable gift for which I am grateful forever. To my family and all my friends, I can't imagine my life without all of you. To Lauren, my talented and sweet editor. You're the best. And of course, I am grateful to all my followers and friends on social media. Thank you for staying with me for years, for your feedback, your love. Thanks, my dear friends, that you keep inspiring me and pushing me on this journey. I can't explain how grateful I am and how much I appreciate this.

ABOUT THE AUTHOR

Passionate, dexterous and highly energetic, Anna Koliadych is a spearheading watercolor/gouache/oil pastel artist, illustrator and educator who aims to motivate and empower others to unlock their full artistic potential. As the founder of DearAnnArt, Anna has an extensive creative background and loves not only to express herself through artistic freedom, but also enjoys giving her viewers/students the ability to experience different techniques and stances that deeply inspire.

Anna was born in Ukraine, lived in London and elsewhere in the United Kingdom, and now permanently resides in her husband's hometown of Tallinn, Estonia, with him and their son. Growing up, she has always had a rooted admiration for creating art and using it as a cornerstone outlet for self-expression. She appreciated the concept of being able to blend colors, tones and perspectives on a blank canvas and to develop something incredibly beautiful from it. However, before transforming her art hobby into a career, Anna earned a master's degree in automation and engineering in Ukraine. She then worked as a graphic designer for five years for international companies in Malta and Ukraine.

During her time as a graphic designer, Anna received her first watercolor set in the summer of 2014. Upon painting her first two illustrations, her ignited fire for this artistic avenue surfaced, and she began self-teaching and later in 2015, studied at a private art school in Kyiv, Ukraine. From there, Anna sharpened her water-coloring skills involving food, children's books, fashion and street illustrations by attending an art school in St. Petersburg, Russia. With these as her building blocks, Anna began working as a freelance watercolor illustrator in 2016. Fast-forward to today, she has orchestrated 20+ watercolor workshops in London, one of which was deemed a top-selling watercolor course in 2018, written two publications called *15-Minute Watercolor Masterpieces* (2019) and *Gouache in 4 Easy Steps* (2020) and has successfully launched her newest gouache course, "Get Started with Gouache," in 2021.

Overall, nothing makes Anna happier than leveraging her cultivated professionalism and passion for teaching to guide others toward reaching their artistic objectives. She has a true ardency for her work and demonstrates her commitment by launching galvanizing courses that unlock new levels of success on a global scale. This, in conjunction with her ability to simplify complex subjects and her expertise built on a foundation of authenticity, have all positioned Anna to become the accredited watercolor/gouache/oil pastel artist and influencer that she is today.

There is no denying that Anna loves what she does and is always seeking ways to advance herself both personally and professionally to give others the opulent course content they deserve. However, when she is not working or flexing her creative side, you can often find her cooking, playing with makeup, enjoying nature, practicing yoga and above all, spending precious time with her husband and little boy.

INDEX